THE ART OF SCENIC DESIGN

Drawing for Scene I, *Das Rheingold*, by Richard Wagner, designed
by Lee Simonson for the Metropolitan Opera Association

THE ART OF SCENIC DESIGN

Drawing for Scene I, *Das Rheingold*, by Richard Wagner, designed
by Lee Simonson for the Metropolitan Opera Association

THE ART OF SCENIC DESIGN

A PICTORIAL ANALYSIS OF STAGE SETTING AND ITS RELATION TO THEATRICAL PRODUCTION

BY

LEE SIMONSON

GREENWOOD PRESS, PUBLISHERS
WESTPORT, CONNECTICUT

Library of Congress Cataloging in Publication Data

Simonson, Lee, 1888-
 The art of scenic design.

 Reprint of the ed. published by Harper, New York.
 Includes bibliographical references.
 1. Theaters--Stage-setting and scenery.
I. Title.
[PN2091.S8S525 1973] 792'.025 72-6182
ISBN 0-8371-6481-8

Originally published in 1950 by Harper & Brothers, New York

Reprinted with the permission of Harper & Row

Reprinted by Greenwood Press, Inc.

First Greenwood reprinting 1973
Second Greenwood reprinting 1977

Library of Congress catalog card number 72-6182

ISBN 0-8371-6481-8

Printed in the United States of America

To

ROBERT BERGMAN

who painted my first setting
and many of my later ones

CONTENTS

ILLUSTRATIONS

FOREWORD

THE THEME of this pictorial history is not only the various techniques of scenic design, but also their relation to theater architecture and dramatic production. Whether it be the palace façade of the Attic theater, the framed perspectives of Renaissance and Baroque stages, or our own, any stage setting creates an environment in which the words of a playscript, once spoken, become not a recitation but an "imitation of action." Speech coupled with bodily movement, motion confined in a pattern of space, provide the nexus in which spoken dialogue becomes an act of living with which an audience can identify itself. The process by which a stage can be made the world of the play is the art of the theater.

I have not attempted to write a complete history of theater art. My purpose instead has been to describe and illustrate certain basic concepts of the Renaissance, to trace their effect on the staging of plays and the structure of the playhouse, and then to analyze the theories and experiments of the latter part of the nineteenth century which have become the basis of play production today

Ever since Sophocles reputedly invented scene painting, the designer of stage settings has been to a greater or less degree an interpreter of a playscript, primarily as an architect from the fifteenth through the eighteenth century, as a scene painter through most of the nineteenth century and since 1900 as an architect of stage space. His extended range of technical control—particularly of light, "bright effluence of bright essence," now his second brush— makes him an essential collaborator of the play's director in interpreting a script and bringing it to life, and makes his settings an integral part of theatrical production.

<div align="right">L. S.</div>

ACKNOWLEDGMENTS

FOR their personal assistance in helping me assemble many of the drawings and prints reproduced in this volume I wish to thank William M. Ivins, Jr., Professor Gustave Cohen of the Sorbonne, Alice Newlin of the Print Department of the Metropolitan Museum of Art, Edna B. Donnell of the Cooper Union Museum, Pearl L. Moeller of the Museum of Modern Art, William Van Lennep of the Harvard Theatre Collection, Henry M. Fuller of the Yale University Library, and Lucien C. Goldschmidt of Pierre Berès Inc. Also W. G. Russell Allen for his courtesy in allowing me to reproduce on the title page a sixteenth-century woodcut from his collection, and the Kirkeby Hotels magazine for the color plate of my drawing for *Das Rheingold*.

I also want to thank my friends and colleagues for permission to reproduce their designs and photographs of their productions—Antonin Heythum, Norman Bel Geddes, Jo Mielziner, Robert Edmond Jones, Stewart Chaney and Donald Oenslager.

<div align="right">L. S.</div>

THE ART OF SCENIC DESIGN

Chapter I. PICTURES AND PERSPECTIVES

1. THE TECHNIQUE OF ILLUSION

I BEGIN this analysis of scenic design with the stage settings of the Renaissance theater in Italy for it was then that the platform stage of medieval passion plays and mysteries was brought indoors and productions were presented under artificial light. This indoor theater became the prevalent type of playhouse for five centuries and still is today. More recent "modern" variants reproduce in "unit sets" the mansions of the medieval stage or those of the seventeenth century *Hôtel de Bourgogne* in Molière's Paris. Innovations in theater architecture revive on a smaller scale the circus arenas of Roman amphitheaters in which the audience encircled the actors or some variation of the Greek theater plan in which spectators on a steeply pitched bank of seats rose above a circular or semicircular playing space backed by a fixed architectural façade.

Renaissance artists of the fifteenth century, by turns architects, painters, and scene designers, were preoccupied with the same aesthetic problem: how to create the illusion of three dimensional space and distance within a single picture plane by what is now called one-point or two-point perspective. A knowledge of Euclid and descriptive geometry was as essential a part of an ambitious artist's equipment as his knowledge of anatomy or the manipulation of glazes and pigments. Research in perspective rendering became a mark of distinction.

We read in Vasari's life of Paolo Uccello[1] (1397-1495), that his wife "was wont to relate that Paolo would stand the whole night through beside his writing table, seeking new expressions of his rules of perspective and when entreated by herself to take rest and sleep, he would reply 'Oh what a delightful thing is this perspective.'" Piero della Francesca (1416-1492) "devoted much attention to perspective and possessed considerable knowledge of Euclid, insomuch that he understood all the most important problems of rectilinear bodies better than any other geometrician and the most useful elucidations of these matters which we possess are from his hand." Filippo Brunelleschi (1377-1446) "gave considerable attention to the study of perspective, the rules of which are often falsely interpreted; and in this he expended much time until at length he discovered a perfectly correct method, that of taking the ground plan and sections by means of intersecting lines, a truly ingenious thing, and of great utility to the arts of design."

[1] This quotation and those that follow are from Bohn's edition of Vasari (London, 1850).

A building correctly drawn in perspective as part of the background of a painting was often of as much aesthetic interest to a painter's contemporaries as the movement or the modeling of figures that dominated a pictorial composition. Masaccio (1401-1428) "successfully coped with the difficulties of perspective which he overcame most admirably and with the artistic skill, as may be seen in a story representing Christ curing a man possessed by a demon which comprises a number of small figures. . . . In this are buildings beautifully drawn in perspective and so treated that the inside is seen at the same time, the artist having taken the view of these buildings not as seen in front but as seen in the sides and angles, to the great increase of the difficulty."

Of a fresco in the church of Santa Maria Novella "representing the Trinity, with the Virgin on one side and St. John, the Evangelist on the other, who are in contemplation of Christ crucified . . . perhaps the most beautiful part of this work, to say nothing of the excellence of the figures, is the coved ceiling, painted in perspective . . . the foreshortening is managed with so much ability. . . ." Again of Uccello's "Annunciation in Santa Maria Maggiore": "In this picture he represented a building which is highly worthy of attention; it was then a new, and was considered to be a difficult thing, since it was the first edifice depicted in a good manner, and with true and graceful proportions; by this work artists were taught that, by due arrangements, the level space, which is in reality small and closely bounded, could be made to appear extensive and acquire the semblance of distance; and he who, after securing this, and distributing his lights and shadows to their proper places and duly managing the colours, will doubtless produce the effect of a more complete illusion to the eye, cause his pictures to exhibit higher relief and give them a more exact resemblance to life and reality."

To make a small, level, closely bounded space (the indoor stage) seem greater than it actually was; to achieve the illusion of depth, distance, and a heightened resemblance to reality—what better description could there be of four centuries of scenic design—with its classic and romantic vistas, until the first attempts of the early 1900's supplanted them with the abstractions of Gordon Craig and those of German and Russian Expressionists?

The key formulations of the technique of depicting objects in perspective and those which most directly affected the subsequent development of scenic design were the work of the architect Leon Battista Alberti (1404-1472), who, Vasari says, "having given his attention to the study of Latin as well as that of architecture, perspective and painting . . . left behind him books, written in such a manner, that no artist of later times has been able to surpass him in his style and other qualities of an author. . . . Such is the force of his writings, and so extensive has been their influence. . . ."

Alberti's treatise, *Della pittura libre tre* (1435-36), "is generally acknowledged to be the earliest statement of logically coherent and pictorially adequate scheme of perspective rep-

resentation. . . . In . . . the third of his Three Books Alberti says that 'the task of the painter is to represent with lines and color with pigments the visible surface of any object upon a given panel or wall in such fashion that, at a certain distance and in a certain position from the center of vision, it may appear as though in the round and will closely resemble the object.' . . . The clue to the sense of these remarks is given in the *Vita Anonyma* of Alberti. . . . [He] wrote several books on painting, for with the aid of this art he brought about things unheard of and he showed these things through a tiny opening that was made in a little closed box. . . . He called these things *demonstrations* and they were of such a kind that both artists and laymen questioned whether they saw painted things or natural things themselves."[2] Alberti's method and his model provided the technical basis for projecting perspective vistas on the stage.

2. ROME REVIVED

The Renaissance concept of form and composition—its notion of the theater, both architecturally and scenically—was derived from a classical text which was in many respects inadequate and archeologically inaccurate. This was *De Architectura* by the Roman architect Vitruvius, which had been known in manuscript since early in the fifteenth century and was first published in Rome in 1486. In Book V, Vitruvius mentions a painted scene being done "when Aeschylus was bringing out a tragedy" and a commentary on it by the scene painter. "This led Democritus and Anaxagoras to write on the same subject, showing how, given a center in a definite place, the lines should naturally correspond and with due regard to the point of sight and the visual rays, so that, by this deception, a faithful representation of the appearance of buildings might be given in painted scenery, and so that though all is drawn on a vertical flat façade, some parts may seem to be withdrawing into the background and others to be standing out in front." (Note how closely this corresponds to Vasari's description of Brunelleschi's "correct method of taking the ground plan and section by means of intersecting lines" and of Uccello's achievement in making "a closely bounded space appear extensive" and producing "the effect of a more complete illusion to the eye.")

But the key passage is one that formulates the three types of stage settings: "There are three kinds of scenes, one called the tragic, second the comic, third the satyric. Their decorations are different and unlike each other in scheme. Tragic scenes are delineated with columns, pediments, statues and other objects suited to Kings; comic scenes exhibit private dwellings, with balconies and views representing rows of windows, after the manner of ordinary dwellings; satyric scenes are decorated with trees, caverns, mountains, and other rustic objects delineated in landscape styles."

[2] *On the Rationalization of Sight* by Wm. M. Ivins, Jr. Paper No. 8, New York, Metropolitan Museum of Art, 1938.

Sebastiano Serlio, in Book II of his *Architecture* which was published in 1545, depicts in three celebrated woodcuts the Tragic, Comic, and Satyric—or, as it would be called today, the Open Air or Landscape Setting. But settings very similar to these had already been seen on many of the first Renaissance stages at the court theaters of Mantua, Ferrara, at Florence and in Rome. A member of the Roman Academy writes to Cardinal Rierio under whose patronage revivals of Plautus and Terence were given between 1480-90: "You first equipped a stage for Tragedy beautifully. This was erected five feet high in the middle of the square. After the play had been acted [in the Castle of Hadrian] before Pope Innocent X you revived it again in your own palace. The audience sat under awnings as in the *cavea* of a circus. The public was admitted and there were many spectators of your own rank. You too when the students of Pomponius acted a comedy first revealed to our age the appearance of a painted scene."[3]

At the court theater of Ferrara in 1508, a setting by the duke's painter, Pellegrino de San Daniele, for Ariosto's *Cassaria*, was described by a member of the audience in a letter to Isabella d'Este: "It has been a view in perspective of a town with houses, churches, belfries and gardens, such that one could never tire of looking at it, because of the different things that are there, all most cleverly executed. I suppose that this will not be destroyed but they will use it on other occasions." Castiglione, who supervised productions for the Duke of Urbino, wrote in 1513 to a friend in regard to a performance of *La Calandria*, "The scene represented was an outer street of the town between the city wall and its last houses. The wall with its two towers was represented in the most natural way possible, rising from the floor of the stage to the top of the hall. . . . The scene was laid in a very fine city with streets, palaces, churches, and towers, and looking as if they were real, the effect being completed by admirable buildings in scientific perspective. Among other objects, there was an octagon building in low relief, so well finished, that even if all the workmen in the Duchy of Urbino had been employed, it seemed hardly possible that all this had been done in four months! . . . This temple stood in the centre of the stage. At one end there was a triumphal arch about two yards from the wall, marvellously executed. Between the architrave and the vault an admirable representation of the story of the Horatii had been painted to imitate marble. The two niches above the pillars supporting the arch were filled with little Victories bearing trophies in their hands made of stucco. . . ."

When the same play (by Cardinal Bibbiena) was given before Pope Leo, Vasari describes Peruzzi's "scenic setting," two scenes "which were marvellous and opened the way for those that have since been made in our own day. Nor is it possible to imagine how he found room in a space so limited, for so many streets, so many palaces, and so many bizarre temples, loggie, and various kinds of cornices, all so well executed that it seemed that they were not

[3] Allardyce Nicoll, *The Development of the Theatre* (New York, 1927), footnote p. 81.

counterfeited but absolutely real, and that the piazza was not a little thing and merely painted but real and very large."[4]

When Raphael succeeded Bramante as architect of St. Peter's in 1514, he also took charge of the papal fêtes and designed a number of settings. One for *I Suppositi* by Ariosto (1518) is described in a contemporary letter. "Music sounded and the Pope, through his eye glasses, admired the setting which was extremely beautiful and from the hand of Raphael himself; in truth it was a beautiful view of streets and perspectives which were greatly praised. His Holiness admired the heavens which were marvellously done."

Not only were the architectural backgrounds of many Renaissance paintings similar to those constructed for stage settings, but a typical stage setting was often the subject of a painting, such as two panels by Luciano Laurana[5] formerly ascribed to Piero della Francesca. The vision of the artist as painter and the artist as scene designer were virtually identical.

Uccello's exclamation: "Oh what a delightful thing is this perspective!" expresses an enthusiasm that not only dominated Renaissance taste but continued to exercise its spell in the theaters of England, France, Germany, and Austria for two hundred years. Serlio begins his *Treatise of Scenes as Places to Play In* with a typical apostrophe: "Among all the things that may be made by men's hands, thereby to yield admiration, pleasure to sight and to content the fantasies of men, I think it is the placing of a scene, as it is shown to your sight where a man in a small place may see built by a carpenter or a mason, skillful in perspective, great palaces, large temples, and divers houses, long streets crossed with other ways, triumphant arches, pyramids, obelisks, and a thousand other fair things. . . ."

3. PEDIMENTS, PLASTER, AND PAINT

Serlio constructed his settings exactly as our more realistic ones are built today, of canvas stretched on frames, the painted surfaces reinforced with moldings. Of both the tragic and comic scenes he says, "I made all my scenes of lathes covered with linen, the cornice bearing out. . . . I have also made some things of half planks of wood which were of great help to the painters to set things out at life. . . . All such houses I always made of spars, or rafters or lathes covered with linen cloth. . . ." Paint and plaster or gesso were combined to give the impression of architectural solidity and, as in Castiglione's description, details of ornament were modeled in full relief. The foreshortened street vistas seen through the archways of the permanent setting of the *Teatro Olympico* were made and finished in precisely this way. The typical Renaissance stage setting began with buildings in the foreground, with "hangings

[4] Lily B. Campbell, *Scenes and Machines on the English Stage During the Renaissance* (Cambridge University Press, 1923), pp. 50-52.

[5] Richard Trautheimer, "The Tragic and Comic Scenes of the Renaissance," *Gazette de Beaux Arts*, June, 1948.

out" of projecting roofs and balconies, and "cornices bearing out"; it then receded to a back-drop where the perspective vista was carried entirely in paint to the vanishing point.

The elements of Serlio's tragic and comic settings became a tradition which was reflected in stage settings a hundred years later. Note, in the settings for the opera *Andromeda,* for which Corneille wrote the libretto, how similar its units are to those of Serlio's Tragic Scene. The triumphal arch of Scene 2 is in the identical position at backstage center; the archway downstage at the left in Serlio's setting is seen upstage at the right; the conical roof of the building immediately behind Serlio's arch tops the second building downstage right in *An-dromeda.* Serlio's small Greek temple becomes a two-storied one. Throughout, the same ele-ments of classical architecture are recombined, pillars, pilasters, columns, and pediments. The balconies, loggias, and arcades of the Comic Scene are repeated in the single setting for *Il Solimano* (1620). The central arch of Serlio's Tragic Setting, combined with arched openings of the Teatro Olympico, reappears in the setting for the Jesuit opera *Saint Alexis,* 1663. The backdrop vista of converging avenues becomes a stylistic formula and persists in innumerable designs as recent as the setting for Edwin Booth's production of *Romeo and Juliet* in 1869.

By the middle of the seventeenth century a decisive technical change had taken place. Painted perspective supplanted the three dimensional structures with their cornices, "hang-ings out," and projecting roofs and balconies. Form as well as space and the vistas on backdrops were simulated by illusionistic scene painting. The stage was framed, as paintings were, in an ornamental frame—the proscenium. The stage itself became an enlarged painting.

This transformation was the result of the popularity of another Italian invention, opera, which speedily captivated all of Europe. Indeed, the first opera (Peri's choral music for the poem, *Euridice*) was performed as part of the festivities arranged for the marriage of Henry IV of France to Maria de Medici in 1600. It was then called a drama set to music—*drama per musica.* But by 1608 Gagliano in his preface to *Dafné* described, though the production may not have exemplified it, what was shortly to expand into the glitter and glamor of elaborate spectacles: "A truly princely spectacle, and delightful beyond all others, being one in which are combined all the noblest oblectations such as contrivance and interest of plot . . . mellif-luous rhyme, musical art, the concert of voices and instruments, excellence in singing, grace in dancing and gesture; and it may also be said that painting plays no unimportant part therein in matters of scenery and costume; so that the intellect and every noblest sentiment are fascinated at one and the same time by the most delectable arts ever devised by human genius."

"Orpheus with his lute made trees." Opera sounded the note which set the technique and the type of stage setting for theatrical productions, whether spoken or sung, for two succeed-ing centuries.

Chapter II. THE GROOVES OF CHANGE

1. GODS AND MACHINES

"IN OTHER scenes you may see the rising sun with his court above the world and at the ending of a comedie you may see it go down most artificially whereat many beholders have been abashed. And when the occasion ariseth you may see a god descending from heaven." Thus, Serlio.

The favorite spectacular effects of the Renaissance theater continued the assumptions and divine descents that were part of the pageantry of the medieval stage. For a performance of the Mystery of the Acts of the Apostles, performed at Angers, St. Peter, bound to a pillar, was raised until he was hidden by clouds suspended above him. At Valenciennes, Moses and Elias, standing on a cloud, disappeared into a heaven of blue canvas. In the same performance a turret was raised revealing Joseph and Jesus within. "All such machines, invented during the 15th century, delighted our forefathers for three hundred years; during the reign of Louis XIV they provided one of the principal attractions of the theater both for towns-people and the court."[1]

Renaissance drama, both sacred and profane, took place not only on its stages but in the streets. The occasion was usually the entry in state of a monarch and his court, when Biblical subjects were pantomimed in "living pictures" on a succession of stages that lined his progress through the streets. An angel seated in a circle of clouds often descended to present the prince the keys of the city. The tradition was continued in public festivities to the end of the seventeenth century. There are contemporary records of twenty-five entries in State between 1443 and 1598 in various cities of Italy from Milan to Sicily, one hundred in France during the same period, and fifty or more in both England and Flanders.

When the Emperor Charles V made his entry into London in 1521, he passed a heaven of painted clouds set with stars where a choir of angels sang. From it a "fair lady" richly apparelled, descended to salute him and then was "assumpted" into the cloud, which was "very curiously done." When the same monarch entered Messina fifteen years later from "a heaven of clouds and golden stars built above a church . . . a chariot bearing twenty-four angels descended to greet him and present him the Tokens of triumph." For an entry of Anne Boleyn (1533), in a bit of symbolic pantomime, first a falcon descended to a stage below, then an angel who placed a crown on the falcon's head. In the coronation procession of Edward VI, a phoenix

[1] G. Bapst, *Essai sur l'Histoire du Théâtre* (Paris, 1893).

accompanied by angels descended from heaven and crowned a young lion. At the entry of Louis XII into Rouen (1508), a globe opened and Renown was carried aloft.[2] When Pius II celebrated the feast of Corpus Christi at Viterbo in 1482, the attending cardinals each erected a stage along his route where allegories and biblical stories were depicted. "There was a suffering Christ and singing cherubs, the Last Supper with a figure of St. Thomas Aquinas, the combat between the Archangel Michael and the devils, fountains of wine and orchestras of angels, the grave of Christ with the scene of the Resurrection, and finally on the square before the Cathedral, the Tomb of the Virgin. It opened after High Mass and the mother of God ascended singing to Paradise where she was crowned by her Son and led into the presence of the Eternal Father."[3]

Brunelleschi, for the Feast of Ascension, constructed in the Church of San Felice at Florence a platform under a dome which held twelve children dressed as angels "with gilded wings and hair formed of golden threads." This was lowered to the church floor; the angels caroled that Christ was risen, then rose themselves, disappearing through sliding trap doors which closed beneath them with a rumble that seemed an appropriate clap of thunder. Leonardo da Vinci in 1489, for the nuptials of the Duke of Milan, devised a machine representing "on a colossal scale" the planets swinging in their orbits. As each of these in turn neared the bride, an actor, representing its guardian deity, emerged and paid homage to the duchess in verse.

Classic myths supplied new themes for the pageantry of court masques and the dance interludes that punctuated comedies. One arranged by Castiglione for the Duke of Urbino is typical of hundreds that were given at every court in Europe. It showed Jason with the Golden Fleece about his shoulders, Venus' chariot drawn by doves, Juno's ablaze with light preceded by puffing cherubs—the winds of heaven—and drawn by two resplendent peacocks. It was so lifelike, Castiglione remarks, that he could hardly believe his eyes, although he had himself given directions as to how they were to be made.

These theatrical and scenic effects were often so elaborate that for a single entry, that of Philip II into Antwerp, 895 carpenters, 235 painters, 16 woodcarvers, as well as 500 other workmen were employed. There are records of no less than 282 French and Italian painters, sculptors, and architects who took part in staging royal entries at Dijon, Lyons, Orleans, and other cities for the kings of France from the time of Charles II to the accession of François I.[4] Among them were Jean Fouquet and Sebastiano Serlio, as court architect to François I.

The tradition reached its climax under Louis XIV at his favorite theater, appropriately called *La Salle des Machines*, with the *gloires* that ended a play or an opera, when bevies of gods and goddesses descended and then rose in glory to an Olympus under the roof. In *Ercole Amante* the platform which held the apotheosis of Hercules and Beauty was 60 feet long by

[2] G. R. Kernodle, *From Art to Theatre* (Chicago University Press, 1944), chap. II.
[3] J. Burckhardt, *Civilization of the Renaissance in Italy* (London, 1904), p. 414.
[4] G. Bapst, *op. cit.*, pp. 299-326.

40 feet deep, "and to the astonishment of the vast audience, bore upwards in easy progression all the members of the royal household or no less than one hundred souls."[5] Evelyn in Venice, 1645, saw an opera with thirteen changes of scene and noted in his diary: "To-night we went to the opera where comedies and other plays were represented . . . with a variety of scenes and no less art of perspective and machines for flying in the air and other wonderful motions."

But such effects, copied from Italian stages, had been popular in Elizabethan England. The Princess Elizabeth was thirteen years old when at a performance of Aristophanes' *Peace*, presented by the students of Trinity College, a machine sent an actor "flying up to Jupiter's palace, with a man and his basket of victuals on his back: whereat there was great wondering, and many vain reports as to how it was effected." Shakespeare was not yet born when, in the year of her accession to the throne, Elizabeth attended performances given for her by the students of Oxford. "On each side of the stage," wrote an eyewitness, "magnificent palaces are built up for the actors. . . . Its wonderful setting and lavish elegance had so filled everybody's minds and ears with its marvellous reputation that a mighty and countless crowd of people assembled together tremendously and immoderately anxious to see." When the Palatine of Saradia visited Cambridge University a banquet was given for him where he saw "Mercurie and Iris descending and ascending to and from a high place, the tempest wherein it hailed small confects, rained rose water, and snowed an artificial kind of snow, all strange marvellous and abundant." The gentlemen of the Inner Temple at the Inns of Court in London performed a tragedy for the Queen in which Cupid descended from heaven in a cradle of flowers and Megara and the furies rose out of hell.

Shakespeare was a member of the cast of Ben Jonson's *Every Man in his Humor*; in its prologue Jonson bragged that he needed no chorus to waft his audience overseas and that his play contained no creaking throne coming down from heaven, an effect fit to please only boys. The Chorus of Shakespeare's *Henry V* apologized for his cockpit that could not hold the vast fields of France or cram into his wooden O the casques that "did affright the air at Agincourt."

Three years before the performance of Jonson's play Sidney's *Apology for Poetry* was published and made his plea for the classic unities, pointing out the ludicrous effect of trying to circumvent them—"when two armies fly in represented with four swords and bucklers" which "an audience is expected to accept as a pitched battle." Five years previously another critic had complained of the dramatic taste of the English public of his day. "The Englishman is most vain, indiscreet, and out of order; he first grounds his work on impossibilities, then in three hours he runs through the world, marries, begets children, makes children men, men to conquer kingdoms, murder monsters, and brings Gods from heaven and fetcheth devils from hell."

[5] W. J. Lawrence, *The Elizabethan Playhouse and Other Studies*, 2nd series (Shakespeare Head Press, 1913).

But a nation of gentleman adventurers, sea captains, explorers, and buccaneers as well as the groundlings wanted a theater of narrative adventure that put a girdle round the earth if necessary; they preferred to feast their eyes rather than rely on their imagination. The battle to preserve the classic unities and the rigid, classic stage setting was lost in Shakespeare's lifetime. And once the period of civil war ended and the ban on play acting and theater building was over, Davenant built his Opera House. In the prologue to one of the first plays performed there, *The Siege of Rhodes,* he pointed out the ample scale of the stage, its "extensive breadth and height," the illusions of perspective, and "inward distance to deceive the sight," as well as its machines, and appealed for half the amount of money "that factions get from fools to nourish war" so that the audience, securely seated, could see "fierce armies meet" and "raging seas disperse a fighting fleet."

As on the continent, public taste demanded plays that were not static. The audience wanted a stage that not only encompassed the earth but included heaven and hell. It craved variety and change, flashing and flaring spectacular effects of fire and flame, thunder and smoke, and transformations that took place almost magically before its eyes. Theaters were built with that end in view. Inigo Jones in his masques brought to England all the elaboration of French and Italian spectacles and their constant changes of scene. Six years before Shakespeare's death, he designed *Tethys' Festival.* The scene was "a port, with bulwarks at the entrance, and the figure of a castle commanding a fortified towne, within this port were many ships, small and great, seeming to lie at anchor, some nearer and some further off according to perspective." Then "suddenly at the sound of music, Tethys and her nymphes appears. . . . First, at the opening of the heavens appeared three circles of light and glasses, one within another; and come down in a straight motion five foote and then began to move circularly . . . in a moment the whole face of the scene was changed, the port vanished and Tethys with her nymphes appeared in several small cavernes, gloriously adorned." This was followed by "a most pleasant and artificial grove."

A year later Jonson, despite his contentions in the prologue to his *Every Man,* supplied the script for the masque of *Oberon.* "The first face of the scene appeared all obscure and nothing perceived but a dark rock, with Trees beyond it and all the wildness that could be presented; Till at one corner of the cliff, above the horizon, the moon began to show." Then, "the whole scene opened, and within was discovered the frontispiece of a great and glorious palace, whose gates and walls were transparent . . . the whole palace opened, and the nation of Faies were discovered with instruments, some bearing lights, others singing, and within, afar off in perspective, the knights masquers sitting in the several sieges; at the further end of all Oberon, in a chariot, which to a loud and triumphant music, began to move forward drawn by two white bears."

The scene shift is as popular today as it was in England under Elizabeth and the Restora-

tion, or in France when the effulgence of the Sun Monarch brightened the stage. Cochrane's Reviews, the Ziegfeld *Follies, Oklahoma,* and our other "musical comedies" remain our most popular, and possibly the most typical, American form of entertainment, drawing the largest audiences. Their "lavish elegance" has "so filled everyone's minds and ears with their marvellous reputation" that they pack our biggest theaters, run for years, and tour the country with carloads of scenery.

The small boy whom Jonson disdained to please lurks in most theatergoers and even in some dramatic and musical geniuses. Wagner's dragon belching steam is a lineal descendent of the snake belching flame, its canvas body held up by hoops of willow, which Satan wriggled across the stage of a Passion play at Mons in 1501.[6] Fricka's chariot drawn by mechanical rams revives Juno's drawn by peacocks in Castiglione's pageant. The mechanical animals of the Nibelungen Ring were made by a London firm which turned out any number of similar ones for English Christmas pantomimes. The eighteen ornate wagons of the Emperor Maximillian's triumphal procession, engraved by Dürer, survived until the day before yesterday in the red, gold, and white floats and bandwagons of our circus parades.

2. PULLEYS, SLOTS, AND WINDLASS

The first mechanical devices for moving the houses and palaces of Serlio's comic and tragic settings were recorded in the next Italian textbook on scenic design: *Practicar di Fabricar Scene e Machine ne' Teatri* by Nicola Sabbatini, printed in 1638. Although nearly a century had elapsed, a succession of treatises on perspective had appeared in the interval between 1505 and 1600, by Viator, Vignola, Barbaro, and Ubaldi. The first French work on the subject was published in 1560.[7] The technique of perspective painting was an aesthetic discovery of the sixteenth century, and the illusion created by this technique became an aesthetic fashion in the seventeenth, just as impressionism, cubism, and surrealism have been in our time preoccupations not only of artists and designers but of poets and philosophers. Ben Jonson wrote: "Picture took her feigning from poetry, from geometry her rule, compass lines and the whole symmetry. . . . From optics it drew reasons by which it considered how things placed at a distance and afar off should appear less; how above or beneath the head should deceive the eye, etc. So from thence it took shadows, recesses, light and heightenings." Francis Bacon in his *New Atlantis* speaks of, "Perspective Houses, where we make demonstrations of all Lights and Radiations, and of all Colours . . . all Delusions and Deceits of Sight . . . things near as afar off, and things afar off as near."

Travelers in England described a portrait of Henry VI as "perspectively painted" and

[6] G. Cohen, *Le Livre de Conduite du Regisseur pour le Mystère de la Passion joué à Mons en 1501* (Paris, 1925), Introduction II.

[7] J. Cousin, *Livre de la Perspective,* followed by Courceau's *Leçons de la Perspective Positive,* 1576.

pictures on a table at Whitehall as "perspectively rather than artistically painted." Painted perspectives were set up in gardens to simulate nonexistent vistas and backed window panes. Perspectives in peep-show boxes were a popular toy. Evelyn notes in his diary that he was shown "a pretty perspective" of the Church of Harlem to be seen through "a small hole" at "one of the corners and contrived into a handsome cabinet. It was so rarely done that all the artists and painters in town flocked to admire it."

By Sabbatini's time skill in perspective painting had reached a point where the projections of cornices and balconies, the indentations of windows and doors with their cast shadows could be successfully simulated on a flat surface. Façades therefore could be made lighter and easier to move. Sabbatini used two methods—sliding and turning. One painted flat could be shoved over another, or the corner of the house be set at the angle of an isosceles triangle, the three upright flats making a prism which revolved on a platform base pivoted in the stage floor. The German architect, Furtenbach, used this system very ingeniously. His woodcuts show that he added two pits—one at the front of the stage, corresponding to the footlight trough, and another in front of the backdrop for additional lights. The backdrop was set at a point where the linear perspective of the side flats could be effectively carried into it, and the entire perspective effect was calculated from a single point of view so as to bring the vanishing point on the horizon into exactly the right relation with the seat of the prince or patron out in the auditorium. For the same reason the stage floor pitched up from front to rear—the origin of our terms upstage and downstage. The stage of the Metropolitan Opera House in New York was built in 1883 with a sloping stage as were most stages constructed earlier throughout the United States.

Sabbatini's revolving canvas prisms were a revival of one of the devices of the later Greek stage, *periaktoi*, described by Pollux, set flush with the palace walls and then turned to indicate a change of place. Modern designers have used *periaktoi* successfully—Joseph Urban in one of his Ziegfeld Follies, I in my production of *As You Like It*. Inigo Jones used another piece of classic apparatus—the sliding stage platform, *eccyclema*, on which the dead bodies were rolled forward through the palace doors. In several of his masques the first setting consisted of two flats built as shutters that slid off stage, as in *Oberon*, and revealed the mound or grotto which then rolled forward. Backdrops were frequently built in the same way as shutters, each opening, in turn, to show another in back which corresponded with the change of scene.

But scene shifts employing any of these methods were not fast enough. Inigo Jones occasionally relied on temporarily dazzling an audience's eyes with a blaze of light. The account of *Oberon* mentions the "lights and motions" which "so occupied the eyes of the spectators that the manner of altering the scene was scarce discerned." This was more likely to have been a wish than an accomplishment; candlelight could hardly have been made a blinding blaze. Sabbatini suggests planting two men at the rear of the audience who could pretend to start a

brawl, or, as an alternative, distracting the spectators with an unexpected blare of drums and trumpets. Obviously no such makeshifts could have made any audience turn and avert its eyes in unison.

The mechanician who made rapid scene shifts possible was Torelli de Fano and the effects he produced with one of his first productions of *La Finta Pazza* in Venice seemed so magical that he was once attacked there by a group of ruffians who tried to stab him for being an emissary of the devil. His apparatus for scene shifting soon became standard throughout Europe and remained so throughout the eighteenth century. It can be studied on a small scale at the Swedish Royal Theatre of Drottningholm near Stockholm, where it has survived with its original stage settings.

Scene painting had become so adroit that a flat could seem to turn a corner and be the angle of a building, a colonnade, or a hedge. Arranged in receding rows at carefully calculated intervals, these carried the converging lines of perspective from downstage into a backdrop vista, although each flat or wing was parallel to the front of the stage. Torelli mounted these flats on frames which went through a slot in the stage floor to sliding carriers just below it, connected by a system of ropes and pulleys to a master windlass. The flats were usually set in groups of three or four. One set showing house fronts, let us say, was drawn on stage, making a street setting, the rest being offstage and out of sight. At a turn of the master windlass below, the houses slid off and the next set, painted pilasters, slid on, forming a classic colonnade. At the same time, one backdrop was flown and another let down. Such scene shifts were probably made in thirty seconds or less and at the time must have seemed done in the proverbial twinkling of an eye.

Torelli was lent by his patron, the Duke of Parma, to the French court at the request of Mazarin to design settings for a group of Italian comedians that the cardinal had already installed on a stage built in the Petit Bourbon palace. In 1645 he reproduced *La Finta Pazza* with sensational success, and to amuse Louis XIV, then only seven, he added ballets of monkeys, mechanical ostriches that stretched their necks to drink at a fountain, and Indians with flying parrots. For his next production, *Orpheus,* he demolished most of the Palais Royal and rebuilt it. The court *Gazette* described the first act setting of a grove "which was so extensive and so deep that it seemed larger by a hundred times than the space of the stage." The spectacle culminated in the arrival of Apollo in a gleaming chariot, highlighted with gold leaf and sparkling "with carbuncles and diamonds."

After six years of theatrical triumphs Torelli returned to Italy and was succeeded by Vigarani as "machinist to the King." By way of outdoing his predecessor he burned every one of Torelli's sets, destroyed every bit of his machinery, and constructed a new theater in the Tuileries, which became the favorite playhouse of Louis XIV. This was so filled with scene-shifting apparatus that it was known as *La Salle des Machines.* Its stage was 32 feet deep, 24

feet high to the sky borders, with 37 feet above that for the apparatus needed to hoist and lower gods and apparitions. The auditorium, 93 feet in depth, held 7,000 spectators. Vigarani described some of the machines of *Ercole Amante* while they were in course of construction: "For the descent of Juno, Hercules, the Stars, the Influences and the Planets . . . we have ordered 2,000 brasses of silver gauze for the sea which can diminish in size." (A brasse was approximately 5 feet.) The dimensions of Juno's peacock seem incredible. It was "17 brasses long and as high and it spreads its long tail while walking thanks to a mechanism concealed within it." There was also a machine for the Moon, "which will open and show within a grotto, silvered in order to accent the crevasses seen through snow." There were 144 back-drops, the largest 75 feet in width.[8] The Inferno of this production was so popular that Louis XIV commanded Molière and Corneille to write the tragicomedy *Psyché* in order to use it again.

"The land of opera" remained a favorite field for painters and designers. Under Louis XV, Servandoni introduced the oblique perspectives through vast colonnades and into soaring vistas of vaults and domes of the prodigious Bibbienas. He was followed by Boucher, who was made chief scene designer at a large annual salary. His fairy tale oriental landscapes for *Indes Galantes* and his transparency, in *Atys*, of a waterfall illuminated from the rear, were the sensations of the day. One critic of 1748 speaks of how successfully he depicted "lovely gardens, beautiful grottos, charming landscapes where one recognizes a felicitous intermin-gling of aspects of Rome and Tivoli" with the French countryside. Fragonard added his characteristic touch. Backdrops began to reflect the landscapes topped with Roman ruins of Henri-Robert. The Romantic gloom of Piranesi's prisons cast its painted shadows on vaults and arches. And with the 1800's another century of scene-painting began.

[8] H. Prunières, *L'Opéra Italien en France avant Lulli* (Paris, 1913), chap. II.

Chapter III. THE FOCUS OF SPACE

1. THE PRINCE AND THE PROSCENIUM

THE ORNAMENTAL proscenium arch of the Farnese theater at Parma (completed in 1618) and its horseshoe seating plan which elongated the semicircular seating of earlier theaters, became the pattern for theater architecture throughout Europe. The proscenium frame, like the frame of any picture on exhibition today, emphasized the stage picture within it and focused an audience's attention. The best seat in the house was at the point from which the designer had calculated the linear perspective of his vistas, namely, directly opposite the vanishing point on a backdrop horizon. The prince's or patron's chair was therefore placed there. His court spread to right and left, leaving an empty floor so that nothing could get between the royal eye and the proscenium opening. The shape of this empty floor space is almost exactly that filled by the orchestra seats of a theater today, as is clearly shown in the engravings of Louis XIV watching performances of Molière's *Bourgeois Gentilhomme* and *La Princesse d'Élide* in his open-air theater at Versailles, or the ruler of Naples in Vicenzo Re's festooned auditorium.

The eye of the designer was that of a man standing opposite the stage opening—five foot six or seven inches from the floor. But for anyone seated at that point the view of the stage floor was flattened and foreshortened. Dance interludes or spectacular ballets were a feature of most performances and these, as any ballet enthusiast knows, are best seen from above. It soon became apparent that the best seat in the house was at the center of a low, first story balcony. The royal seat was moved there and became the focal point of every royal theater and opera house. The ruler's court rose with him, spreading itself to right and left in a shallow horseshoe balcony suspended from the side walls[1] and the empty orchestra space was filled with seats occupied by the gentry.

But the constant growth of cities, the continuous increase of the merchant class—with it middle class prosperity—bred a theater-going public that could no longer be accommodated on the orchestra floor. In order to seat it, shallow horseshoe balconies were added—three, five, and even seven, up to the roof. Magnificence was the mark of authority. The gilded balconies and the gilded proscenium of a theater refracted the splendor of a monarch no less than his throne room. The glitter of his court was reflected from the orchestra floor and from the

[1] The first tier boxes at the Metropolitan Opera House in New York were called parterre (or ground floor) boxes and originally the privilege of occupying them was accorded only to the rulers of the opera house, i.e., the stockholders who owned it.

upper balconies where prosperous shopkeepers and their wives, in gold and silver lace, vicariously shared the glamor of an upper class world just below them or just over their heads. Long before the French and American Revolutions created the first political democracies, the theater was a democratic institution. When the royal summer theater of Drottningholm palace near Stockholm was restored, the original labels marking off the rows of seats were discovered. They ran from seats reserved for the court down front to those for the royal hairdresser and the royal cooks and coachmen in the last row.

The theaters of the eighteenth century established a pattern of theater architecture which was copied through most of the nineteenth century until the first architectural innovations were attempted at Bayreuth and then at Dresden and other German cities. A series of new state theaters and opera houses, built or remodeled shortly after 1860 in most of the capitals of Europe, repeated the characteristic features of eighteenth century theaters, with their gilded prosceniums and gilded horseshoe balconies, from Rome to London and from Paris to Berlin and Moscow. Sightlines remained bad from most of the upper seats, particularly those nearer the stage along the prongs of the horseshoe, and with each successive story they grew progressively worse. But this disadvantage was to a great extent offset by a large forestage extending well beyond the proscenium, on which entire scenes of a play were performed. As the engravings reproduced here demonstrate, actors could be seen even from the upper box seats at the side. The great mistake of later theater building was to suppress these forestages while retaining the horseshoe balconies. Sightlines from the upper and cheaper seats were not improved until steel trusses could span an auditorium and support deeper cantilevered balconies. Twentieth century theorists, in order to reunite actor and audience, attempted to establish a more vital contact between them by reviving the forestages of the eighteenth century playhouses.

The dimensions and layout of the stage were planned to reinforce the illusion of painted perspectives. In order to heighten it, the dimensions of actuality were often approximated. The ideal theater designed by a Danish architect in 1760 shows a stage 145 feet in depth; that of the Opera in Paris was 110. The only technical change which took place in the early 1800's was in the method of scene-shifting. The slots, grooves, and pulleys below stage were replaced by an above stage slotted gridiron or "fly floor" to which settings and backdrops were hauled out of sight and dropped into place in almost exactly the way that a ship's sails were raised and lowered. An enlarged counterpart of a ship's pinrail was placed in a first story "fly gallery" and the "lines" of the theater rigging, like a ship's ropes, were "tied off" on belaying pins with nautical knots, then sandbagged to counterweight the dead lift of a long haul. But outdoor settings were still designed as symmetrical vistas in a series of horizontal planes which, when set in place, became so many arches parallel to the footlights; overhead sky or foliage borders overlapping the "wings" or "leg drops" which extended to the stage floor.

The only technical improvements added by the 1890's—an era of modern engineering—were two: the counterweight rail (which brought the fly gallery to the stage floor, making it more accessible) with cast iron counterweights running in grooves along the stage wall, to accelerate the raising and lowering of settings during scene shifts; and the use of revolving and sliding stages (large enough to hold either the entire setting of an act or, in rotation, all the sets of a play) propelled electrically or raised and lowered on hydraulic elevators. Such elaborate and costly systems of stage engineering were only possible in subsidized state and municipal theaters where the theater was a public as well as a private institution and permanent repertory companies were the basis of play production. In this country, where companies have to go on tour to reach the audiences of our larger cities, the gridiron system of flying and setting scenery is still the usual one, unless settings are shoved on stage piecemeal on small, hand-propelled wagons.

2. DWINDLING ILLUSION

Nineteenth century stage settings, like those of the eighteenth, were designed by virtuoso scene painters who painted every detail of a scene, including cast shadows, moonlight on clouds, sunlight on trees, sticks and stones, cliffs and temples, furniture, and bric-a-brac on the walls of rooms. Painting was still so novel an art for most spectators—most of the major museums of Europe were not founded or did not become public galleries until the early part of the nineteenth century—that paint could still deceive the eye and successfully simulate reality. I reproduce the artist's sketch for one setting depicting a garden fête at the Drottningholm theater. In the actual stage set, part of the crowd along the fountain at the rear is painted on the backdrop.

By 1870 the ducal director of the Meiningen players complained that the usual stage setting was preposterously flimsy and flat and incapable of conveying any illusion whatsoever. "The simultaneous use of painted and plastic objects on stage must be managed so that the difference of material is not too disturbingly apparent. There is no more inartistic effect than that of plucking a rose which is the only artificial flower among a lot of painted ones, or, in the workshop of *The Violin Maker of Cremona* seeing on the rear flat among half a dozen painted violins and their painted shadows, the actual violin that has to be used, casting an actual shadow. . . . An actor must never lean against painted scenery. If his gesture is a free and easy one, he cannot avoid shaking the setting and destroying the illusion of whatever it portrays."

As early as 1808, Wilhelm Schlegel, poet, critic, and translator of Shakespeare, remarked: "Our system [of stage decoration] has several unavoidable defects . . . the breaking of the lines on the sides of a scene from every point of view except one; the disproportion of the

player when he appears in the background and against objects diminished in perspective; the unfavorable lighting from below and behind; the contrast between the painted lights and shades; the impossibility of narrowing the stage at pleasure, so that the inside of a palace and a hut have the same length and breadth. The errors to be avoided are want of simplicity and of great and reposeful masses; the overloading of the scene with superfluous and distracting objects, either because the painter is desirous of showing off his strength in perspective or because he does not know how otherwise to fill up the space; an architecture full of mannerism, often altogether, nay, even at variance with possibility, colored in a motley manner which resembles no species of stone in the world." A formidable indictment and bill of particulars!

The change from candle- to gaslight merely helped to dispel a dwindling illusion. Candlelight on a stage as in a room, precisely because it was a wavering and weak source of illumination, could add a penumbra and envelopment to painted backgrounds. The even flood of gas jet borders made every painted drop and wing more glaringly flat. Sketches for Italian opera settings of the early nineteenth century are as free and fluid in rendering as many modern water colors. But in execution, enlarged to the size of backdrops in the blare of gaslight, scene painting could only have the precision of steel engraving seen through a monster magnifying glass. Any setting became a series of obviously flat cut out pieces that might have been so much cardboard. The upright sections of any stage setting, however solidly built are still referred to as "flats."

The total effect of a production became increasingly artificial and conventional. Acting was operatic both in tone and tempo, and poetic melodramas of the Gothic Revival and the early Romantic movement of the 1830's and 40's tended to sustain a method of acting in which players hurled tirades at the audience like tenors and sopranos or exchanged verbal arias. The performance of one English actor was undoubtedly typical: "With very little variation of cadence, and in a deep full tone, accompanied by a sawing kind of action which had more of the Senate than of the stage in it, he rolled out his heroism with an air of dignified indifference. . . . But when, after long and eager expectation, I first beheld little Garrick . . . it seemed as if a whole century had been swept over in the transition of a single scene."[2]

The naturalness of Garrick's acting would have probably been less apparent to us if we could have seen him play Macbeth in the uniform of an English officer. The interplay of ensemble acting to which we are accustomed did not exist and was hardly conceived of. Rehearsals were virtually unknown. Macready in his reminiscences remarks: "It was the custom of London actors of the leading ones to do little more at rehearsals than read or repeat the words of their parts, marking them on their entrances and exits as settled by the stage manager, and their respective places on the stage." Edwin Booth continued the custom.

[2] R. Bayne-Powell, *Eighteenth Century London Life* (New York, 1938), p. 161ff.

Rehearsing one company for a road tour, he "came down to cues," and did not read any of his speeches. His supporting cast did not act with him until the performances took place. Macready, resolving "to rehearse with the same earnestness as I should act," was nearly mobbed by his company when he first attempted it.

It was not until 1874 that the Meiningen repertory players achieved their first success in Berlin and then toured Europe. Between 1887 and 1897, Antoine organized his naturalistic Théatre Libre and Stanlislavski his Moscow Art Theatre—which today would be called experimental theaters—and the unity of effect in a production, conceived by a director and controlled by him to the last detail, began to be generally realized. Even then the theater as a whole was so slow in attaining true ensemble that Strindberg could still declare in his preface to *Miss Julie* in 1888: "Of course I have no illusions about getting actors to play *for* the public and not *at* it, although such a change would be highly desirable. I dare not even dream of beholding the actor's back throughout an unimportant scene, but I wish with all my heart that crucial scenes might not be played in the centre of the proscenium, like duets meant to bring forth applause. Instead I should like to have them played in the place indicated by the situation. . . . To make a real room of the stage, with the fourth wall missing, and a part of the furniture placed back to the audience would probably produce a disturbing effect at present."

Strindberg also complains that "stage doors are made of canvas and swing back and forth at the lightest touch . . . nothing is more difficult than to get a room that looks something like a room although the painter can easily enough produce waterfalls and flaming volcanoes. Let it go at canvas for the walls but we might have done with the painting of shelves and kitchen utensils on canvas." And in regard to stage lighting he remarked, "Another novelty well needed would be the abolition of the footlights. . . . Would it not be possible by means of strong side lights (obtained by the employment of reflectors for instance) to add to the resources already possessed by the actor?"

Within twenty years the innovations dreamed of by Strindberg were already an accepted part of the technique of theatrical production. This so-called revolution began as an attempt to create a new reality on the stage with realistic acting and realistic stage settings. But the actual revolution achieved by modern stage production, both in direction and design, was much wider in scope. It was nothing less than a new conception of a dynamic theater accompanied by a complete change in our ways of seeing—the balance of speech, gesture, form, and light, fluctuating in their continuous interplay but at all times achieving a continuous unity of effect at every moment of a sustained and coherent performance.

Chapter IV. THE DYNAMIC THEATER: I

1. LIGHT: ADOLPHE APPIA'S *TRISTAN AND ISOLDE*

IT HAS become a commonplace to speak of stage lighting which heightens the mood of a play or emphasizes the emotional significance of a scene. But no one had a conception of how varied, how subtle, and how dramatically important the lighting of a stage setting could be until Adolphe Appia in 1899 published his description of the staging of *Tristan and Isolde* as an appendix to *Die Musik und die Iscenierung*[1] (Music and Staging). Both drawings and text appeared when electrical apparatus which could control stage lights with such fluency had not yet been perfected. Although Appia had at the time never staged an opera (or a play) his visualization is so complete that any modern director and designer using this "light plot" as his guide could achieve a production far more fundamentally poetic and visually more beautiful in almost every detail than any that has yet been seen on the opera stage.

I reproduce my translation of the major part of Appia's text. I can think of no better way of demonstrating the function of stage lighting in the modern theater. The fact that this light plot was planned for the production of an opera in no way limits its relevance. The words "drama" or "poetic drama" can be substituted for the words "music drama" throughout. In its integration of stage setting, lighting, and acting, this scenario of Appia's gives a complete picture of what the designer is expected to provide and the director to utilize in interpreting any important script.

The audience sees a dramatic performance which obviously involves the inner spiritual drama described above. But Wagner's indications as to how the work should be staged are restricted to a minimum, leaving the designer free to exploit any number of possibilities. The essential action is communicated to the spectator's ear with the convincing clarity and freedom peculiar to the kind of poetic music drama that Wagner has made possible. At the same time the spectator's eye comes in contact with a purely arbitrary scenic scheme. Even if this seems a fortunate state of affairs at first glance, in practice it will be found that the consequences are not. The balance of sight and sound, which is the very essence of music drama, is disturbed and the drama itself is liable to degenerate into a chaos of sensory impressions.

It is essential for the spiritual conflict involved that some form of representation be found which allows it to be successfully dramatized. Therefore the problem of the scene designer

[1] The manuscript, originally written in French, is at the University of Geneva. There is a typewritten copy in the Theatre Collection of the New York Public Library; unfortunately the appendix is not included. My translation appeared in *Theatre Workshop*, vol. I, No. 3, April, 1937.

is not to reconcile the inner and the outer drama of the opera itself, but to establish their relation in a way which will make their import clear. Moreover the audience can be made directly aware of the inner or spiritual action involved only by some form of scenic investiture which is based upon the dramatic line of the play.

What method of stage setting should be adhered to in a drama where the physical setting, the outer world it embodies, is so essentially unimportant?—Unquestionably, the utmost simplification of all of its decorative and pictorial elements.—The illusory nature of this phantom world which surrounds Tristan and Isolde is precisely what must be established by the stage setting, from the beginning of the second act on, sustained of course by the music itself which divests both Tristan and Isolde of any contact with an actual world. The unreal, phantom nature of the world, for such it has become to them, in itself explains their need to escape its unreality in death. Insofar as we make the spectator aware of how unimportant the physical stage-setting is in comparison to the inner spiritual action, we induce him vicariously to become a part of this inner spiritual drama. The essential thing then becomes the purely inner, poetic, musical expressiveness of the play, and the balance between inner and outer drama can be maintained by a form of stage setting which underlines this relationship. Wagner in *Tristan* allows us to share the the emotional life of his hero much more completely and more intensely than in any of his other dramas. Despite this fact we can find no visual equivalent for this experience as spectators. On the one hand the members of the audience are spectators and at the same time they remain, so to speak, blind supernumeraries.

The fundamental principle on which the staging of *Tristan and Isolde* should be based is this: *the audience must see the world of the protagonists as they themselves see it.* Naturally this cannot be taken literally. But nevertheless the statement indicates clearly enough the spirit in which the scenic designer must work if the essential spirit of this masterpiece is to be visualized. He must aim at the utmost simplicity and be careful to avoid a single superfluous detail even in the scenes that do not seem to lend themselves to such simplification. Let us therefore begin with the second act:

When Isolde enters she is aware of only two things: Tristan's absence and the torch (last glimmer of the first act) which motivates this absence. The warm summer night arching over the lofty trees of the castle park is no longer factual reality for Isolde. These shimmering distances to her eyes are simply the empty and terrifying space that separates her from Tristan. At the same time, in spite of the agony of her desire, there burns in the depth of her soul a flame which transmutes all the powers of nature and miraculously makes them a harmonious whole. Only the torch remains obviously exactly what it is—a sign, a symbol which keeps her from the man she loves.

When she extinguishes the torch she destroys this barrier. She nullifies this inimical space. Time stops. In identifying ourselves with her we marvel at the extinction of these two inimical elements. Finally the obliteration is complete. Time, space, the echoes of the natural world surrounding her, the ominous torch, everything is wiped out. Nothing exists, for Tristan is in Isolde's arms.

Time, which has stopped, takes on a fictitious continuity for the audience as music. And space—what remains of that for us who have not drunk the potion?

Like the hero and heroine we experience nothing more except this ecstasy of being together. The passion that is burning in their souls seems to us as to them, much more real than their corporeal presences. And the rhythm of the music draws us deeper and deeper into the secret world in which their union is eternally consummated. Only one thing shocks us: we can still see them. We become painfully aware that we are forced to see these two who no longer really exist. As the phantoms of the material world appear again to us at the same time that they become apparent once again to the two lovers, when these two, who have transcended the corporeal world, once again come into contact with it, we feel as though we had practiced a deception on them, and were part of a conspiracy.

How will the stage designer embody all this so that the spectator in the course of this act does not rationalize what has happened, does not analyze it intellectually, but is carried away by its inner emotional surge?

On the basis of this analysis let me indicate point by point the following method of staging: Picture of the stage at the rise of the curtain: A great torch at stage centre. The somewhat narrow stage space is filled with enough light so that the actors can be distinctly seen, without dimming the brilliance of the torch and above all without dimming the shadows which this source of light casts. The forms which demarcate the stage setting are seen only hazily. The quality of the light veils them in an atmospheric blur. A few barely visible lines in the stage setting indicate the forms of trees. Gradually the eye becomes accustomed to this; above, it becomes aware of the mass of a building in front of which one perceives a terrace.

During the entire first scene Isolde and Brangaene stay on this terrace and between them and the foreground one senses a declivity, the forms of which one cannot identify clearly. When Isolde extinguishes the torch the entire setting is enveloped in a monotonous half-light in which the eye loses itself without being arrested by a single definite shape. Isolde, as she flies towards Tristan, is enveloped in mysterious shadow which intensifies the impression of death that the right half of the stage has already induced in us. During the first ecstasy of their encounter both remain on the terrace. At its climax (page 112, piano 8°, ff° in orch. *Mein!*) we perceive that they come toward us imperceptibly from the upper terrace and by means of a barely noticeable ramp reach a lower platform further in the foreground. This platform, the ramp leading from the terrace to it and another incline which leads to the forepart of the stage itself, make an uneven terrain on which the glowing dialogue of the scene that follows takes place.

Then, when their desire is sufficiently appeased, when a single idea possesses them and when we become increasingly aware of the death of time, only then do they reach the foreground of the stage where (pp. 136-37) we perceive for the first time a bench that awaits them. The whole mysterious half-lighted space of the stage becomes still more uniform in tint. The structural forms are blotted out in the shadow of the background and even the different planes of the stage floor are no longer visible.

Whether as a result of our visual reactions induced by the gleam of the torch and the shadows it casts, or whether because our eye has followed the path that Tristan and Isolde have just traversed, however that may be, we become aware of how tenderly they are en-

folded by the world about them. During Brangaene's song the light grows still dimmer. Even the figures of the actors no longer have any clear definition. Finally when passion awakes once more, grows and threatens by its overwhelming power to annihilate any scenic investiture that might be given it, at this moment (p. 162, first ff° in the orch.) a pale red light strikes at stage right in the background. King Mark and his men-of-arms break in upon the scene. Slowly, cold and colorless, the dawn begins. The eye begins to recognize the general forms of the stage setting and the painted flats that suggest them become clear and hard in quality for the first time. With the greatest effort at self-control Tristan comes back to contact with the world once again, challenging Melot, who betrayed him, to a duel.

In the setting, now cold in color and hard as bone, only one spot is veiled from the dawning day and remains soft and shadowy: the bench at the foot of the terrace.

In order to indicate this projected form of stage setting more clearly and to amplify the accompanying sketches, I add the following detailed description of the stage setting.

The terrace which cuts through the stage at an angle goes from stage left, meets the stage right flats which are further up stage and loses itself in the night of the backdrop. This terrace should be at least two meters higher than the stage floor. The left side of this terrace for about one-third of the width of the stage is bounded by a wall. This wall slopes gradually towards the foreground and at the left forms an angle which bounds the stage setting from there to the proscenium. From the left third of the stage to the extreme point on stage right two ramps lead from the terrace to the foreground and incorporate a fairly large platform that extends at a slight angle toward the left side of the stage:*

The actual foreground in consequence is very restricted as it is bounded on one side by the corner of the terrace and its supporting wall and on the other does not extend beyond the descent from the terrace which occupies more than half the width of the stage. The building which flanks the terrace spreads from the torch, which is about stage center, to stage left where it follows the line of the terrace and of the entire setting from there to the proscenium.

On stage right the setting remains open. One can distinguish the silhouettes of dark trees which bound it at that point. Their barely indicated foliage serves to mask the sky borders. At the foot of the terrace is a bench with the corner of the wall forming its back. This bench at the left quarter of the stage serves to balance the descent leading from the terrace and seems also to overlook the open right side of the stage setting even though this is not actually possible. The torch is fastened to the wall of the building between the gate and a small flight of stairs the outline of which detaches itself from the background. This torch must be placed quite high so that for the majority of the audience it makes a brilliant contrast not with the building but with the background. The general coloring of the stage picture is vague. The walls and a part of the stage seem to be overgrown with moss and ivy. The various platforms must be painted so as to seem as far as possible a unit, and they are only noticeable as the actors move on or across them.

The lines which indicate the top of the stage setting must not be anything like a symmetrical arch of branches and leaves, but rather lean towards the left side somewhat in the fashion of an arbor. At the right side they must extend upwards with as much definition as

* Right and left throughout seem to be from the audience's point of view.

possible so that this half of the stage keeps its essential characteristic: the left half, a refuge and resting place completely confined, the right side an opening leading out into the unknown.

In the setting of the second act the arrangement of the platforms is of chief importance. Of course lighting must give the stage setting a definition as well as the necessary envelopment by which the essential character of the setting is established. However, in relation to the actors the lighting plays a comparatively negative role, whereas in the third act it constitutes the principal element of the setting and the painting of the setting is reduced to the barest minimum.

When Tristan awakes he does not at first know where he is. When he is told, he does not understand. The name of the castle, its location, are matters of complete indifference to him. The plaintive shepherd's tune that awakes him does not give him the slightest clue. When he tries to express what he feels he is only conscious of the light which disturbs him and a desire for the darkness in which he sees refuge. He connects Isolde with these two sensations because Isolde is brought back to him with the dawning day. In this blinding daylight he must "seek, see and find" her, but nevertheless it is this daylight which, like the ominous torch in Act II, separates her from him. But as he learns that Isolde is coming, indeed that she is near, the castle becomes a reality for him; it commands the sea and from it one can see on the horizon the ship that carries Isolde. In this fever of desire the idea takes shape: Tristan, who from his bier cannot even see the sea, sees the ship.

Now the melody that awakened him speaks to him more distinctly than all his visions.

His desire remains importunate. His fever heightens it. And the pitiless sunlight that will not let it die offers no possibility of appeasement. In a paroxysm of despair Tristan once more is shrouded in darkness. He loses consciousness.

What awakens him is not a melancholy lament or even the belated, inimicable light of day. No. Out of the depth of the night a miraculous ray reaches him. Isolde is near, she is at his side.

After this heavenly vision we become aware of reality again.

The sinking sun, the blood of his wound are only further symbols of his ecstasy: they must flood the castle. "She, who will forever heal his wound . . ." she nears . . . her voice is heard. . . . But in order to reach her the torch must be extinguished—Tristan falls lifeless in Isolde's arms.

The lovely, radiant light of day, which has been in reality their illusion, sinks slowly into the sea and with its last rays surrounds the protagonists with a wreath of blood.

The role which lighting has to play in this act is therefore clearly indicated. As long as light is only a source of suffering for Tristan he must not be directly touched by it. As soon as he is able to accept its reality and use it as a medium for his visions it illuminates his face.

This is the entire scenic problem of the act and determines the way both the setting and its arrangement are to be used.

In order to achieve this effect the area of light must be greatly limited and a great deal of space left for shadows. Under these circumstances it would appear as though the scenery were totally unimportant. However, in order to provide the right background for the light,

the setting must be carefully planned and because the setting has only this function there cannot be much choice as to how the site of the action is to be realized. I trust that one will think me neither arbitrary nor fantastic if I attempt to give it definite shape.

The walls of the castle, which bound the settings at stage left as well as upstage and from there extend towards stage right must surround Tristan as a screen might surround a sick person. The scenery down stage right must seem to indicate the end of this screen, so that it seems almost as though one had removed part of the screen to enable the audience to see the stage. The two ends of this screen leave a wide view of the sky and are connected with the stage floor by a bounding wall.

To the general outline of this as indicated one only needs to add the barest essentials, namely to cover the skyborders and to provide a sufficient motivation for the shadow which covers the castle courtyard. But in order to make the play of light on the stage floor vibrant the stage platforms should be arranged in the following manner. The entire length of the wall at stage left is reenforced by a buttress-like support which gives it a more definite accent without disturbing its simplicity. From its base the stage floor descends slightly, then rises again, in order to form the roots of the gigantic trees under which Tristan lies. From these roots the stage floor sinks, but this time to a lower level, so that from this tree to the lower right there seems to be a path leading from the castle door in the background toward the foreground. The approach from the sea which is near the wall is also slightly raised. Using this construction the stage becomes a plane sloping from left to right, so that the light coming from stage right, always at a declining angle, eventually hits the base of the buttress wall.

What also has to be planned with greatest care is the general outline of the setting which contrasts with the brilliance of the sky, and here the greatest simplicity must be preserved. The high point, from which Kurwenal can watch the horizon, must be incorporated in the wall at the right side of the stage, but downstage so that it does not obviously break the unity of line and at the same time keeps Kurwenal throughout as an expression silhouette. It is obvious that the sea must not be visible to any of the audience, that no horizon is seen between the wall and the sky and that the arch of the sky is unbroken blue without clouds.

In order that Tristan may be illuminated by a natural play of light, he is placed opposite the open sky and surrounded with as few accessories as possible. Stage properties would only destroy the unity of the setting as conceived. Kurwenal has simply thrown a cloak between a few protruding tree roots and places Tristan there, thus improvising an inconspicuous resting place where the wounded Tristan is stretched out. The curtain falls on a scene, quiet and monotonous in color, in which the eye distinguishes nothing except the last rays of the sunset playing above Isolde's pale countenance.

It is probable that the notes on the scenery, added to the score by Wagner, are meant to be taken as nothing more than a brief comment on the setting rather than as a scheme to be literally followed. For it is obvious that Wagner in describing the stage setting has done so not from the point of view of the actor but from the essential poetic content of the act. It seems almost as if Wagner had attempted to find scenic forms outside the score.

In these last two acts of *Tristan and Isolde* stage lighting and the general structure of the setting have reduced scene painting to a minimum. The designer has had to give painting

itself no particular function. On the contrary, his task has been to reduce its importance so that it is wholly subordinate as an element of the background. But in the first act we are part of the outer life of the hero and heroine and we can be aware of its tragic import only if it is completely visualized. If, in the succeeding acts, we want to reduce this actual world to the simplest forms that can express it we must, in contrast, in the first act establish not only its actuality but express as well the quality which in the end makes it an illusion from which the protagonists can flee.

In this respect the scenery of the first act offers a golden opportunity.

In the twilight of her tent Isolde tries, head in her pillow, to evade the reality she dreads. But an echo of this hated life meets her ear. Beside herself, she jumps to her feet. The song of the sailors seems to her almost a personal insult. The lying evasion of her retreat lies heavy upon her. She fairly suffocates under the folds of her tent; and finally when the actuality of the situation forces itself upon her, she decides to confront it, triumph over it. At her command the curtains of the tent open.

The wind blows into the open tent. Isolde gazes and gazes, saturates her eyes with this light whose radiance means nothing more to her than what it symbolizes. It condones Tristan's betrayal. For the only reality to her is the world which she grows conscious of in his presence. Spellbound, she regards him but she cannot bear this passive role long. As it becomes increasingly impossible for her to evade the issue, she decides to take part in it. Tragic conflict is imminent. Isolde must await its advent silently and the curtains of the tent close again at the moment when this duplicity of Isolde becomes insupportable.

The music seems to have been muffled by these conflicting alternatives. She, the consort of an immensely powerful ruler, did not know what to do with her golden opportunity. Now in the quiet twilight of her tent her emotions overflow. The world of actuality beats against its walls like breaking waves, but of what importance is that? The curtains will not open again until Tristan and Isolde have denied the reality of the situation that they enact, until their momentary attempt to dominate it will force from them the passionate outcry of their deepest moment of suffering. The implications of their deed will no longer be obvious to them. The curtains of Isolde's tent therefore, in the most literal sense of the words, constitute the boundary between the inner and outer drama of the play. The essential action of the play is materialized by them plastically and dramatically, both from the point of view of the subtlest demands of the score and the simplest implications of the actual space to be utilized.

Nothing remains for the stage designer except to emphasize the contrasts of these two parts of the stage. With every means at his command he must emphasize the dramatic symbolism of the entire setting. In Isolde's tent, where most of the act takes place, nothing occurs except what serves to express Isolde's inner conflict. To be sure, Brangaene has the traditional role of the confidante, but this role is transmuted by its musical treatment. She is nothing more than a dramatic expedient to lessen the improbability of too lengthy monologues and exchanges of sentiments between the leading personages. The music makes her a mere voice whose import is much more than that of a conventional personage whose only function is to elicit replies. Therefore her presence is justified in this inner shrine, in this refuge. The curtains of the tent are like eyelids which close or open upon outer actuality.

The lighting of this part of the stage must be very uniform and so arranged that there are no cast shadows. The footlights, even though used at minimum intensity, must show the forms of the actors' features clearly. The light outside the tent must throw as many and as varied shadows as possible, so that, in contrast with the tent, it becomes the arena of the actual world. Within the tent the few necessary properties, such as furniture and other objects, must have the least definition possible. The expressiveness of the light must reach its high point in the open part of the stage. At the same time the construction of the stage setting must be such that the unification of the actors and the total stage picture is furthered. The role that painting plays in the stage setting can be clearly deduced from the above.

When these essential conditions are fulfilled, the general arrangement of the stage picture is unimportant. But these general conditions entail certain consequences; e.g., the sea and sky must not be visible when the curtains of the tent are closed; when at the beginning of the act Brangaene opens one of the flaps of the tent in order to look overboard the spectator must get the impression of the outer world entirely by means of the brilliance of the light beyond, which only touches Brangaene's feet, but not strongly enough to throw a shadow on the floor of the tent. The ship can be easily indicated by a few characteristic lines of rigging, for the ship itself is so clearly indicated by the score that the heaping up of nautical details on the part of the scene designer must seem like a clumsy repetition of the text. (Note: which is unfortunately always the case when this act is staged.)

Let us sum up the role that the stage setting plays in *Tristan and Isolde*. In the first act it dramatizes in the most tangible way the conflict which eventually becomes an inner and a spiritual one in the lives of the two protagonists. The lighting plays the same negative role in Isolde's tent that it does as far as the actual setting is concerned in the second act. Outside the curtains of the tent it indicates the entire arena of conflict and prepares for the dramatic contrast which the subsequent stage pictures provide. In the second act the greatest simplification of the stage setting is essential. However, in order to preserve its connection with the dramatic action it becomes, as indicated by the roles of the actors, a highly expressive arrangement of stage levels unified by the lighting which has the further purpose of dramatizing the action involved. In the third act the lighting is dominant and determines everything else in the scenic scheme. Light and shadow in the course of the drama achieve the same significance as a musical motif which, once stated and developed, has an infinite range of variation. Tristan's agony is sufficient motivation for carrying this kind of lighting to its greatest degree of expressiveness and the audience, overwhelmed vicariously by the spiritual tragedy of the hero and heroine would be disturbed by any form of stage setting which did not incorporate this element of design. The audience would really suffer for lack of the kind of staging I have indicated, because it needs to get through its eyes a kind of impression which, up to a given point, can equal the unexampled emotional power of the score. Light is the only medium which can continuously create this impression and its use is motivated and justified by the score itself.

One can see that for the staging of *Tristan* the important thing is the pictorial ensemble and this short résumé that I have given is proof of this fact. A stage designer who has sufficient sensibility to accept the kind of subordination that music drama demands of him thereby proves that he is cultured enough to avoid any obvious errors of taste.

Chapter V. THE DYNAMIC THEATER: II

1. THE PULSE OF INTERPRETATION

THE ASSUMPTIONS of Appia's scenario are basic for modern stage setting. These might be defined as the integration of form, movement, and light into an aesthetic unity. The stage is no longer a space symmetrically split by flat picture planes *against* which an actor gestures; it is a three-dimensional area *through* which he moves in a carefully calculated pattern. Light is not an even flood spilling down from parallel borders or upward from a row of footlights. It is three-dimensional, has depth and defined limits so that actors move in or out of it, or, if they do not move, light moves on or off them. Light determines form. The playing area is contracted or expanded by fluctuations of light; a setting is no longer a picture seen in its entirety from one side of a frame to another. Light models the form of a stage setting with the accent of high light and shadow, the balance of concentration and diffusion. The planes of a stage set are planned primarily to frame motion and to reflect light. Color is not absolute but relative, changing its hue with the light that ebbs and flows over it. In this envelopment a three-dimensional actor and a three-dimensional setting are fused. But their relation is not static; it is in continuous flux. Light confines movement, defines it, expands playing areas or blots them out. An actor is brought into prominence without necessarily having to move forward or becomes less important without moving upstage or offstage.

Such stage lighting is at once factual and symbolic. It may reproduce the gleam of a torch, the glow of sundown, the haze of dawn and twilight, or bright sunlight at sea. But the timing of its variations is arbitrary. Its fluctuations are accurately called a light plot because they are planned to coincide with the emotional key of the scene illuminated, the successive moods of hope, fear, pity, resignation, ecstasy, or despair of the dramatic plot as it is played. In music drama a light plot is a second score; in spoken drama it corresponds to an orchestral accompaniment that parallels and intensifies the emotional impact of the dramatic situations being enacted.

A designer therefore must plan his setting not only as an architectural and pictorial composition, as a congeries of related forms and acting areas; he must at the same time see it, in his mind's eye, as lighted. It must be designed with an eye to the light that will finally envelop it, define it, and model it. Without such lighting it loses both essential form and dramatic significance. The design of a stage set cannot be realized on paper as a color sketch, however carefully drawn, or on architectural working drawings accurately done to scale. The former is

no more than an intention, the latter no more than a bare framework. The design of a setting does not yet exist when it is actually set up on stage. It is complete as a design only when it is finally lighted, after hours of experiment in a light rehearsal. Change the balance of lighting, shift it arbitrarily and it can be literally destroyed as a design, its most ponderous forms flattened, its distances erased, its color made muddy and lifeless. By way of demonstration to lecture audiences, I have set up a scene and blown it to pieces before their eyes by arbitrarily changing the lighting of it; then one by one, or in groups, brought on my spotlights and borderlights to their rehearsed marks and the same setting took on color, form, life, and whatever degree of beauty I had managed to achieve.

Not many plays that come a designer's way will have the poetic intensity of *Tristan and Isolde*, of *King Lear* and *Hamlet*, or supply so many obvious cues for a light plot to accompany their emotional crises. For most scripts a designer must interpret what is implicit rather than what is explicitly motivated. Liliom and Julie are romantic lovers, however inarticulate, and do fall in love—though without the magic paraphernalia and the fanfare that attend the self-conscious dedication of a princess and a knight. This gangster and servant girl, on a park bench, must also be "tenderly enfolded by the world about them," by the forms of trees "seen only hazily" in Whistler's twilight that clothed the riverside "with poetry as with a veil." At the railway viaduct where Liliom plans his holdup, the lighting of the sky must evoke space as infinite as the designer can make it in order to suggest the "magic of strangeness and distance," the lure of a world beyond the horizon that Liliom feels, and again expresses only inarticulately as he watches an express train disappear. The arch of the viaduct becomes a trap where the cashier can be quickly cornered by Liliom, and Liliom in turn by two rural policemen. The massing of shadow must not only accent the bulk of the viaduct, but also, by its gloom, give a premonition of danger and so heighten the dramatic suspense of the scene. At the same time a few carefully focused spotlights must illuminate the faces of Liliom, his accomplice, "The Sparrow," and the cashier, but must seem to be no brighter than the light that might be cast by the semaphore along the railroad track. When Liliom, after committing suicide, preferring death to dishonor according to his code, is brought on a stretcher to the back alley, its board fences and his shack must be invested with tragic dignity and austerity, although he is not a knight upon a bier.

The actual incidents of the play are those of a routine police report: amateur gangster and pimp seduces servant girl, attempts holdup, cornered by police kills himself before he can be arrested. But Molnar's subtitle reads "A Legend in Seven Scenes and a Prologue." The problem for the director and the actors, as well as the scene designer is, to express the implicit tragedy, the romantic tragedy, of the story without departing from a realistic milieu in which Liliom as a character seems true enough to be convincing.

Beyond this point, with Liliom's arrival in Heaven and his return to earth, the problem

became, as I staged the play with Frank Reicher as director, how far to indulge in fantasy. We discussed it at length and finally followed Appia's maxim: "The audience must see the world of the protagonists as they themselves see it." Reicher pointed out that the only "seat of judgment" Liliom could conceive of was the one he had known, a police court. In his opinion it would be fatal to make the "heavenly police" pseudo angels, possibly with wings sprouting from their uniforms. I agreed with him. The play was a parable. But, whereas on earth Liliom's surroundings could be veiled in the tradition of romantic poetry—in fact needed to be—here all the traditional trappings of the celestial regions were to be avoided. The angels would be policemen, as Molnar had indicated, and God a police judge. Heaven was to be realistic to a point. But beyond the wainscoting its courtroom walls stopped. Above was the infinite space of Heaven, or at least something as nearly like it as electric lamps diffused over a cylinder of canvas could make it.

Such alternatives are inherent in the staging and the designing of any play that is not merely imitation of the surfaces or the inflexions of contemporary life. The realistic idiom of *Liliom* must not stifle its implicit poetry. Explicit poetry on the other hand can be deprived of its vitality, its innate validity and reality, if it is overornamented or loaded down with traditional trappings, as for instance the silvery figure of a woman in Gordon Craig's production of *Hamlet* for the Moscow Art Theatre, who reappeared and disappeared in a ray of light, who "tempted Hamlet to come to her" during his soliloquy "To be or not to be." Even the stage directions of a poet are not always to be relied upon. Those for Werfel's *Goat Song*, for instance, are cluttered in places with an unnecessary amount of barnyard detail. When I met Werfel in Vienna he was both surprised and pleased at the amount I had eliminated and the simplified scheme of my settings.

The absence of explicit stage directions, or such nominal ones as exist for Shakespeare's tragedies, leave both director and designer faced with the necessity of inventing them. The placing of Hamlet, the King and Queen, and the players in the mousetrap scene is a crucial problem that must be analyzed and solved every time the play is given. The business of exchanging rapiers in the dueling scene must be devised. Is Hamlet's melancholy to be projected onto his surroundings? Is he to be a gloomy young man in a gloomy world, or as I contend, a gloomy young man in the bright world of a sensuous, guzzling court? Will one visualization or the other project his tragic dilemma more effectively? There is no dogmatic or *a priori* answer to such problems of designing and staging. A production, as planned, and in rehearsal, is an experiment. A performance is an event. Only in its actual impact on an audience can methods, ways, and means be tested, vindicated, or invalidated. The designer's settings and his light plot, though fundamental, are only two elements in a continuous dynamic interplay of every other element of a production, which is essentially not acting or action but interaction—the continuous interplay of intonation, gesture, movement, form, color, and light. Designer and

director are, or should be, *alter egos*. The director's general conception of a performance, its rhythm, tone, tempo, and pattern of movement, determines the essential design of a production. A designer's scheme of setting the stage and lighting it determines how a play can be performed. A director's suggestions may be general or concrete or incomplete. Many may be given to the director by the designer. The success of a production depends on how successfully the two are able to collaborate, on the degree to which a designer's and a director's imagination coalesce.

2. THE DOMINANT DIRECTOR

The intricacies of organizing a production were first made apparent by the Meiningen repertory company because the Duke of Saxe-Meiningen happened to be a draftsman as well as a director. In his sketches actors are shown for the first time as an integral part of a stage setting.[1] Remove them and the line of pictorial composition is lost. Often the sketch for a scene consists almost entirely of groups of actors with only the most summary indication of the architectural framework surrounding them. These sketches are memoranda for a production, indications of how a play is to be performed. A setting is never conceived as a self-sufficient entity, as a separate background or foreground in which actors can later be more or less effectively placed. Acting and setting are foreseen in continual interaction. A particular ground plan, a particular arrangement of pillars and portals, vistas and trees, are visualized as they will effect a continuous flow of movement and dramatic action.

When a setting is drawn by itself it is as part of the preliminary study of an acting problem. Seven sketches were made for the prologue of Schiller's *Maid of Orleans*. Schiller's stage directions read: *"A rural landscape. In the foreground at the right a shrine. At the left a chapel."* The dramatic climax of the scene is Joan's monologue in which she apostrophizes her native fields, dons a helmet, and sets out to meet the Dauphin and to save France. The voices that command her emanate not from the shrine, but from an ancient oak. The first two versions of the setting are landscape compositions; one shows the oak towering over the chapel on a rocky slope topping a hillside. Only the tops of pines suggest the countryside below. Pictorially it would have made an effective setting. Its drawbacks for the acting of the scene are obvious. The oak is too far upstage, and Joan, apostrophizing invisible fields below, might have seemed more an Alpine cow girl than a French shepherdess. The next two sketches correct this by emphasizing the peasant milieu. The scene becomes entirely rustic, the yard of a farm with a swinging gate, wooden benches, and a watering trough. The corner of a farmhouse fills stage left. But this ignores the atmosphere of magic and mystery which is an essential element in the scene's climax. Joan's father, in a ponderous and lengthy exposition, has not

[1] Max Grube, *Geschichte der Meininger* (Berlin, 1926).

only complained of her unfeminine behavior but warns her against frequenting the neighbor-hood of the ancient oak which is supposedly a haven for witches, although when Joan later hails the voices that sound from it she hails them as those that once inspired Moses and David. Under the second of these two farmyard versions the Duke scrawled, "No good." The next sketch makes the scene a shadowy grove, a dark and gloomy wood, where, according to one of the most ancient of poetic traditions, mysterious and magical events occur. But the oak tree is almost blotted out in shadow and the chapel in contrast seems too prominent. In the final version, the oak dominates the stage, rising out of a group of *druidic* dolmen stones suggestive of pagan rites. It arches over the chapel at the right and frames the vista of a farm valley at the rear. The bulk of the tree casts enough shadow to suggest the aura of magic and mystery ascribed to it without being lost in shadow. The pictorial emphasis of the scene now corre-sponds to its dramatic emphasis.

Such experimental analysis of the effect of a stage setting on acting is now taken for granted. But in the 1870's it was unique. Performing *Hamlet, Lysistrata,* or *Richard III* up and down stairways has now become almost commonplace. Breaking up the stage floor into various levels or using balconies and stairways is an almost standardized device. When the Duke of Saxe-Meiningen first used it it was an almost revolutionary innovation. The stage directions of Schiller's *Fiesko* call for nothing more than *"A Hall . . . one hears the distant sound of dance music and the hub-bub of a ball."* The balcony with its two flights of steps that the Duke pro-vided dramatized particular entrances and avoided the confusion of a large cast entering and leaving the scene at one level. In *Macbeth* the murderers of Macduff's children approached stealthily from a shadowy balcony at the rear. Lady Macduff, with her back turned, was unaware of them until they struck. The heightened suspense given the scene is obvious. But the kind of inventive imagination that conceived it is still rare.

Breaking up playing space into various levels and avoiding monotony of movement on a flat stage floor became a principle for the Duke. Conventional symmetries both in acting and setting were systematically avoided. His biographer quotes a number of dicta taken down during rehearsals.

In composing a stage picture one must beware of making the centre of the picture correspond with the centre of the stage. If one starts the composition from the geometric centre of the stage there is always the danger that in arranging groups of actors and their entrances into the stage picture from left and right, more or less symmetric uniformity occurs, which in effect seems stiff, wooden, and boring.

The central portion of the stage, opposite the prompter's box and from the footlights to the back-drop, should only be used by actors for crossing from right to left or vice versa. Otherwise it should be avoided; the actor has no business to be there. Also to be avoided is for two actors to occupy the same area opposite the prompter's box.

Parallelism with the footlights is objectionable during the continuation of a scene. . . . When three or more actors are involved any straight line in their respective positions is particularly to be avoided. They should always be at an angle to each other, the distances between them never alike. The effect of standing equidistant gives them a tedious and inert look, like pieces on a chessboard.

Whenever the stage has various levels—stairways, rocky hillocks, and the like, the actor should not miss the opportunity to give posture a rhythmic and alert line. For example, he must never stand with both feet on the same step. If he is standing on a rock, let him put one foot on it. If he has a line to speak while stepping down from a higher level to a lower one, he should keep one foot lower than the other. In this way his entire carriage will gain in freedom and animation.

"On the diagonal," or "more diagonally" were constant commands at rehearsals both to leading actors and to crowds of supers. Any regular rhythm was to be avoided. The Earth spirit in *Faust* was reminded, "Pauses! Pauses! You are a God, a God speaks in his pauses!" Mobs were broken up into smaller groups so that they never marched or gesticulated in unison. The respective positions of groups, principals, and crowds were again kept fluid so that they never faced each other as separate units. Mobs were not allowed to line up in a compact mass across the front of the stage. The effectiveness of suggestion was recognized. "Whenever one wants to give the impression of a great crowd of people, they should be so placed that those at the side extend well into the wings. At no point in the auditorium should any be able to see where a crowd ends. The general effect should enable the spectator to have the illusion as though there were even greater crowds offstage."

The routine of organizing and rehearsing a production of the Meiningen Company would serve as a model for any director today. Not much more than forty years after Macready had failed in his first attempts to "rehearse with the same earnestness that he should act," rehearsals that began at five or six and ended near midnight were the rule. Mobs were rehearsed as carefully as leading roles; they consisted not only of supers but of young actors and often included leading actors not cast in a particular production. Every extra was as carefully rehearsed as any principal, trained to carry his costume, handle his weapons, assume the characteristic stance of the period. Actresses were expressly forbidden to wear crinolines under their classic robes, as they still did at the time in other theaters. Photographs of the company demonstrate that their costumes, made or forged in the company's own workshops, were historically accurate to the last detail of helmets and greaves, shoebuckles or buttons, the dressing of a wig or the convolutions of a ruff. They were among the first stage costumes that were authentic, and sharply differentiated the clothes of the Italian from the German Renaissance, Molière's France and Joan of Arc's France—an achievement that delighted and astounded young Stanislavski, still an amateur, when he saw the company for the first time on tour in Moscow. Rehearsals were the equivalent of dress rehearsals except for the fact that no audience was present. Costumes and props were ready from the first rehearsal, as well as the stage

setting. Any production was rehearsed for weeks on end. One rehearsal of a scene of eleven lines lasted two hours.

The smallest detail of a setting was used to heighten a dramatic effect. In *Maria Stuart*, when Elizabeth signs Mary's death warrant, it was done under the eyes of Henry VIII looking down on the scene from his portrait hung on the rear wall. Masqueraders danced on a bridge as Jessica eloped, a bit of business that Max Reinhardt later adopted. When Caesar was stabbed there was a moment of terrified silence, the conspirators and senators seemed frozen in horror, then a howl from the crowd against a swelling undertone. In the scenes in the Forum, Mark Antony delivered his funeral oration under the flicker of torches, was carried on the shoulders of a cheering mob, and read Caesar's testament in the midst of the wildest excitement. "One seemed to witness the beginnings of a revolution." It was this same revolutionary frenzy that Reinhardt gave to his mob scenes in *Danton's Death*. Again, in the coronation scene of *Joan of Arc*, the mounting cheers of the expectant crowds and the fanfares that punctuated the entrance of successive groups of nobles achieved a crescendo of excitement, until the final entrance of Joan actually capped a climax. But emphasis was not always shrill. In Brutus' garden the conspirators conferred almost in whispers.

The Meiningen Company on seventeen annual tours from 1874 to 1890 gave 2,591 performances in 36 cities, including London, Brussels, Stockholm, Amsterdam, Warsaw, St. Petersburg, Moscow, and Odessa. Its repertory included not only Shakespeare, Schiller, Goethe, and Molière, but Bjornsen, Ibsen, Echegaray, and Heyse. It was nothing less than a school of the theater for an entire continent and for succeeding generations of directors beginning with Antoine and Stanislavski. The standards it established are still those of any production today, however "modern" in theory or method it may be. If the theater that was superseded can be best described as operatic, the theater that was established might be termed orchestral. The director of a play dominates it as Toscanini or Stokowski does a symphony he is interpreting. Stage directions are no more than the printed *tempi—largo andante, allegro, allegretto,* or the markings from *piano* to *forte*. The director's imagination sustains the dynamic interplay, the balance of choirs, the constant transition from one moment of a scene to the next, as a conductor does from bar to bar, whether the *scherzo* of comedy or the *fortissimo* of a frenzied mob. Setting, light, voices, intonation, gesture, movement are so many instruments combined into a pulsing unity, which fuses players and public, stage and auditorium, and, at its best, makes the performance of a play a form of expression that can be called an art—the art of the theater.

Chapter VI. THEORY AND STRUCTURE

1. WAYS AND MEANS

"WHAT'S THIS place?" says Valentine, the five-shilling dentist in *You Never Can Tell*, when he falls in love with Gloria, "it's not heaven. What's the time? it's not eternity; it's about half past one in the afternoon." A designer is enthusiastic about a script and dreams of a production. But he has to realize it, usually in four weeks' time, in terms of paint, canvas, lumber, lamps, the wiring of a dimmer switchboard and the dimensions of a particular stage. In planning any stage set he is faced with the necessity of finding ways and means of realizing his intentions. It is comparatively easy, given any degree of graphic ability, to make an effective drawing of a stage setting, or, after a certain amount of technical experience, to design one that can be constructed and shifted. The difficulty consists in getting the two to correspond. The particular quality of imagination a designer must rely on is his mind's eye, the ability not only to visualize his conception but to test it, as he works, with the question, "Can I construct and then light my setting so that it will give precisely the effect I have in mind?" Water color renderings that seem effective settings on an exhibition wall can become parodies of themselves when set up in a theater. While I was collecting material (in 1932) for an international exhibition at The Museum of Modern Art in New York, Alfred Roller, then the dean of Viennese scene designers, refused to lend any of his sketches. "The only place to exhibit a stage setting," he remarked, "is in the theater." Any designer might do well to pin that statement within sight of his drawing board.

Our method of constructing scenery is still substantially the same as it was in Serlio's day: no substitute has been found for canvas (or muslin) stretched on frames of 1 × 3 inch battens, making flats that are hinged together or cut in overhead strips (borders) and side tabs (wings).[1] Flats are made three dimensional by nailing moldings onto them (Serlio's "bearing out") or by applying relief—pilasters, cornices, pediments—and adding the thicknesses of archways and portals.

Due to our itinerant system of sending plays on short preliminary tours to be revised and rehearsed at public expense before their official opening in New York City, and then, (if they are acclaimed as "hits" or "smash hits") later touring a circuit of cities to the West Coast, the American designer never can be sure in advance of the actual dimensions of the stage on which he will set up his production—its width, depth, amount of offstage space, or the height

[1] Except cotton velour which I discuss in the following section.

of the gridiron, which may vary by as much as 15 or 20 feet. He must plan on minimums rather than possible maximums. Theaters in this country, except those built as university playhouses or community centers within the last ten or fifteen years, are strictly a "real estate proposition." Erected on centrally located and therefore high-priced city plots, they are leased primarily for their site value. The owner or operator is the equivalent of a landlord renting unfurnished rooms and he provides, besides the seats, no more than the usual "services"—heat, lights for the "front of the house" during intermissions, toilets, running hot and cold water, and, on stage, either a fly gallery or a counterweight system. All the apparatus needed to light "the show" and any mechanical aids to speed scene shifting, such as sliding or revolving stages, have to be hauled in with its scenery, the theater having been built solely with an eye to renting the maximum number of seats on a minimum amount of land, with the lowest possible investment in permanent equipment and construction.

Few stages can be easily trapped in more than a very limited playing area. The only trap that can as a rule be counted on is the so-called "Hamlet trap," (in which to bury Ophelia) dating from the days when popular tragedians toured the country to Denver and San Francisco. Platforms, stairways, ramps—unless the production has a single unit setting—may easily clutter up entrances and exits when stacked. Student designers, although they may not have to reckon with stagehands' salaries, will do well to bear them in mind by way of training themselves for the professional or "Broadway" theater. Labor costs have risen in the theater as in every other industry, and the number of men needed to haul and hang a production or to move settings during scene shifts or intermissions may be an important item not only in the original cost of a production but in the possible margin of profit even when it is running to capacity houses. Stage space must be calculated not only for the sets themselves but for stacking space for the accumulation of "props" and furniture in a play which may require three realistic interiors, as well as for flats that have thicknesses, making them too deep or too heavy to fly.

Cantilevered balconies, stretched to hold half or more of a theater's seating capacity, have also stretched the proscenium frame by way of improving sight lines from side seats. An opening approximately 40 to 45 feet wide has become more or less standard for musical comedies, 30 or 32 feet for contemporary or period interiors. Unless these are supposed to be in palaces, their walls are not over 13 or 14 feet high and the height of the stage opening, in order to mask a ceiling and overhead lighting apparatus, is brought down to 11 or 12. When a designer is planning "box sets," he is constructing rooms which, however realistic in detail, have not the proportions of a room but of a large entrance hall, approximately twice as wide as it is deep, 32 × 12 or 14 feet. If he opens up his stage for outdoor settings of architectural exteriors or landscapes, half of the orchestra floor may see the bottom of the drops if he raises the opening to more than 20 feet, unless he cuts his design with the sharp line of a marking border.

Mechanical aids to relieve the weight of stage settings and to speed scene shifts were developed between 1890 and 1900 principally in the state and municipal theaters of Germany where permanent repertory companies played in subsidized theaters which were considered public rather than private institutions, as our art museums and libraries are. Stages could therefore have width and depth enough, and offstage space was extended often to equal the area of the stage itself. Instead of breaking up every scene in the process of setting it up and shifting it, hanging part of it and stacking the rest piecemeal, sliding and revolving stages could be made sufficiently large to set an entire play before the rise of the curtain or to keep entire settings intact, bringing them on stage or taking them off in rotation.

When the German technician, Lautenschläger, built the first revolving stage in Munich it was considered a revolutionary modern invention. He had copied it from one he had seen in a Japanese theater. But unless a revolving stage is considerably larger than the stage opening, at least 55 to 65 feet in diameter, a gap occurs between the ends of the settings it carries and the proscenium. This has to be filled with diagonal flats; settings tend to be constructed in a pie-shaped wedge ground plan and variety of design is constricted. However in Germany it was not necessary to set up every scene in advance as performances began at 7 or 7:30 and were played with only one intermission—*die grosse Pause*—usually half an hour, during which an audience got supper in the theater's restaurant, allowing ample time to set the last two or three acts.

But even the largest revolving stage is not an ideal mechanical solution for setting a play in which open air scenes alternate with interiors, for it needs to be supplemented with wagon stages that can take off architectural backgrounds and roll on landscape foregrounds, leaving an unobstructed vista to the sky. Too small a revolving stage, too few wagon stages, are worse than none. Too many tend to dull the designer's imagination. It becomes too easy to fill them with full scale reproductions of a public square in Seville or Nuremberg.

An ounce of suggestion is usually worth a quarter of a ton of scenery. The American designer may console himself with Goethe's dictum, "It is under limitations that the master really reveals himself." It is significant that in Germany, indeed throughout the continent, a trend of scenic design was constantly toward simplification and stylization even where a vast amount of stage space was available. As in this country—where constricted stages provide the incentive—unit sets, or some form of screen setting, whether flat or partly architectural, have been the basis for most of the important achievements of both designers and directors. Of the six productions of *Hamlet* that I reproduce, Hoffman's in Prague was a series of architectural screens. Five of the American designers' are based on some type of unit set. Most of Jessner's Berlin production of *Richard III* was played up and down a red stairway. Robert Edmond Jones' consisted of a single courtyard of the Tower of London, which with lighting changes and the introduction of smaller units—a dais or screens—became alter-

nately a throne room, a prison, or a torture chamber. The design of Jurgen Fehling's production of *Masse Mensch* (Mass Man) at the Berlin Peoples' Theatre consisted almost entirely of the movements of groups of actors on a few platforms, a scheme I followed in designing and directing it in translation (*Man and the Masses*). Max Reinhardt's *Lysistrata,* like Norman Bel Geddes', was played up and down series of terraced platforms. The Viennese production of *Danton's Death* by Strnad utilized two sets of columns on a pediment base, alternating in position with changing backdrops, to indicate open squares, council rooms, the entrance to the Chamber of Deputies and the interior of the Chamber for the climactic scene. The Baroque palaces of *Volpone,* the study, streets, gates, witches' kitchen, and prison of *Faust,* the pageantry of *Marco Millions,* were all done with the same unit frame.

Any degree of realism or naturalism can be achieved with the corner of a room as well as with full stage sets that omit only the fourth wall. In *The Failures* the angle of two walls of a room, no larger than needed to contain a doorway and a window, were sufficient to establish the drabness of a third-class hotel; two arches papered in pink and a buffet bar made the promenade of a provincial theater; a grimy wall with a time table pasted on it and two benches conveyed the dreariness of a branch line railroad station. The same scheme under an open sky in *Goat Song* established a rich peasant's home and the altar front of a Greek church. The silhouette of a charred gable and a well became the courtyard of a ruined farm. The massive scale of an Egyptian temple in *Aïda* or the Roman temple in *The Road to Rome* can be better conveyed by a portion of a column built to full scale than if it were carried up 30 or 40 feet and made unwieldy and unmanageable. If the designer uses his imagination the audience will use theirs and sense the scale of the building better than if all of it were shown. The Duke of Saxe-Meiningen demonstrated that the size of a stage crowd is relative, a matter of its composition within the space it occupied. Almost every form of design used by designers and directors in the last fifty years has embodied the kind of composition that we associate with Impressionism and which Degas summarized in a remark to George Moore apropos of a painting in one of the official French Salons, "You make a crowd with five people not with fifty." I am not denying the need for mechanical devices to relieve waste of time, energy, and money spent in rehearsals and performances—revolving stages, wagon stages, traps electrically or hydraulically operated—nor the stimulus to director and designer that a spacious stage gives. But the freedom it provides should also free their imagination, not their capacity for imitation, and a designer should remain an artist rather than become a substitute mason with canvas and wood.

2. PIGMENT AND ILLUMINATION

A more important technical contribution made by the German theater in developing the range of stage lighting embodied another phase of Impressionism—*plein air,* the atmospheric

envelopment and space of outdoors. Instead of a sky drop, a plaster dome (in section a quarter of a sphere and semicircular in ground plan) gave a complete illusion of the infinite space of a firmament when light was evenly suffused over it and provided the modern theater with its greatest single element of beauty that was not a revamping of century-old forms.

But such a dome requires a stage of very large proportions. It must be far enough back of the playing area so as not to catch reflections from spotlights that will rebound from the darkest floor; it must also be wide and high enough to enable settings to be brought on and off without destroying the sense of space it creates; and it must have obvious masking borders overhead or wings at each side. Otherwise the working space of a stage is permanently constricted when open air settings are not needed. An effective substitute of finely woven linen was perfected by Hazait, the technical director of the Dresden State Theatre. This linen cylinder was hung on an overhead track that held it taut without any weighting at the bottom and at an angle, making it slightly conical in shape. The diffusion of light over it was as effective as on plaster. When not in use it was rolled up on a drum, like an immense upright window shade, and left the entire stage area free for scene shifting. But the mechanical know-how required to construct the overhead track was never acquired by anyone in this country. Our substitute is a cylinder of canvas—called a cyclorama or usually a cyc—hung on two metal pipes top and bottom. Two parallel side arms join the rear pipe on a five foot radius and the entire cyclorama is lowered into place or flown as a unit to clear the stage by about fifteen or twenty feet during scene shifts. But the canvas invariably pulls at one point or another; hours can be spent trimming it to eliminate wrinkles which develop again with every variation in humidity. Canvas cycs are the bane of light rehearsals and have driven every designer to distraction at one time or another. Cotton velour gives a denser reflecting surface and a sense of greater depth when lighted; its greater weight allows the side arms of a velour cyclorama to be drawn on overhead travelers for scene shifts and then, when extended, pegged down and kept taut. As tightly woven cotton velour tends to wrinkle less than canvas, it is preferable to a canvas cyclorama for the American theater both on tour and as a permanent installation.

Unless the design of a setting is intended to be entirely decorative—an expanse of flat, ornamental pattern—its color must be conceived in relation to the fluctuating light that is to play on it. Like every other element in a stage setting color is relative not absolute. The planes of a stage setting are reflecting surfaces. And here again the technique of Impressionism, broken color or large scale pointillisme, is used. Any large expanse of canvas painted in a solid color under the amount of light required for a daylight scene, has the glaring monotony of a brick wall or a whitewashed fence at noon, reflecting so much light that it becomes almost impossible to emphasize actors moving against it. The difficulty can be obviated by painting in broken rather than solid color, dragging or scumbling it with a fairly dry brush or spattering tones of gray, violet, or blue over a warm ground tone and vice versa, variations close

enough in value not to be apparent. When flats or drops are painted in this way, even when brightly lighted, they have a density which absorbs enough color to make them backgrounds for figures and faces and at the same time enough vibration to keep them from seeming gray or dingy.

A more subtle technique of painting was perfected by Robert Bergman and is known as the Bergman bath. It is done by laying flats on a studio floor and then dousing them with thin washes of paint,—all close in value grays, blues, violets, or ochres, occasionally thinner washes of silver and gold—floated over a ground tone. A setting painted in this way is astonishingly rich in texture and responds to the slightest variation of light.

I prefer to use black or gray cotton velour, stretched over duck, as a substitute for canvas. Color is dragged over it in successive layers without entirely obliterating the black or gray ground. The texture is richer and more vibrant than can be gotten on canvas and it absorbs enough light so that a certain degree of chalky brilliance, which painting on canvas tends to give, is avoided.

Another method of painting that I have found particularly valuable for landscape compositions which call for receding planes on a large scale—such as stretches of water, headlands, cliffs and mountains—is semitransparent or translucent painting on muslin. The design is painted in analine dye. The drop is then reversed and opaquing of varying degrees of density is applied at the rear, in silhouettes that correspond to the various masses; those in the foreground are solidly opaqued, those in the distance are semitransparent; high lights on water and the sky are left entirely transparent. Such a drop when hung with the right balance of light from front and rear established, will give in a single plane the transparency of water, the depth of sky, and the solidity of mountains or hills. It obviously allows for a freedom of large-scale composition not possible in any built setting and there is the further advantage that such a drop can be hung close enough to a built up foreground so that upstage space is left free for stacking portions of other sets. I used two semitransparent drops for the background of Siegfried's Rhine journey in *Götterdämmerung* to depict the waters of the Rhine between receding cliffs and headlands. These translucently painted forms responded to the subtlest variations of lighting exactly as though they had been solidly built, first at night, then catching the first glints of dawn, and finally emerging into full morning light. Another stretch of the Rhine was seen in the fading sunlight of late afternoon that faded into twilight gloom after Siegfried's death.

The color given electric light by gelatine slides is still crude and rudimentary; it runs from a few tints of amber through a pink, supposed to be flattering even to young female countenances and nothing less than rejuvenating to elderly ones, and then to a limited range of blues from a pale or "steel" blue to "sky" and "midnight" blues. All the ambers except the palest—bastard amber—bleach color, particularly the color of costumes, and turn syrupy

on actors' faces. Of the blues, only steel blue is light enough to be used except for moonlight and on night skies. But with light as with paint the impressionist principle of color mixture applies. Daylight scenes can be cut with enough steel blue, sufficiently diffused, to restore the color of costumes, model features, and give atmospheric vibration and envelopment to the entire setting without being apparent. For lighting a cyclorama, glass rondels in the light primaries—red, green, and blue—spectroscopically accurate, are available commercially. On a white cyclorama or dome, color can be mixed with light in a cycle running through the entire range of the spectrum.

Painting part of a stage set with light has been successfully accomplished in some European theaters by lamps that are modern versions of the old magic lantern. In 1926 at the *Burgtheater* in Vienna I saw an elaborate Arabian Nights city that was projected at an acute angle from an overhead lantern onto a backdrop which filled the entire width of the stage. The design on the lantern slide, not larger than about 4 × 5 inches, had been mathematically distorted to correspond with the angle of projection so that the design on the drop was in correct perspective, with vertical and horizontal lines entirely plumb. The lantern could be hung close enough to the drop and far enough backstage to be clear of all overhead lighting apparatus and other sets hung over the playing area. The elaborate detail of the design, suggesting an Indian miniature, was sharply defined and not blurred at any point. This particular lantern has since been redesigned and improved by one of its original engineers and is being manufactured in Holland. Others similar in type were regularly used in a number of Europe's theaters and opera houses before World War II. But the concentrated filament lamp generates heat so intense that in some installations the slide is cooled with a jacket of running water or with an electrically driven blower.

I have seen the specifications of another lamp now in use at the Paris opera. Its inventor claims that slides will not crack when used for the average duration of an act. However such projection lamps are practical only as part of the permanent installation of a repertory theater. They are heavy and more or less bulky, usually at least four feet long and two or three feet square, requiring a light bridge upstage where they can be firmly set and focused by an operator who must also stand by. None has been imported. I used two lamps of 2100 watts burning at 65 volts, now manufactured here, to project Walhalla emerging from the morning mist in the second scene of *Rheingold* and later reappearing in the final scene, one lamp projecting the nimbus of clouds, another dimming up Wotan's castle on cue. But the pigment on our lantern slides burns out and fades after more than half an hour even if the slide itself does not crack unless care is taken to cool the lamp and slide.

Available lenses require one foot of distance for every square foot of the projected picture. The apparatus must therefore be 24 feet from a cyclorama or backdrop in order to cover an area approximately 24 feet square, and 15 or 20 feet upstage, in order to have an unob-

structed throw and clear the entire playing space—a setup possible only on the largest stages. With less than 15 or 20 feet of distance behind the rear of the acting area, reflected light blurs the projected design. Even if this is obviated, definition of design tends to become blurred, while masses and forms can be only somewhat vaguely suggested. Furthermore, the projected portion of a setting tends to have the translucent quality of stained glass, so that it can be more successfully integrated as part of a pictorial setting when it is a vista or a vision, like Walhalla or cloud capped towers that might be called forth by Prospero.

A recent American projection lamp, not yet being manufactured in quantity, has been designed for two 5,000 watt lamps and two lenses set side by side. Color film is used instead of glass slides and is set at sufficient distance from the lenses to be air cooled and so prevent burning or fading. An attached transformer allows an operator to lap the two images or to dissolve one into the other. However, even a perfected projection lamp will be at best an occasional although valuable adjunct to a scene designer's resources rather than a substitute for scene painting. I am inclined to believe that for most settings, where projections might be used, analine, semitransparent drops will prove to be more practical as well as more flexible and allow greater freedom of design.

3. NERVE CENTER

I have never found it practical to diagram the lighting of a production in advance. No light plot is better than its subtlest fluctuations. And the number of lights usually required would be graphically too complicated to be legible, even if the designer were certain of all of them in advance. He cannot be. He may anticipate most of them, perhaps, after watching rehearsals and conducting his preliminary light rehearsals. But the precise and essential timing of his light plot can only be developed when the actors enter the set and the interaction between setting and drama takes place. It is only then that the focus of lamps can be finally changed, often by inches, the timing of a dim by seconds.

Precision in focusing and timing is essential. A single spotlight or a group of lamps must not spill from Liliom's face onto the railway embankment just below or in back of him nor a few inches beyond Tristan's bier or Isolde's tent. In the final moments of *Elizabeth the Queen* the first glow of dawn, (supposedly coming through the narrow slits of turret windows in the Tower of London) that caught the edge of the red banners, lost in shadow until that moment, hanging over Elizabeth's head, had to catch just the edges of the banners, and nothing more. Had the ray of light spilled over, the effect would have been worthless. Therefore every focusing spot should be equipped with four-way cut-off shutters to frame the area covered and to throw a slit of light if necessary in a horizontal or vertical line. It should also have a built-in iris shutter. There is no substitute for mechanically well built lighting

equipment nor for enough of it. A designer using too few individually controlled outlets for his lamps, however well designed they may be, sooner or later finds himself in the position of someone who has only a fifty dollar bill and cannot change it to buy a bottle of milk.

There are, besides the lamps used on a cyclorama, three types of lighting equipment that a designer habitually uses. (1) Focusing spotlights of 500 to 1,000 watts with 6- or 8-inch condensing lenses. (2) Soft focus spotlights which cover a wider area. (3) Borderlights, wired in 3 circuits, with outlets of 75, 100, or 150 watts each. The usual and most effective arrangement is to place six or eight spotlights on an upright pipe at either side of the proscenium 18 to 24 inches downstage of the curtain line. On each pipe two or three 500 W spotlights are placed below, beginning slightly over head height, with the 1,000 W spots above. The pipes are mounted on a castered truck, approximately 6 to 8 inches high and 5 to 5 feet 9 inches long,[2] masked by wings painted black or covered in black cotton velour. These indispensable units, called light tormentors, have the further advantage that they can be used to narrow or widen the stage opening and serve as an inner proscenium. One or two overhead pipes, depending on the extent of the playing area and the elaboration of the light plot, carry the three-color borders and additional spots, both sharp and soft focus. Footlights cannot be entirely dispensed with, for they are often needed to indicate the glow of twilight or any other source of light that should come from below; also because many actors have eye-sockets that cast deep shadows when their faces are lighted entirely from the side. If footlights are used at more than half their full intensity they tend to throw distracting shadows of the actors across a rear wall and also wash out the balance of light on it. The best method for lighting actors' faces when they near the front of a set and for covering the forestage area is to install one or two banks of 1,000 or 1,500 watt spotlights in the ceiling of the auditorium with an angle of throw of about $35°-45°$. These lamps are reached on catwalks, for focusing; when properly angled they will catch an actor at head height as far back as the playing line and throw shadows on the stage or forestage floor and not on the setting.

But the nerve center of stage lighting remains the dimmer control board. It is usually referred to as the switch board, and accurately so, because the fluency and subtlety of any light plot depends on the speed with which lamps can be coupled or uncoupled, singly or in groups, from a master dimmer control. In any light change, some lamps will "dim up" to a quarter, half, three-quarters, or full intensity on any one of a hundred "points" (or "marks," indicated on the perimeter of a semicircle). Others dim down to a given "mark." And every lamp must reach its final mark, whether it goes through a full circle or only quarter of its range of intensity, at the same time.

Resistance dimmers, in which each dimmer unit with its handle is mounted as part of a

[2] As any setting may have to tour, it must be built in units not more than 5' 9" wide, to clear the standard height of the door of a railway baggage car.

circular plate (the current not needed at a low point of intensity being shunted off through resistance wire as heat) are cumbersome. A comparatively small bank occupies the cubage of an upright piano case. Interlocking and unlocking individual units mechanically on a master lever at the speed required by a complicated light plot is physically almost impossible. As many as four or even six such dimmer boxes often have to be used; they clutter up offstage space and require unnecessary hours of light rehearsal to co-ordinate the timing of three or four operating electricians. The ideal operators for such dimmer boards would be a pair of intelligent orang-outangs or an automaton with as many arms as the goddess Siva.

Resistance dimmers are being supplanted by remote control systems in which dimming control is entirely electric. The dimming units, or rheostats, are banked in the cellar. The pilot or control board placed onstage can be set flush with the stage wall, is no deeper than an ordinary fuse box, and for 40 or 50 circuits need be no more than approximately 3 by 4 feet. The control panel can be a portable desk or console type like the console of an organ or a piano keyboard, and no wider than the reach of a person's arms. Indicators and switches are worked either like piano keys or on semicircular indicators approximately 5 to 6 inches in diameter, clearly marked in 100 gradations from zero to full intensity. A minimum of two is provided—one for the intensity of any lamp or circuit of lamps in use at a given mark, the other for the next step or point of a dim, up or down. Any one control is switched to a master handle or "fader" with no more effort than the flick of a finger, and all circuits reach their respective marks—proportional dimming—at exactly the same time, whether they have been moved up to full intensity or down to out or nearly out. At any moment of such a light change, any circuit may be instantly detached from the master control, and after a given mark has been reached, can be separately operated.

This type of control has the further advantage that all the wiring for the control panel can be contained in a light flexible control cable which is plugged as a unit into a receptacle (or plugging box) at the most convenient point on stage. A small wiring conduit can be led to any point in the auditorium, so that a single operator can conduct a light rehearsal, accurately record every point or mark of a light plot, and, as some directors prefer to do, also control the lighting of a performance from in front rather than from backstage. The cost of the original installation is high, but it is an essential endowment for any modern stage.

The outline I have given may make the lighting of a production seem a formidable problem. But where equipment, circuits, and control have been well planned, a designer will find, after a comparatively short apprenticeship, that it is nothing less than an extension of his person and his personality. He will use his lighting apparatus to express his sensibility and his intentions as instinctively and as freely as his own body.

Chapter VII. RECURRENT FORMS AND NEW DIRECTIONS

In discussing any art we are apt to become the dupes of names, which are merely the labels and classifications used by critics to catalog our burden of culture, from the prehistoric and primitive to the modern experiments of the day before yesterday: Impressionism, Neo-Impressionism, Expressionism, Naturalism, Realism, Surrealism, Constructivism, Futurism, Functionalism. But one need do no more than run through the illustrations of any history of the fine arts to realize how inadequate such labels can be, how much a matter of convenience they have become, like the main subdivisions of a card catalog drawer. No school of art has ever been original, in the sense of achieving a complete break with the past. As in every form of growth, dominant and recessive characteristics intermingle. Every epoch of art is to a greater or less degree a re-nascence, whether or not its originators are as aware, as the artists of the Italian Renaissance were, that they had revived fragments of the past. The most abstract forms of modern painting become symbolic patterns like those on the tapa cloths or the totem poles of the South Seas—the significance of their symbols being interpreted by art-critics in the role of soothsayers, instead of by tribal priests. Realism existed as an essential element in painting centuries before it was labeled as a dominant tendency. Dürer's drawings of a rabbit or a clump of wild flowers are accurate enough to illustrate any textbook of zoology or botany today. Any textile manufacturer could weave the velvets and brocades depicted in German and Flemish altarpieces or those in Ghirlandaio's, Benozzo Gozzoli's and Raphael's frescoes. He could be certain enough of the most minute detail of every pattern, gauge the weight, sheen, and texture of every bit of fabric, so that he could set the punched pattern cards for his jacquard looms. Any carpenter could build to scale the beds, tables, chests, and chairs in any Renaissance painting. Any jeweler could reproduce to the last filament the encrusted ornament on the robes of angels, saints, and saviors in Van Eyck's altarpiece *The Adoration of the Lamb*. The plants and flowers blooming in *The Lion and the Unicorn* tapestries were so carefully observed that their botanical species have been identified—*Mathiola incana, Hesperis matronalis, Lychnis falba, Calendula officinialis, Physalis Alkekengi*, among others. You may order them from a nurseryman's catalog and grow them in your own garden. Any theatrical costumer could make the gowns of the figures kneeling on tombs in English churches to the last flounce and frill, the convolutions of their ruffs and the curls of their wigs.

Before the atmospheric vibration of *plein air* became the mark of Impressionism in

Pisarro's, Monet's, and Seurat's landscapes, it could be seen in the mountain vista of Leonardo's *Madonna of the Rocks*, the hills and valleys of Breughel's *Four Seasons*, the horizons of Claude Lorraine's "classic" allegories, and the haze of dawn or the shimmer of noon in Turner's harbors and seascapes. The gargoyle of Notre Dame leers over Paris and functions as a waterspout. Art always functions and serves a purpose in displaying itself. The portrait in a frame, on a pedestal, or as an equestrian monument, portrays the importance and authority of a founder, a leader, or a ruler in order to impress subjects or followers and sustain the allegiance of a family or a nation. At the same time it is a bid for immortality on earth or in heaven.

In the theater or out of it an artist plays a dual role. The god, hero, demon, or human being he presents is real enough to arouse intense emotions of awe, wonder, or delight in a spectator. At the same time, he views the creation he has made at arm's length. However real it may be, more real than life itself as the phrase goes, it is an artifice, like Castiglione's and Vigarani's mechanical peacocks, and the artist has either given the directions for making it or has contrived it himself by chipping stone, thumbing clay, pouring bronze, or manipulating pigment.

This ambivalence inherent in every form of art is fundamental in the theater. Every participant plays a dual role of making believe and pretending that he (or she) is not making believe. However rigorous the stylization of a production may be, it is unavoidably naturalistic. The theater must use not an imitation of life but the living bodies of actors, and no actors in the most rigorously stylized and "abstract" productions have yet crouched over empty space sitting at symbolic tables or on invisible chairs.

This dual role is shared by the audience at every moment of a performance. We are purged by pity or terror, moved to laughter or tears. In terms of current psychology, we sublimate our emotions and identify ourselves completely with the hero or heroine in their ecstasies or their agonies. But at every moment we realize that we are doing so. We interrupt our emotional spell and break the transference, in order to applaud Booth or Barrymore playing Hamlet and Richard III, or Bernhardt dying of consumption as Marguerite Gauthier. We know that Richard III is not a hunchback, that Hamlet is not dead as the final curtain falls, and that Bernhardt is not a victim of phthisis. And we are as well aware of it through three or five acts as we would be if we were backstage in a dressing room congratulating any one of them on the performance.

Theorists who attack the theater of illusion and the picture frame stage by one method or another, base their contentions in the reactions I have outlined. Why not admit, ask these spokesmen, that a stage is always a stage? Why not acknowledge the fact and do away with any pretense that actors move under the light of the sun or moon or anywhere else than on a platform? Thus we get the stage of Jacques Copeau *Le Théâtre du Vieux Colombier*, with

its permanent balcony and no division between stage and audience; or Reinhardt's "Theatre of the Five Thousand" in Berlin, where the mobs of *Danton* or *The Miracle* surged among the spectators; and the smaller arena theaters, now called The Theater in the Round, in which there is not even a simplified architectural frame, and a few rows of seats completely encircle a group of actors; or, during the 1920's, the constructivist settings outlined in slats which were used in Moscow. But Copeau's theater was essentially a rearrangement of the Elizabethan stage with its smaller balcony or heavens and its inner stage and tyring room. Arena theaters, large or small, revive the Roman circus. Forestages thrust into the auditorium restore with a change of proportions the ground plan of the Attic theater. In Meyerhold's constructivist production of *Roar China* the British gunboat was truncated just back of its conning tower and stood against the bare brick walls of the stage house. But it was placed in a tank of water across which sampans were poled from a dock to the warship's gangway and into which a coolie was thrown, with a splash, supposedly to drown. On the stage of the Mons Passion Play, in 1501, there was a smaller tank in which Noah launched his Ark after having constructed it of prefabricated segments. The same tank served the next day as the Sea of Galilee into which the disciples cast their nets. Santayana once observed that a fanatic redoubled his energy while forgetting his aim. It might be said of most modern theorists in the theater that they intensify their experiments while ignoring their origins.

The alternatives presented have no intrinsic value. Whatever degree of illusion, or lack of it, that may be decided upon becomes largely a matter of emphasis, the decision of designers and directors as to how self-conscious they want or expect an audience to be. Any production is an experiment, any performance is an event. The test is, in Broadway's phrase, "Did the show get over?" There is a gap to be bridged, over the footlights or without them, through a proscenium or beyond it—a connection to be made, a current of communication to be set up. Once the connection is established there is an electric cohesion. The fusion of play, players, and public takes place which makes any form of convention real, any kind of stylization vital, and keeps the theater alive by filling it for a few hours with the breath of life.

PRODUCTIONS AND THEATERS
PAST AND PRESENT: 1545-1949

THE illustrations in this first section are not arranged in chronological order. Instead, I have juxtaposed the designs of successive centuries in order to show the persistence of certain forms and conventions over a period of several hundred years. The development of scenic design does not proceed in a straight line. Various types of design, as well as technical methods, recur. Innovations are often survivals or revivals. The architectural forms of Serlio's comic and tragic settings—the central archway, temples, and loggias —continue to appear in the eighteenth century at the Drottningholm theater. In reproducing photographs of these settings I have tried to show how such architectural vistas looked when executed and set on a stage.

One feature of medieval passion plays also survived: the mouth of hell, the so-called "toad's face," with its open jowel belching smoke and flame. We see it in Santorini's hell scene of the seventeenth century. Indeed, infernal effects remained so popular that we find them reproduced in the hell scene in an Amsterdam theater of the 1770's. The continued use of such effects probably accounts for the fact that so many theaters burned down (two Paris opera houses were destroyed by fire within the course of a few years). The Drottningholm theater is one of the few that has remained intact with many of its original settings.

As Kernodle has shown in his volume, *From Art to Theatre,* design in the theater employs or reflects prevailing types of composition in contemporary painting and sculpture and employs typical forms or symbols current in the fine arts. Indeed, many of the spectacular effects of the indoor theater were often seen in the streets—in the smoking grottos and fuming beasts of the Bolognese pageant of 1662. The painted arches framing actual vistas of Florentine streets for a wedding procession of one of the Medici are the prototype of the proscenium arch of the Farnese theater and the ornamental prosceniums of many theaters today.

In scene shifting, two different trends continued to develop. On the one hand, part of the glamour and excitement of a performance was watching settings change, often without the lowering of a curtain. Much of the technical equipment of the stage has been and continues to be designed for that purpose—whether wings moving on and off in slotted grooves, gridirons for flying flats and backdrops, or elevator and sliding stages. At the same time, unit settings were also used and still are, today, in one form or another. In the "simultaneous" settings of the Hotel de Bourgogne in the seventeenth century, all the sets, like the various mansions of a mystery play, were onstage—a cave, a bit of wood, a house, or a shop. The actors moved from one to the other as the play progressed. Often only part of a set was moved, as in *Pélée and Thétis,* where a grotto served as a permanent frame and the effect of a change of scene was made by changing a backdrop. Modern designers and authors continue to use the unit setting. Eugene O'Neill's stage directions for Act I of *Dynamo* called for the interior of a house which could be seen at the same time as the street in front of it. This kind of simultaneous setting, on several levels, has been frequently

used in Russian, German, and Scandinavian theaters. Robert Edmond Jones has often used unit settings —in *Othello* and *Hamlet*, which I reproduce, and for *Richard III* and *Desire Under the Elms*. Jo Mielziner's skeleton set for *Death of a Salesman* is another instance of how effective a unit setting can be. Note also, in connection with it, how exactly the drawing anticipates and visualizes the actual setting, as built and lighted.

The engravings of the early nineteenth-century London theater demonstrate how the large forestages of theaters at that time improved sight lines—even from upper, side seats. Elevator forestages, as in the Malmö theater, have become an important feature of modern theater design and provide valuable flexibility in staging plays. Such a forestage can be used at stage level in front of a screen or curtain for stylized productions; it can be sunk to the level of the auditorium floor and filled with seats for more intimate or realistic productions; or it can be sunk to make an orchestra pit for plays given with music.

Realism in stage setting, which became a modern "movement" in the 1890's, is not as modern as it seems. The London street scene of the eighteenth-century Amsterdam theater reproduces with remarkable fidelity Georgian architecture of the day. What makes the realism of such settings seem old fashioned to us is the fact that so much of the detail was painted rather than built and, in interiors, so much of the furniture—as in the two Drottningholm settings—was painted on the flats themselves. The box set did not become common until the nineteenth century. Until then (note again the Drottningholm settings) interiors were a series of parallel flats, like open-air settings—actually a series of receding arcades. And the effect of sunlight coming through windows was painted on the flat as well.

It must be remembered that in the era of candlelight the auditorium and the audience were as brightly lighted as the stage. Even after the introduction of gas light the practice persisted. When, during the first performances of the Ring Cycle at Bayreuth in 1876 Wagner lowered the lights in the auditorium while the acts were being sung, it was a startling innovation. Stage lighting today can only achieve its full effect from a darkened auditorium. Even when a setting is not changed, a blackout and a complete change of lighting on stage becomes another method of scene shifting.

What these illustrations make plain, I hope, is that theatrical production and scenic design are not governed by aesthetic absolutes. The art of scenic design continues to be eclectic and protean. As Santayana once observed, origins do not determine values. The test of design in the theater continues to be its effectiveness in interpreting a script in performance. And there are, and always will be, more ways than one of doing that.

49

Serlio, Setting for Tragedy, 1545

Setting for the opera, *St. Alexis*, 1663

Torelli, Setting for *Andromeda*, Act I, 1647
Bibliothèque Nationale, Paris

Photo Rigal

Bérain, Setting for a Comedy, 1699
National Museum, Stockholm

Courtesy, Museum of Modern Art, N. Y.

51

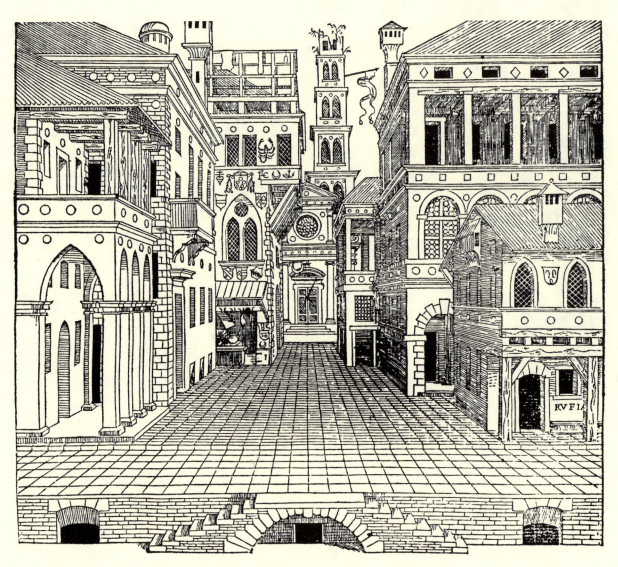

Serlio, Setting for Comedy, 1545

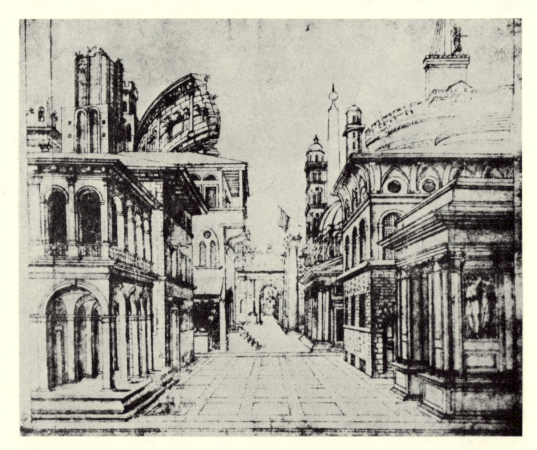

Peruzzi (1481-1537), Street Scene

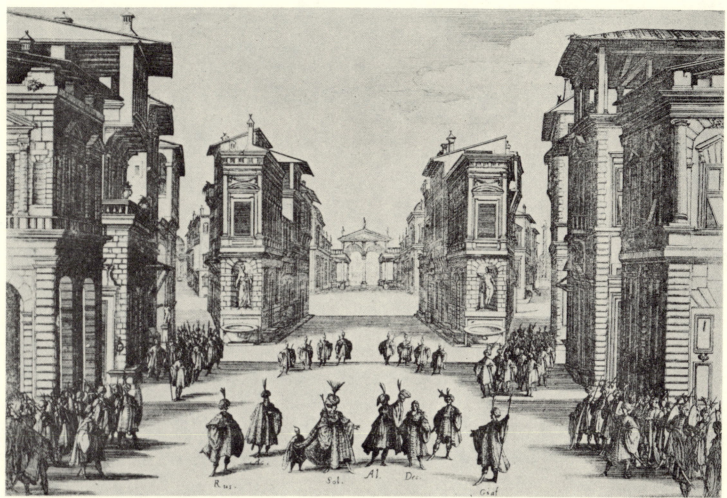

Parigi, Setting for *Il Solimano*, 1620

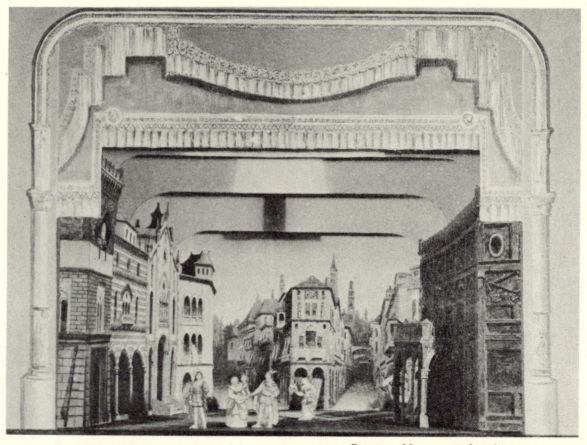

Model, Edwin Booth's *Romeo and Juliet*, 1869

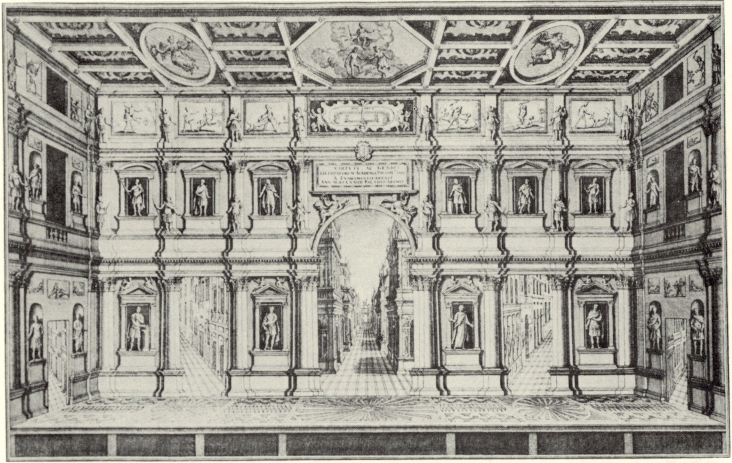

Stage, *Teatro Olympico*, Vicenza, 1584

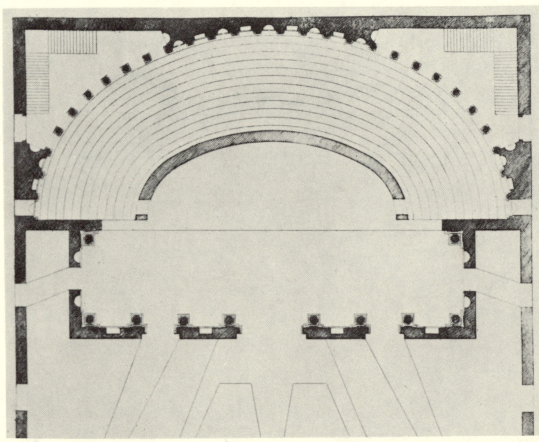

Plan, *Teatro Olympico*

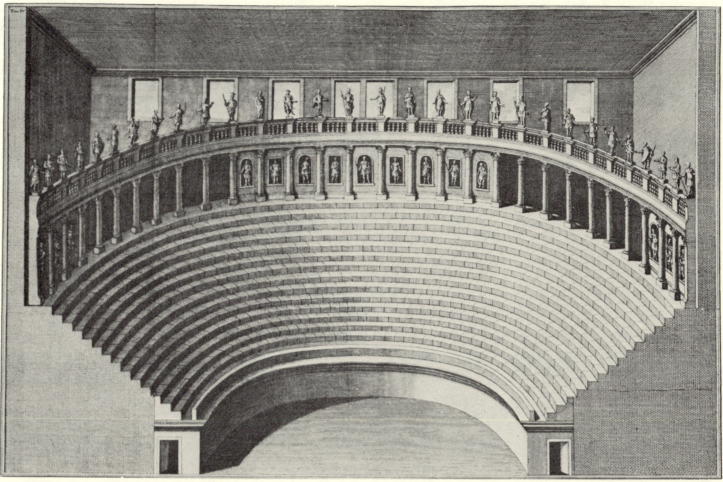

Auditorium, *Teatro Olympico*

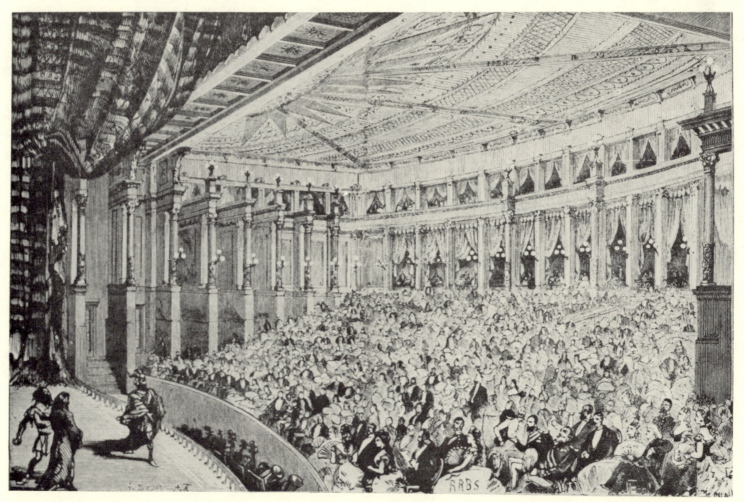

Bayreuth, Festival Playhouse, 1876

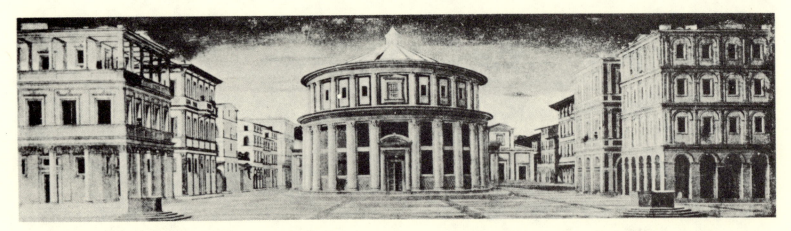

Luciano Laurana (?) ca. 1470 Painting of a Comic Scene

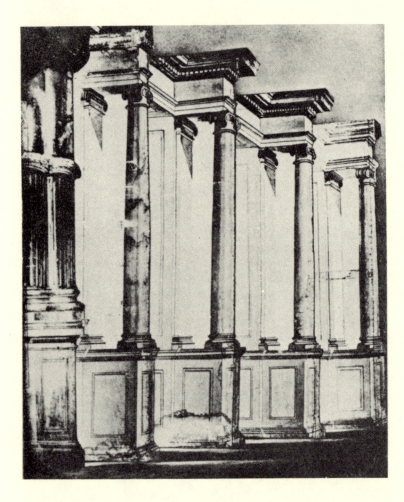

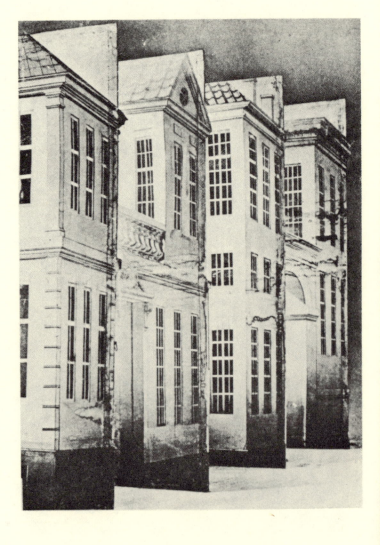

Wings of Stage Settings
 Drottningholm Theatre, ca. 1766

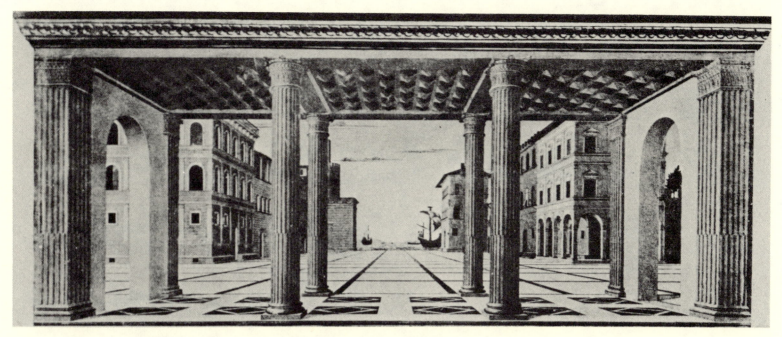

Piero della Francesca (1416-1492), A Painting of a Street Scene

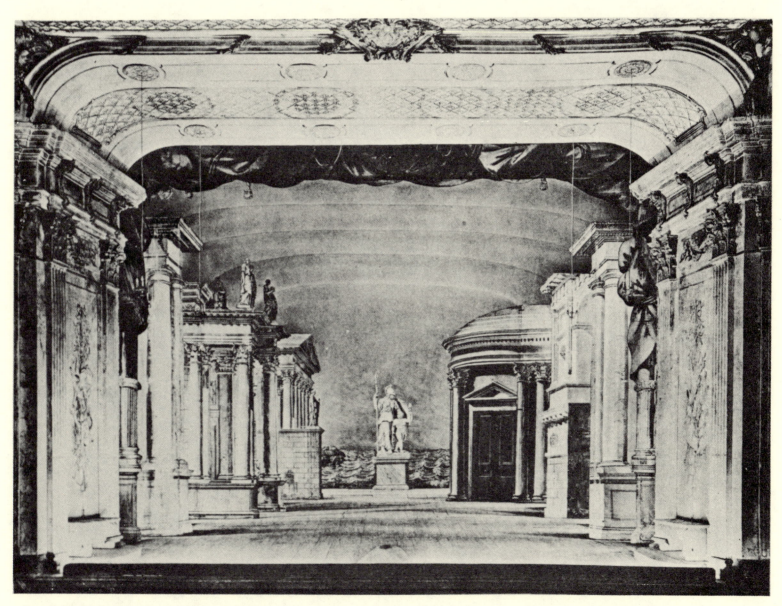

Stage Setting, Drottningholm Theatre

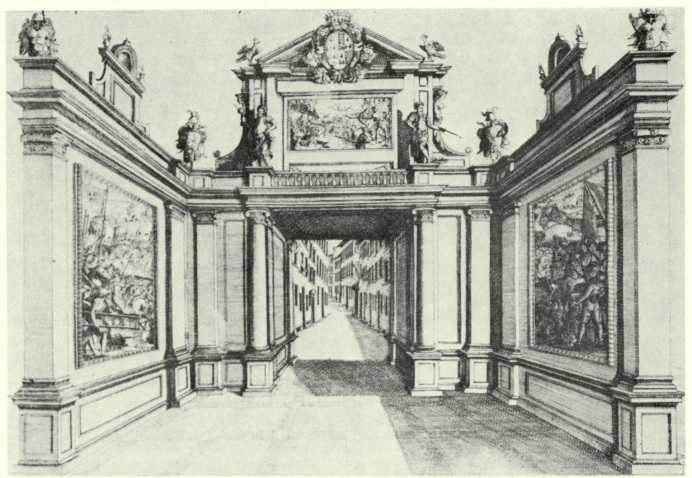

Stage Sets in the Streets—Florence, 1589

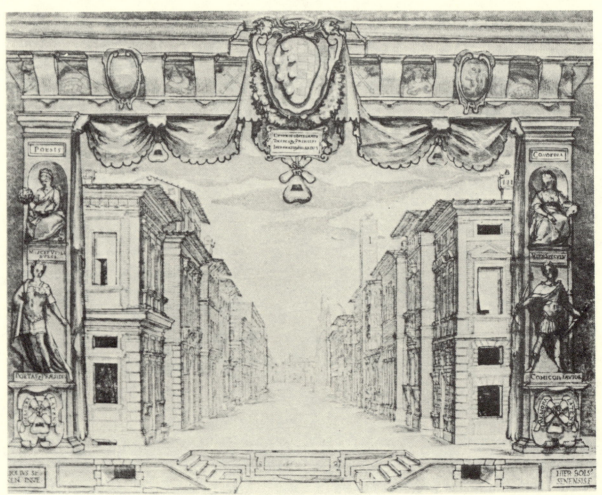

Riccio, Setting for *L'Ortensio*, 1589
National Museum, Stockholm

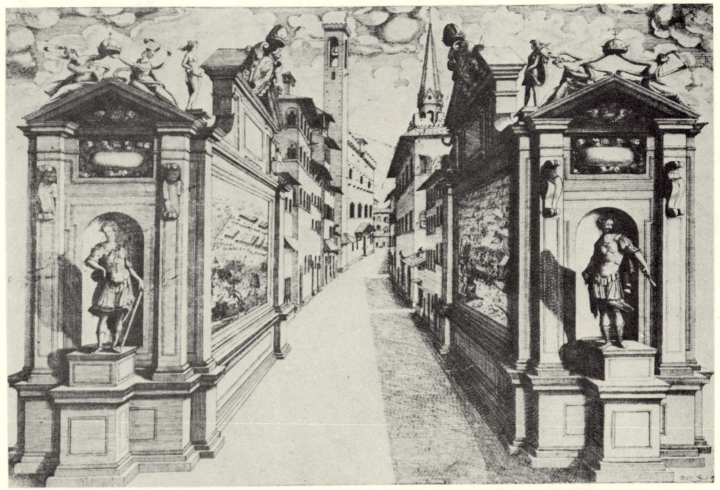

for the Wedding of Ferdinand de Medici

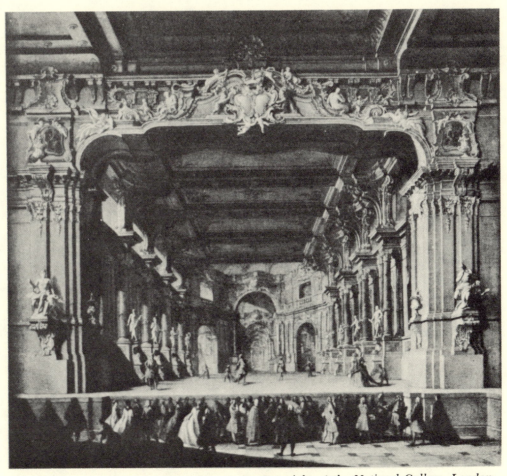

Bibiena (?), Interior of a Theatre, first half 18th Century
The National Gallery, London

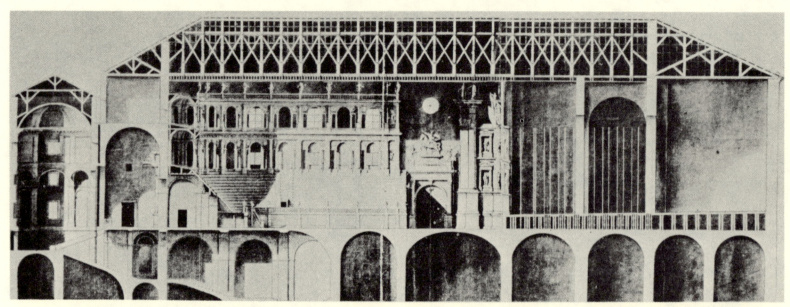

Cross Section, *Teatro Farnese*, Parma, 1618

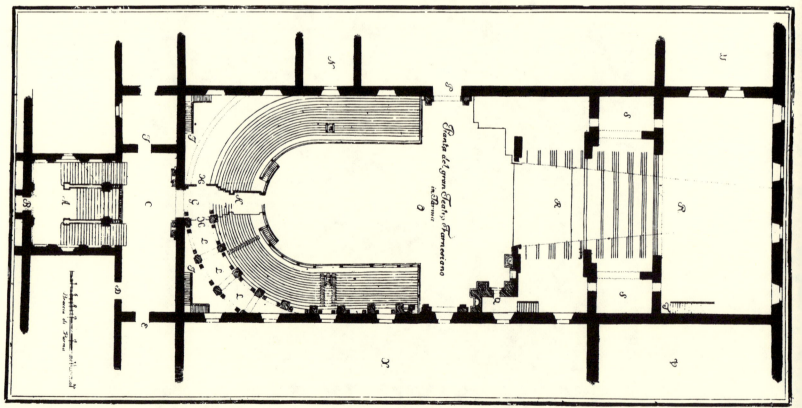

Ground Plan, *Teatro Farnese*

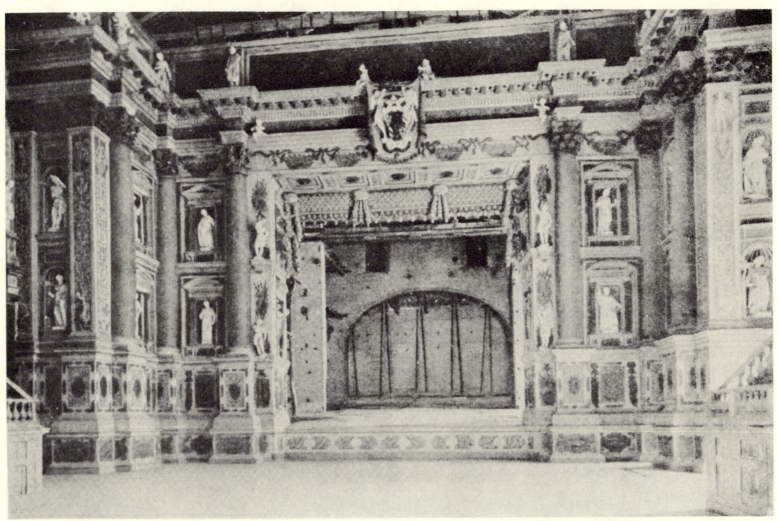

Proscenium, *Teatro Farnese*

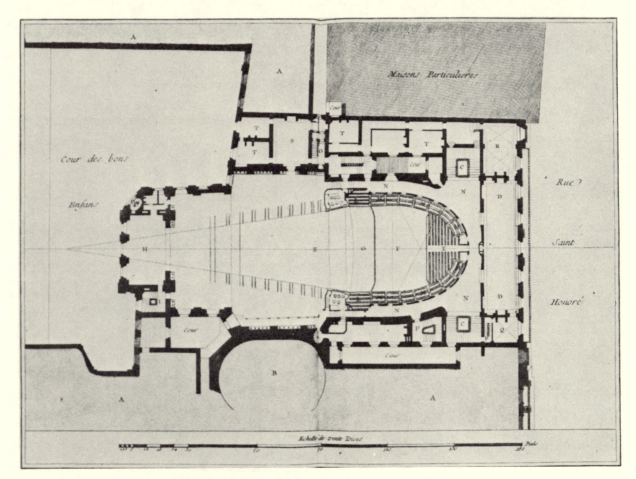

Ground Plan, Paris Opera House, 1778

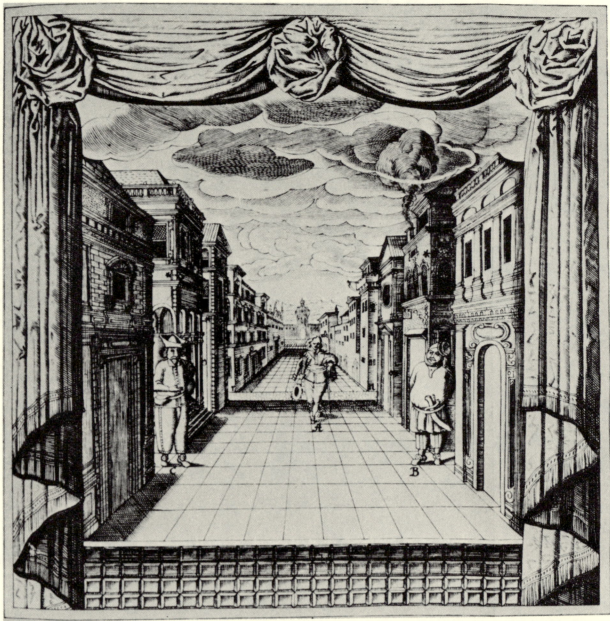

Joseph Furttenbach, Setting for a Comedy, 1640

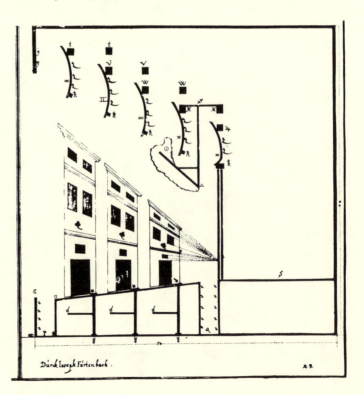

Cross Section of the Setting

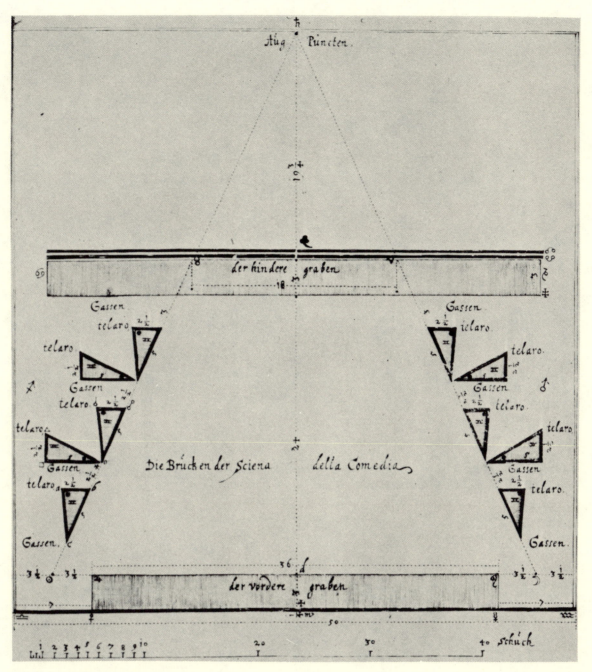

Ground Plan of the Setting

Scene Shifting with Periaktoı

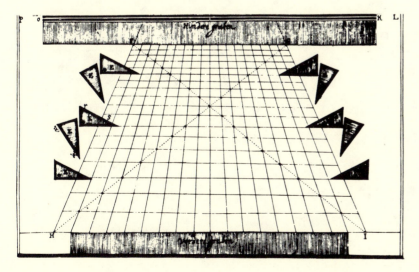

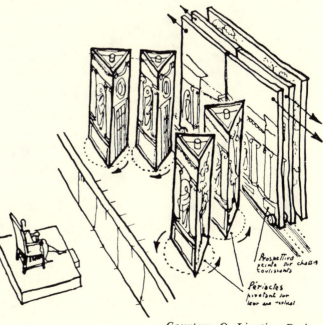

Courtesy, O. Lieutier, Paris

Andromeda. Prologue

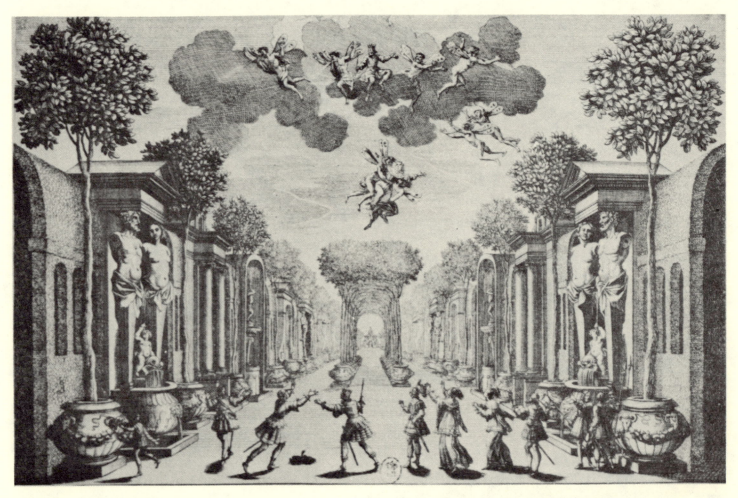

Andromeda. Act II

Four Settings by Torelli, 1650

Andromeda. Act III

Andromeda. Act IV

Bibliothèque Nationale, Paris

Scene Shifting Mechanism, Paris, 1776

Sketch of same.
From Traité de Scènographie

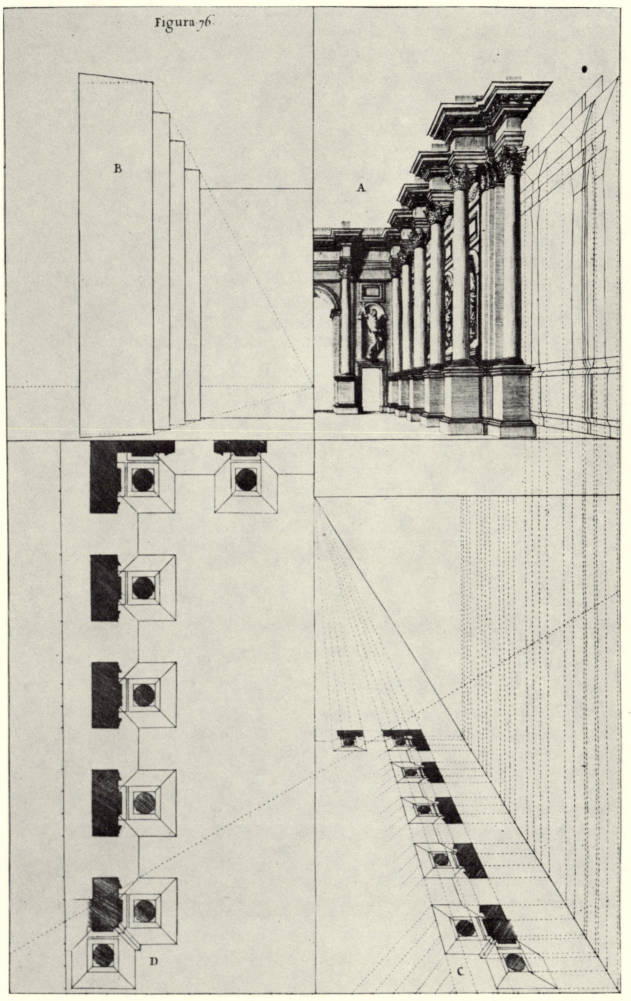

Figura 76

Pozzo, Treatise on Perspective, 1693

Courtesy, Metropolitan Museum of Art

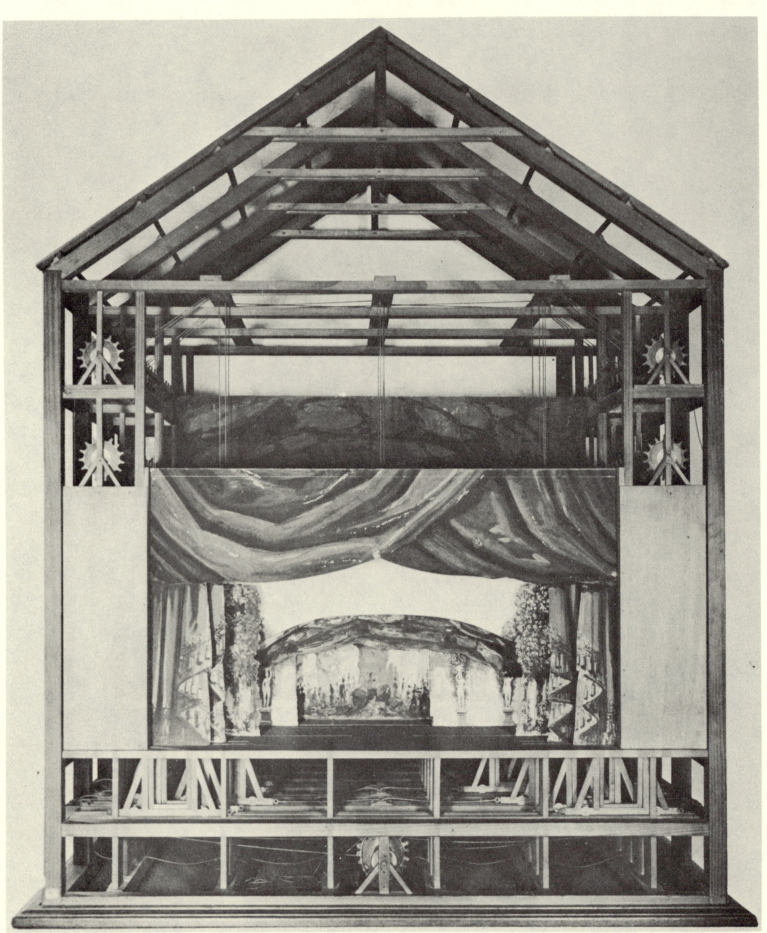

Model of a 17th Century Stage
Bibliothèque de l'Opera, Paris

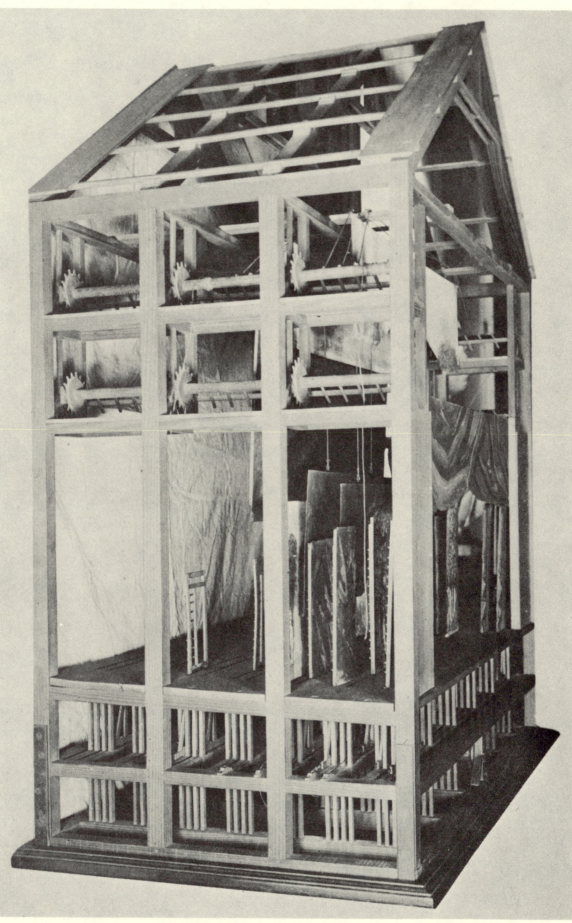

Model of a 17th Century Stage
Bibliothèque de l'Opera, Paris

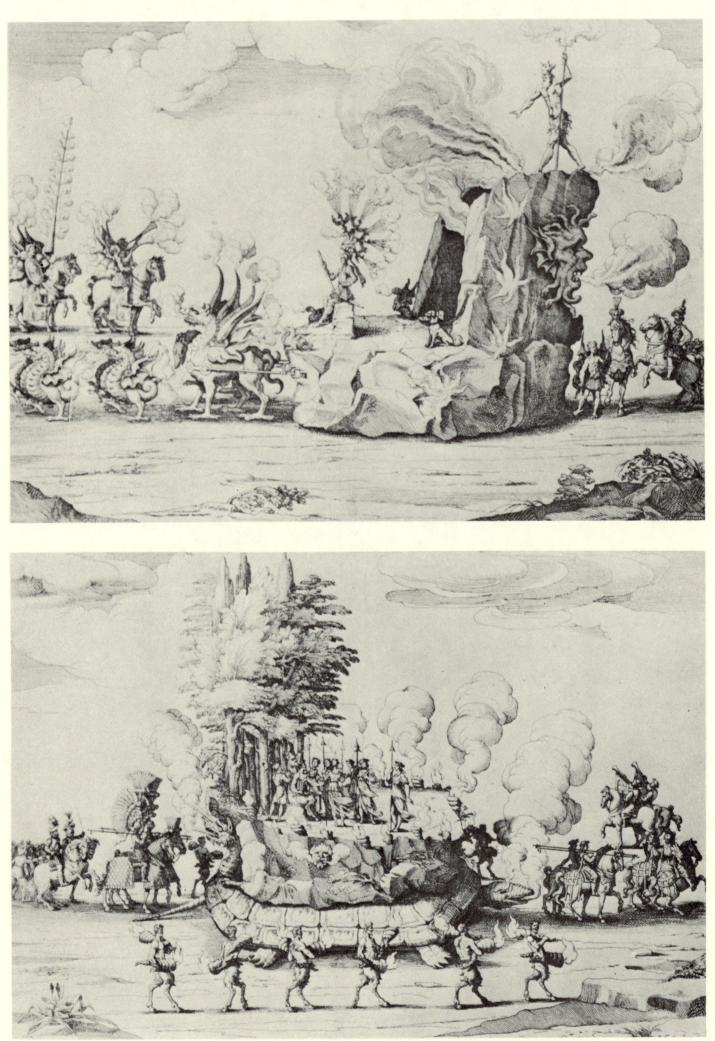

Floats, Pageant, Bologna, 1628
Collection Pierre Berès Inc.

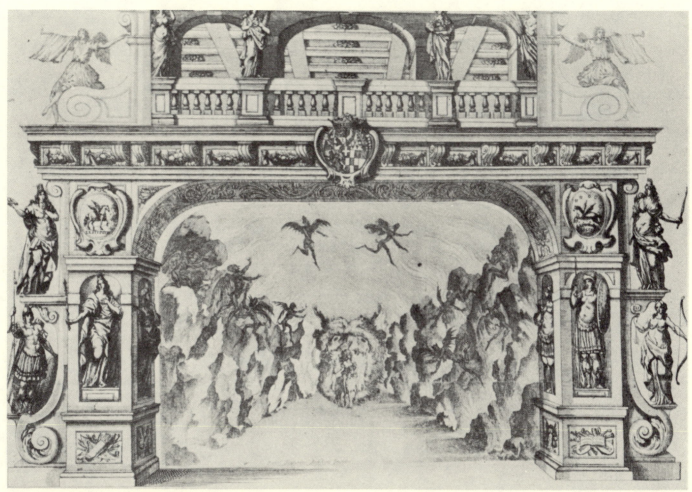

Santorini, Hell Scene, Munich, 1662
Collection Pierre Bèrés Inc.

Photo Brenwasser

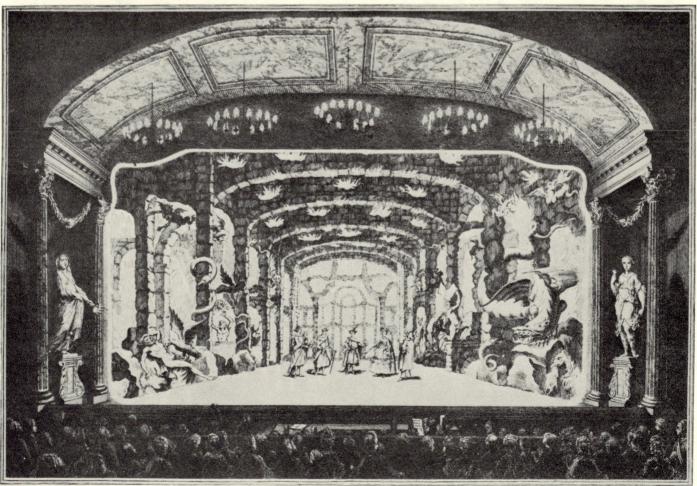

Courtesy, Harvard College Library

Hell Scene, Amsterdam, ca. 1770
Harvard Theatre Collection

71

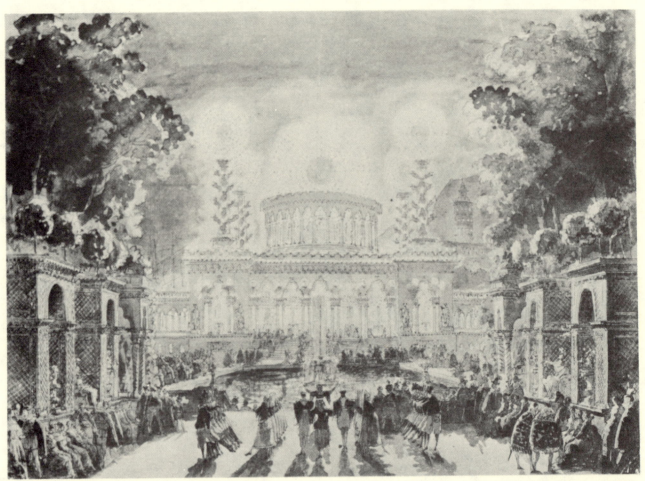

Despréz, Drawing for a Setting, 1784
Collection National Museum, Stockholm

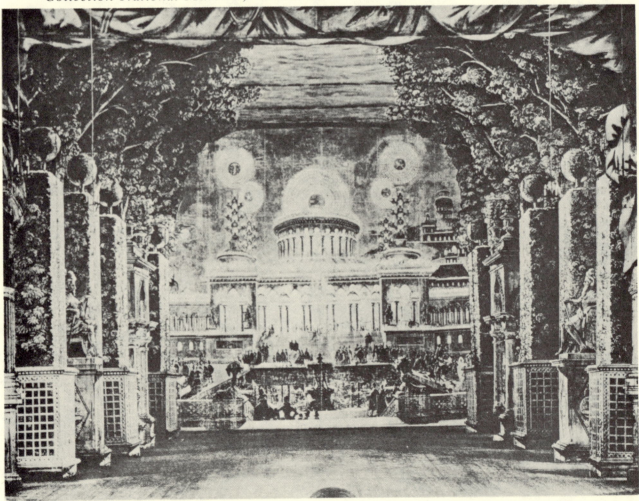

The Setting in the Drottningholm Theatre

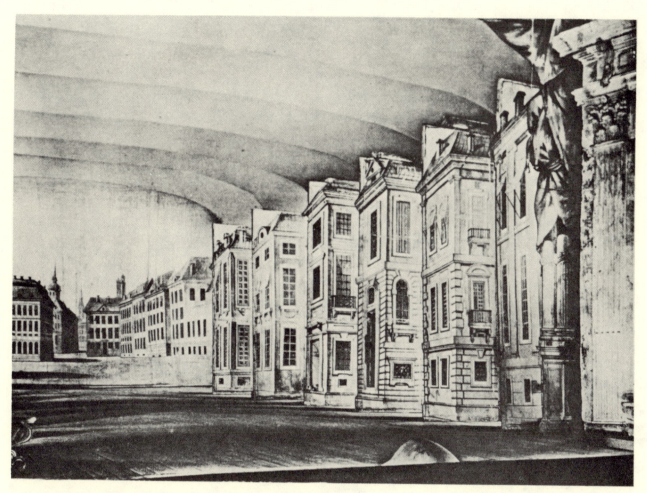

Setting of a Street Scene, Drottningholm Theatre

Ludwig Sievert. *The Broad Highway,* 1933 *Courtesy, Museum of Modern Art, N. Y.*

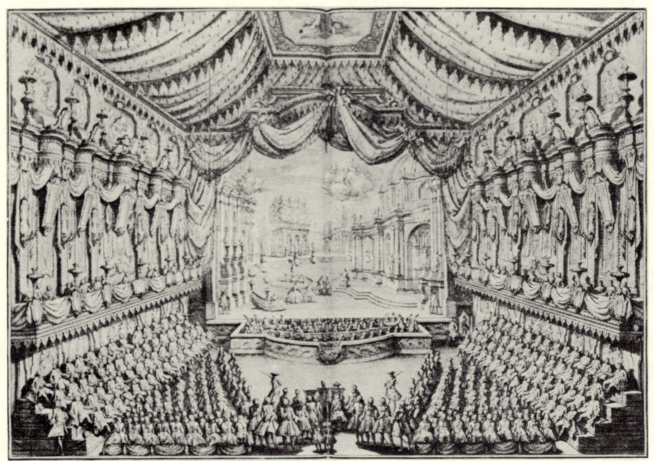

Vincenzo Ré, Royal Theatre, Naples, 1749

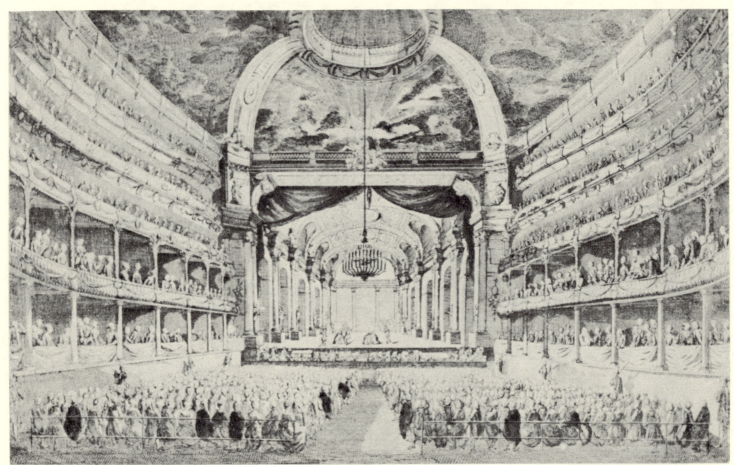

Theatre at Verona, 1775

Giuseppe Galli Bibiena, Stage Settings, Munich, 1740 *Courtesy, Metropolitan Museum of Art*

75

Vigarani, Drawing for a Setting, Paris, 1660
National Museum, Stockholm

Courtesy, Museum of Modern Art, N. Y.

76 Giuseppe Galli Bibiena, Design for an Opera, 1719

Courtesy, Metropolitan Museum of Art

Bérain, Design for *Armide*, Paris, 1680
National Museum, Stockholm

Carlo (?) Galli Bibiena, Stage Setting, Munich, 1774

Setting, Drottningholm Theatre

Prison Setting, Drottningholm Theatre

Galliari, Design for a Setting, ca. 1775
National Museum, Stockholm

Vincenzo, Ré, Drawing for a Prison Setting, 1750
National Museum, Stockholm

Unit Setting, Hôtel de Bourgogne, Paris, 1630

Lutze, Unit Setting, *Bread*, Leningrad, 1930

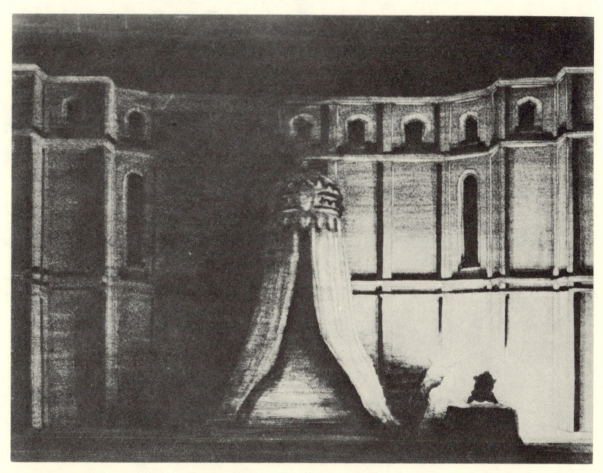

Othello, Desdemona's Bedroom

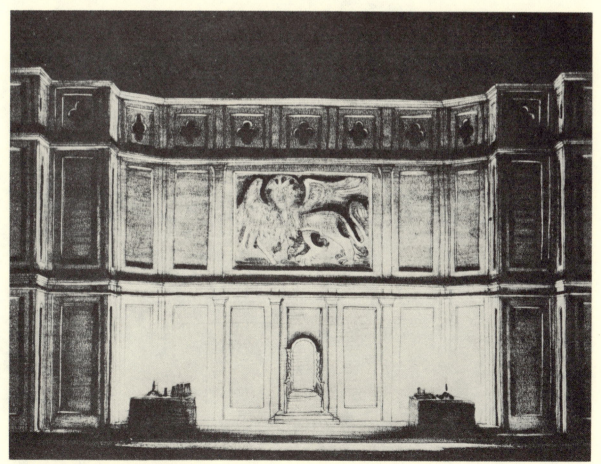

Othello, Council Chamber
Robert Edmond Jones, Unit Setting, 1933

la ferme d'architecture est
pour le palais
et la ferme de paysage est pour un Jardin
et le village pour des Pastorales serieuses

la ferme d'architecture est
pour le palais
et la ferme de paysage est pour un Jardin
et le village pour des Pastorales serieuses

Bérain, Design for Unit Setting, 18th century
National Museum, Stockholm

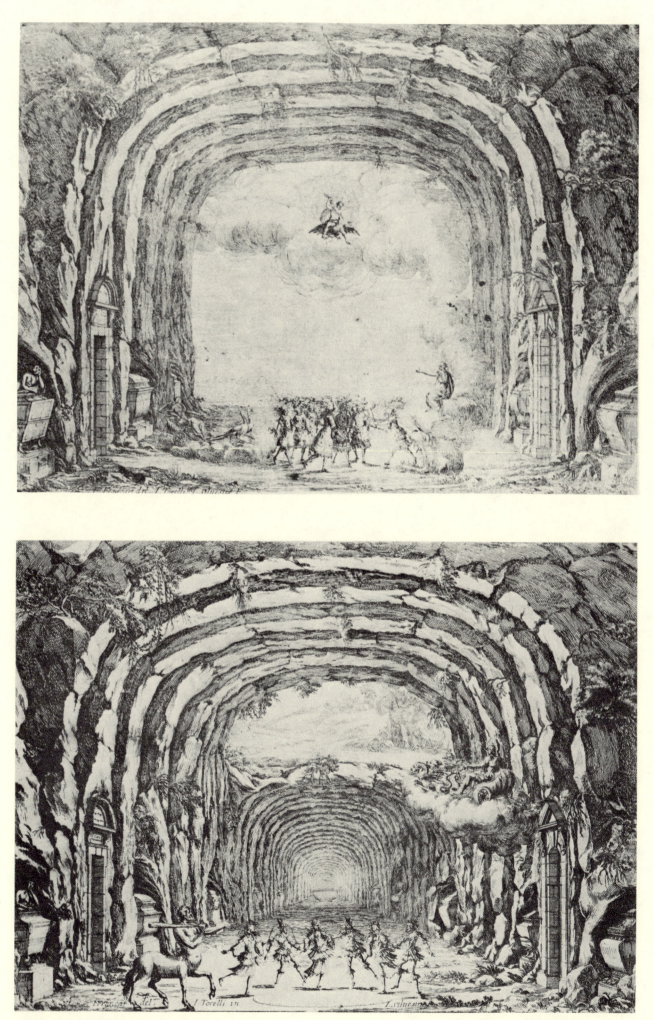

Torelli, Unit Setting, 1654
 For *Les Noces de Pélée et Thétis*
Collection George Chaffee

83

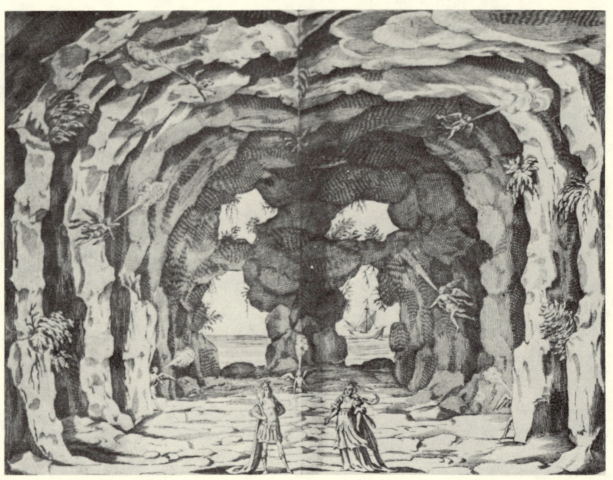

Torelli, Setting for *Bellero Fonte*, 1642
Bibliothèque Nationale, Paris

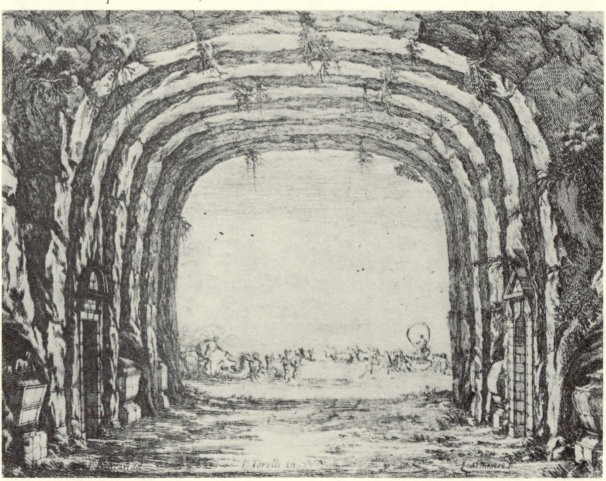

Torelli, Grotto
Collection George Chaffee

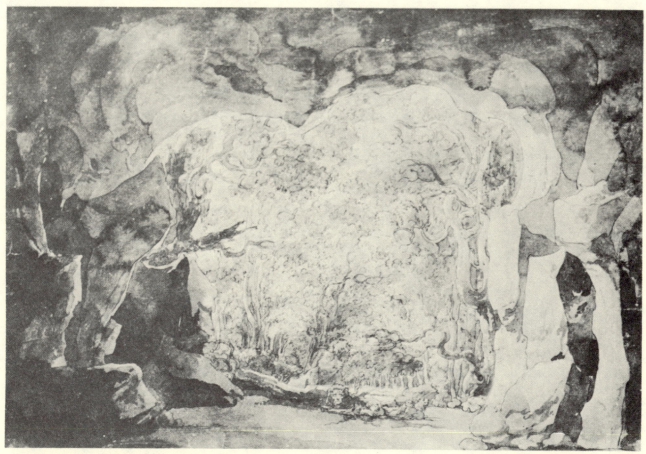

Despréz, Drawing for Landscape Setting, 1799
National Museum, Stockholm

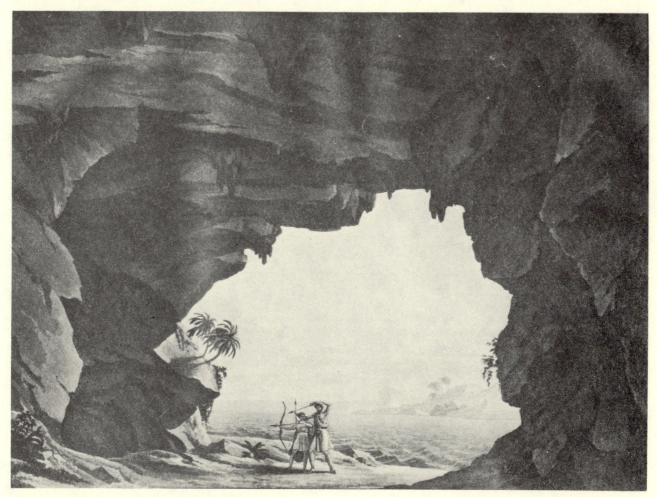

Sanquirico
Design for an Opera Setting, ca. 1820

85

Serlio, Satyric or Landscape Setting, 1545

Design for a Landscape Setting, France, 1680

86

Landscape Setting, Drottningholm Theatre

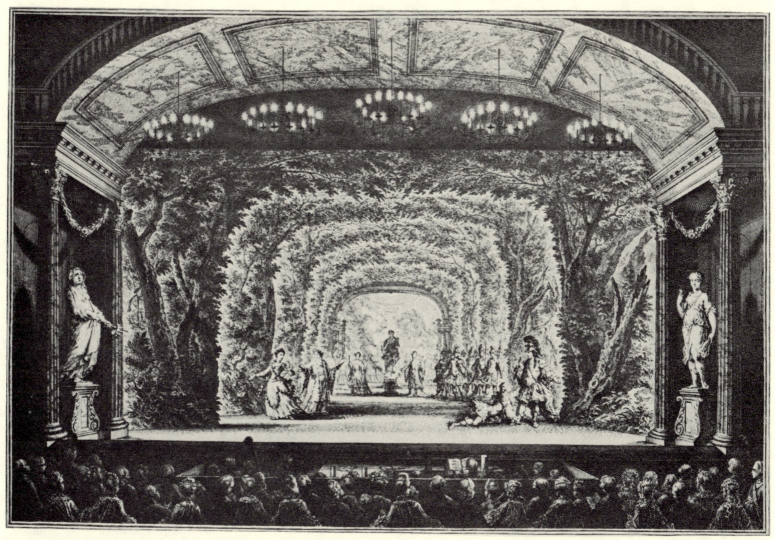

Setting, Amsterdam, ca. 1770
Harvard Theatre Collection

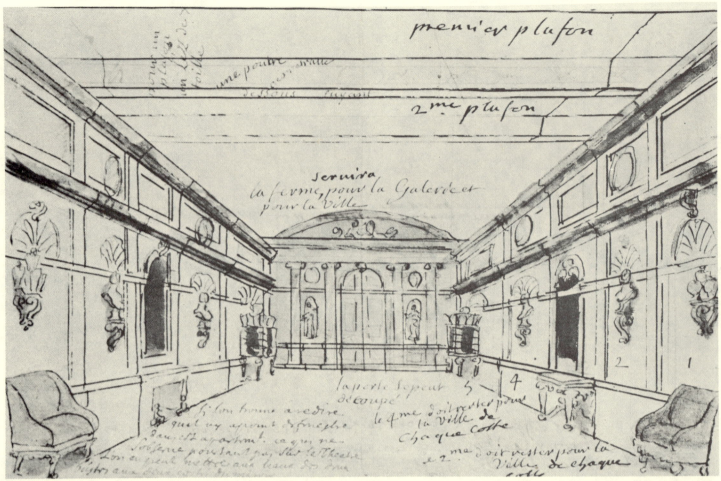

Courtesy, Museum of Modern Art, N.Y.

Bérain, Design for an Interior
National Museum, Stockholm

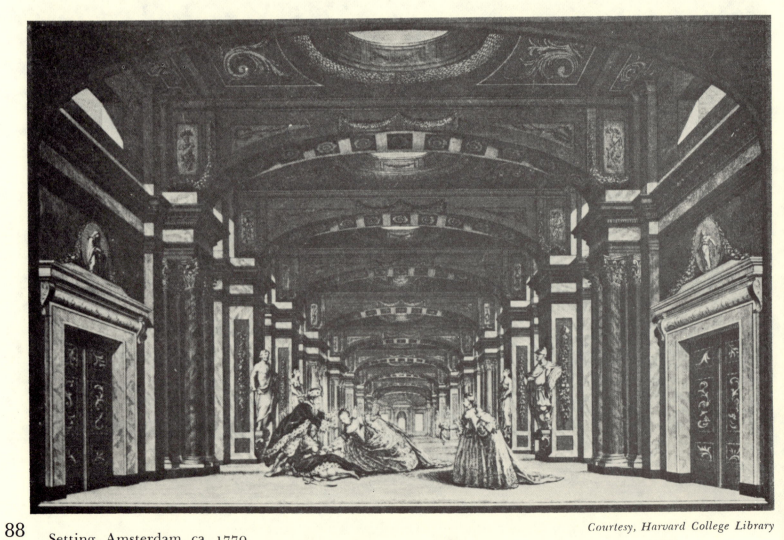

Setting, Amsterdam, ca. 1770
Harvard Theatre Collection

Courtesy, Harvard College Library

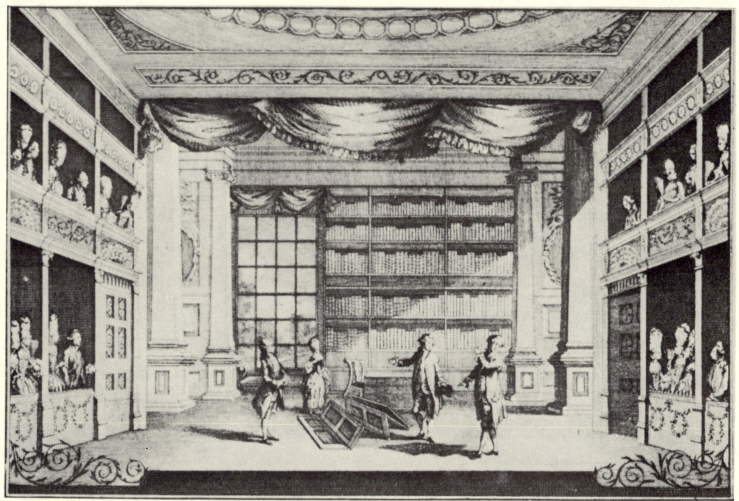

Setting for *The School for Scandal*, 1778

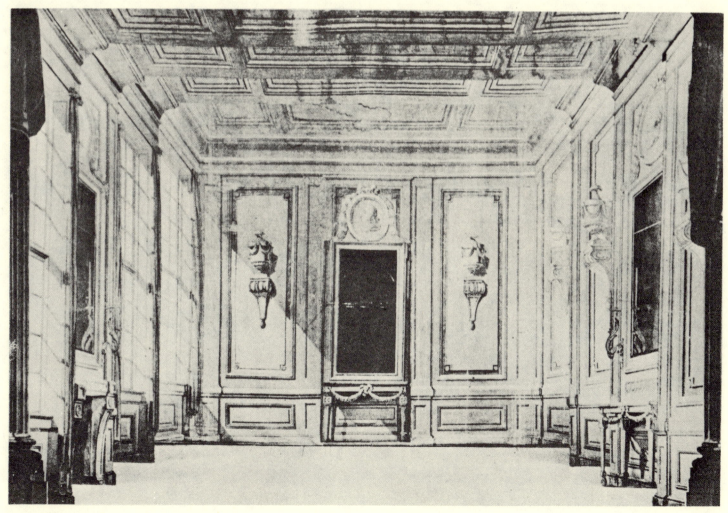

Setting, Drottningholm Theatre

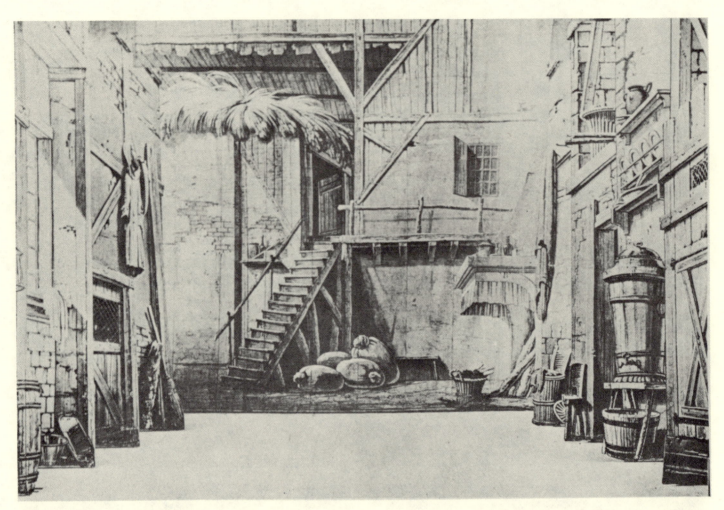

Setting, Drottningholm Theatre

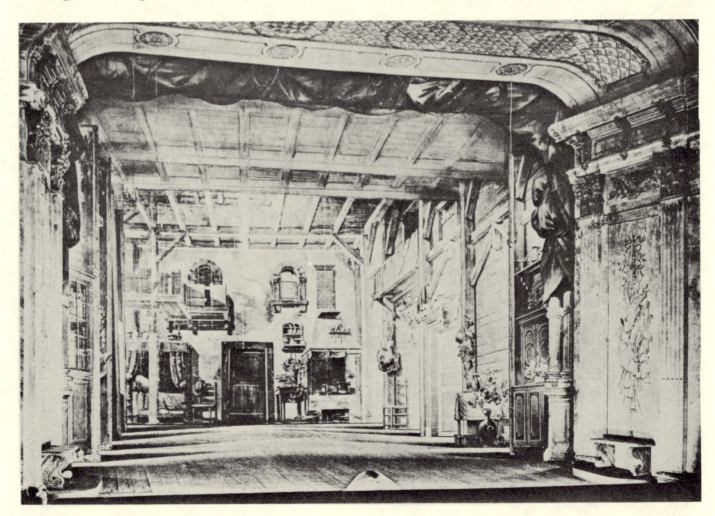

Setting, Drottningholm Theatre

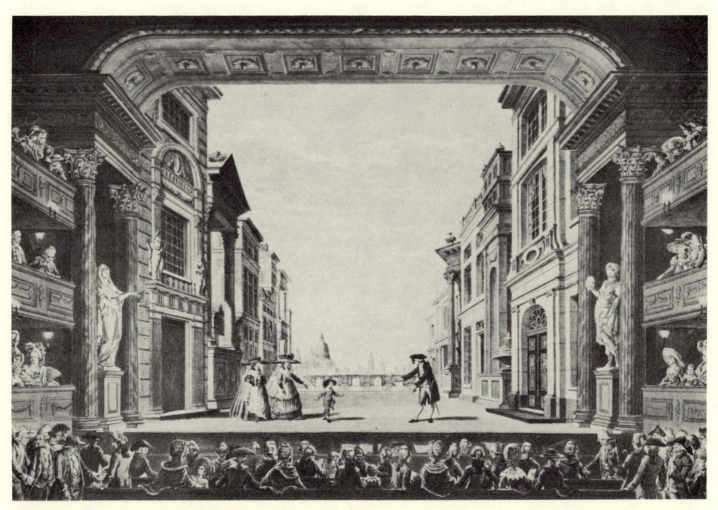

London Street, Amsterdam Theatre, 1774

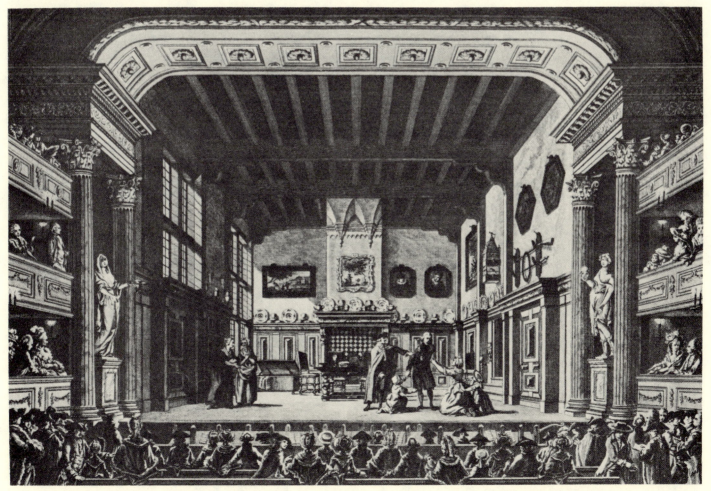

Dutch Interior, Amsterdam Theatre, 1774
Harvard Theatre Collection

91

S. Von Trapp, Setting for *Aïda* (Verdi)

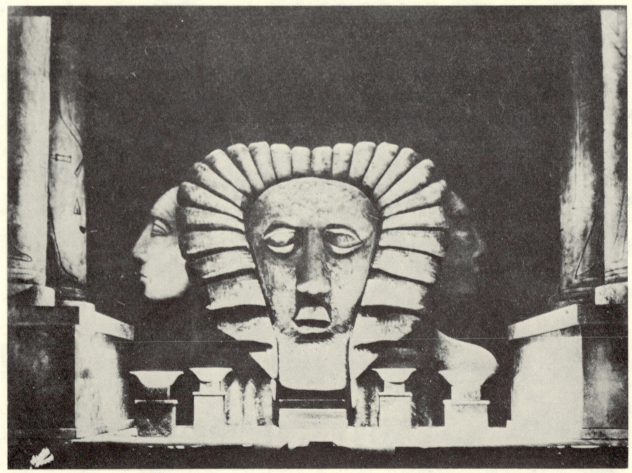

S. Von Trapp, Setting for *Aïda* (Verdi)

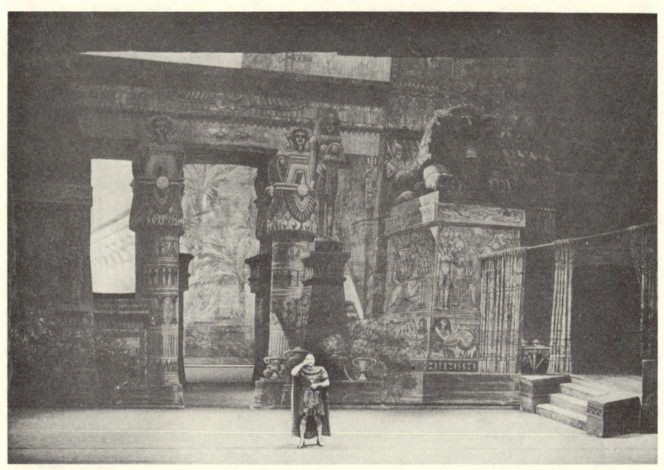

Setting for *Aïda*, Metropolitan Opera, N. Y.

Photo Louis Melançon

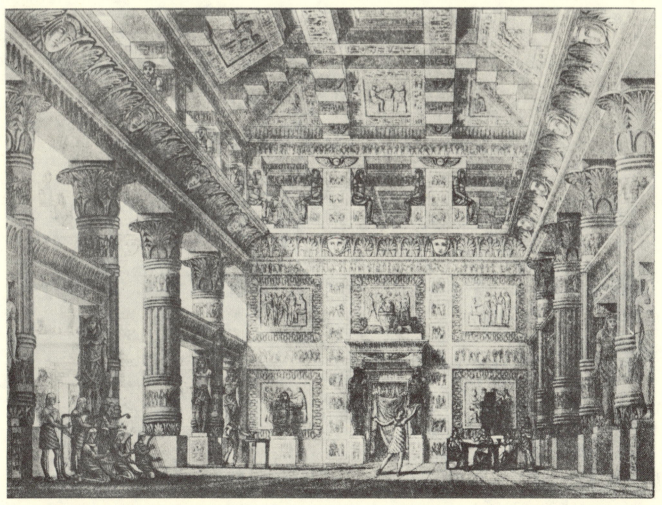

Sanquirico, Egyptian Temple, ca. 1820

Courtesy, Metropolitan Museum of Art

93

Duke of Saxe-Meiningen. Four Studies for the Prologue
of Schiller's *Jungfrau von Orleans*

Duke of Saxe-Meiningen, Studies for Act V, Schiller's *Fiesko*

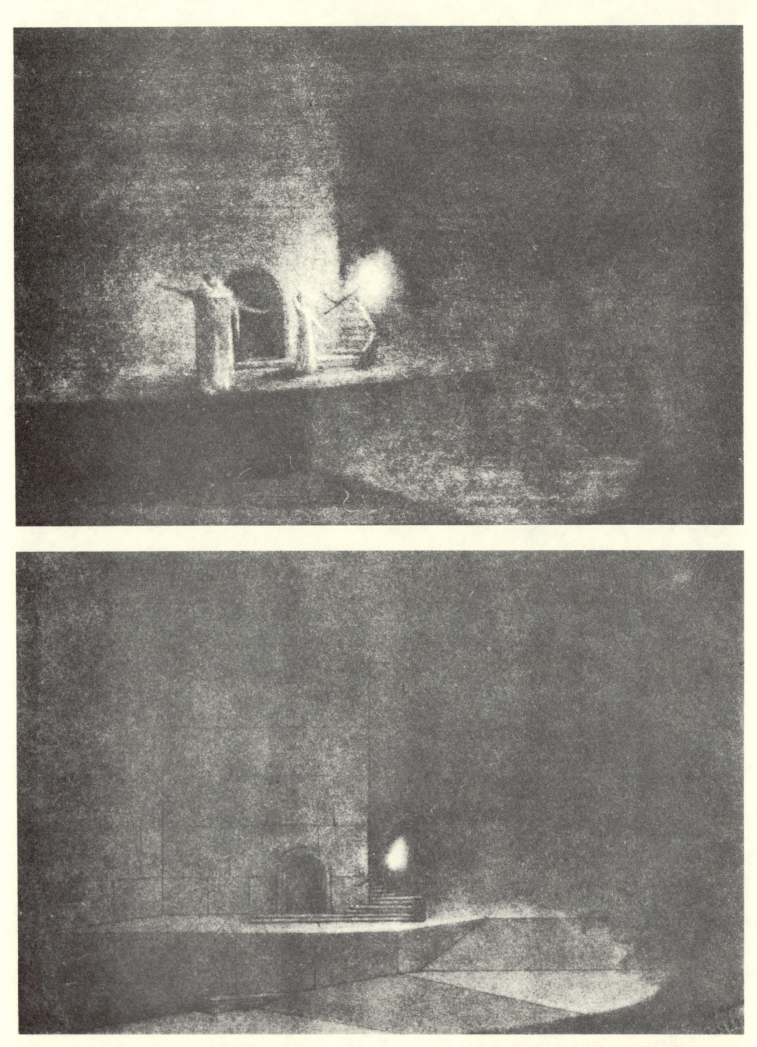

Adolphe Appia, Four Studies

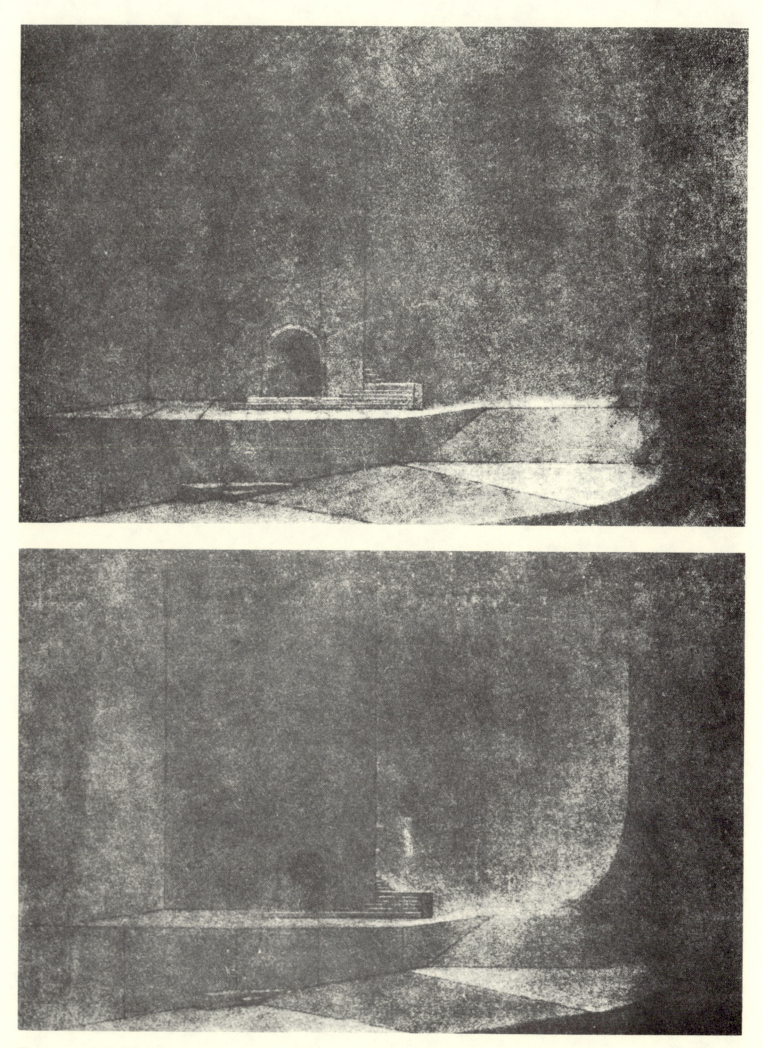

for *Tristan and Isolde*, Act II

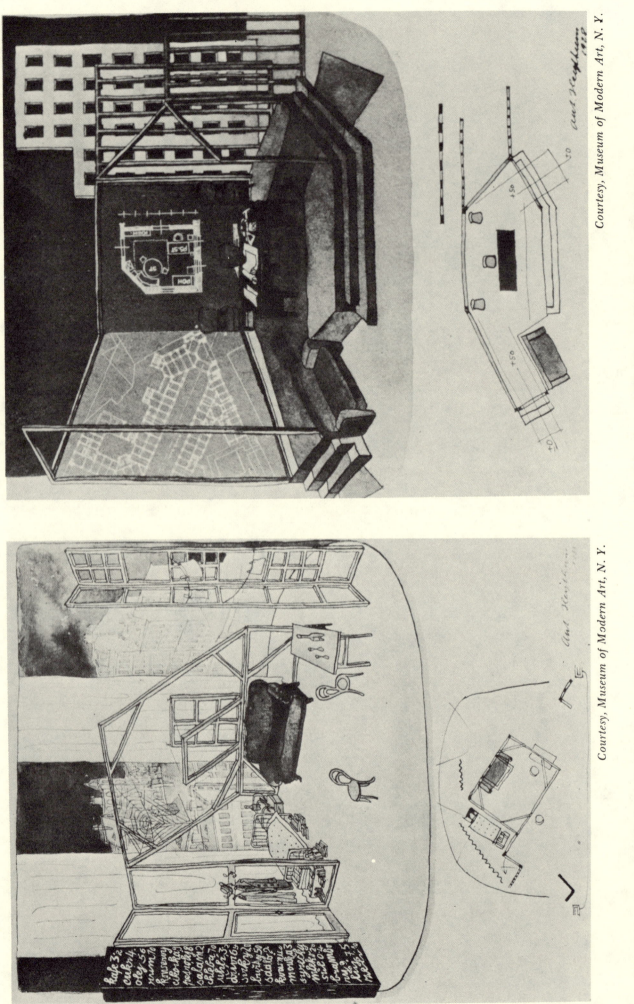

Courtesy, Museum of Modern Art, N. Y.

A. Heythum, *The Great God Brown*, Prague, 1928

Courtesy, Museum of Modern Art, N. Y.

A. Heythum, Drawing for *Aladdin*, Prague, 1933

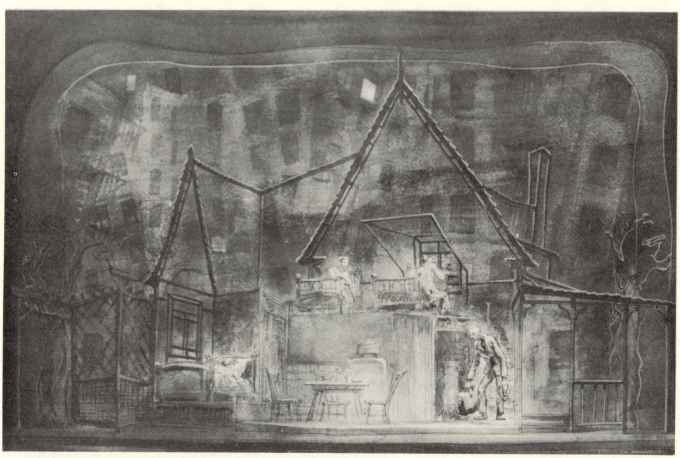

Jo Mielziner, Drawing for *Death of a Salesman*, 1949

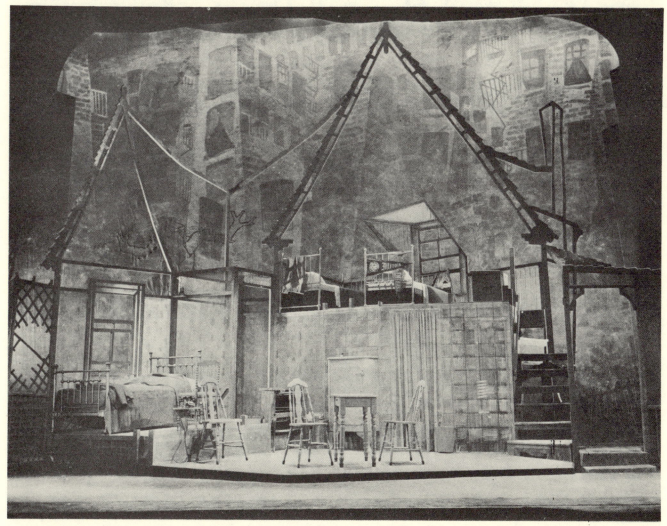

Jo Mielziner, The Setting as Lighted

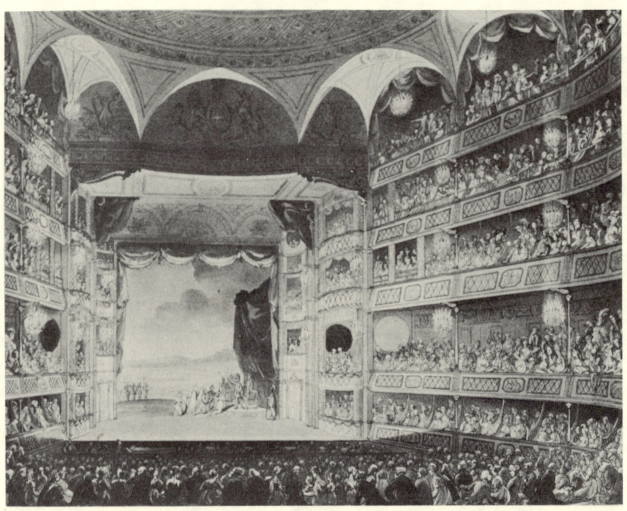

Drury Lane Theatre, 1808

Courtesy, Metropolitan Museum of Art

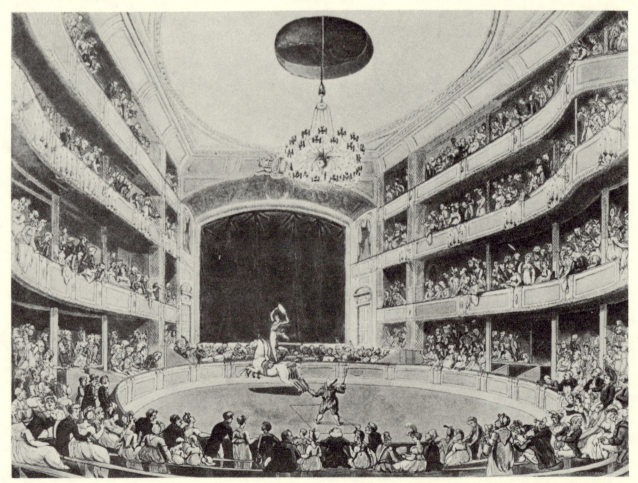

Astley's Amphitheatre

Courtesy, Metropolitan Museum of Art

100

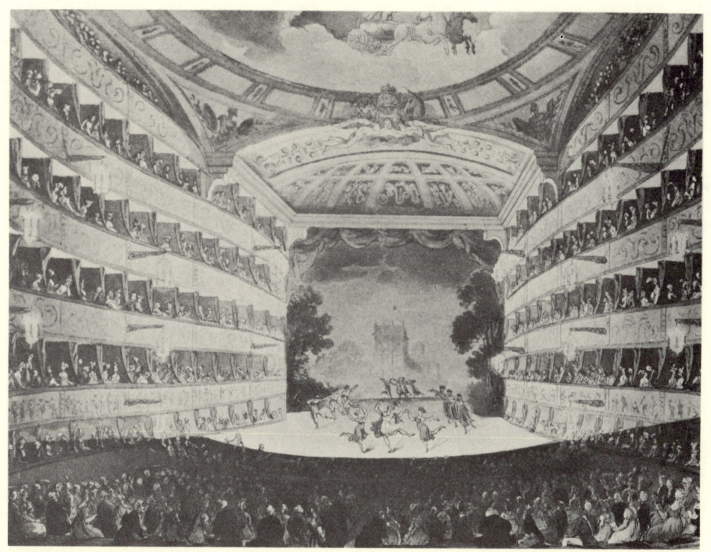

Opera House, London, 1809

Courtesy, Metropolitan Museum of Art

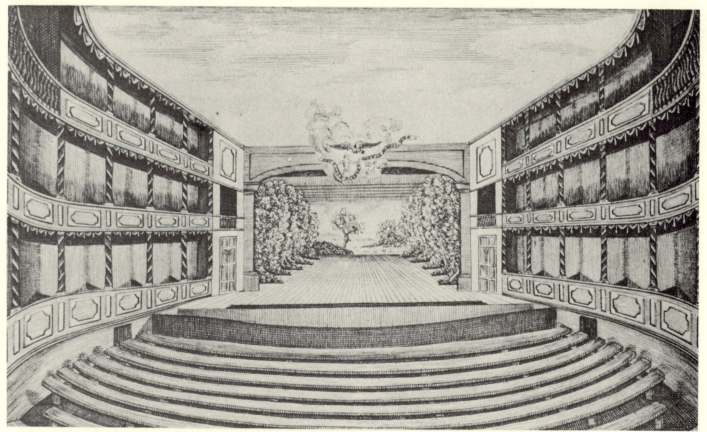

New Theatre, Philadelphia, 1794

Courtesy, Cooper Union Museum

101

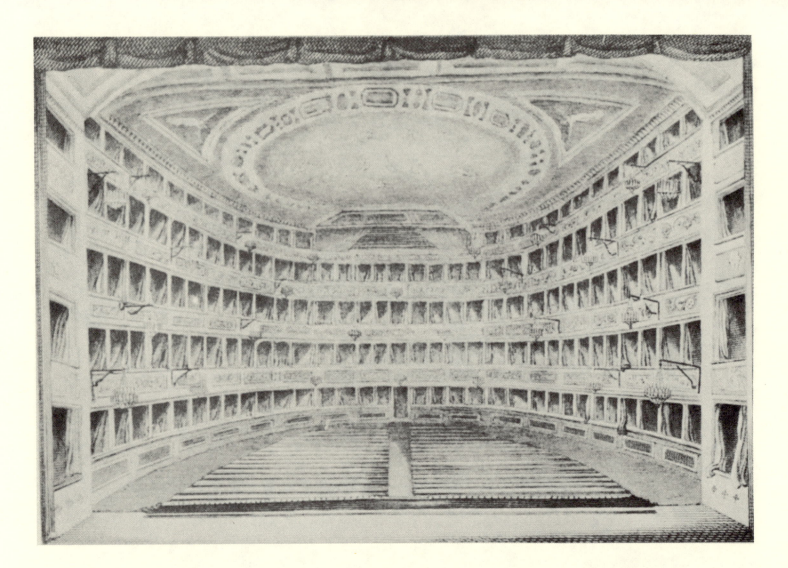

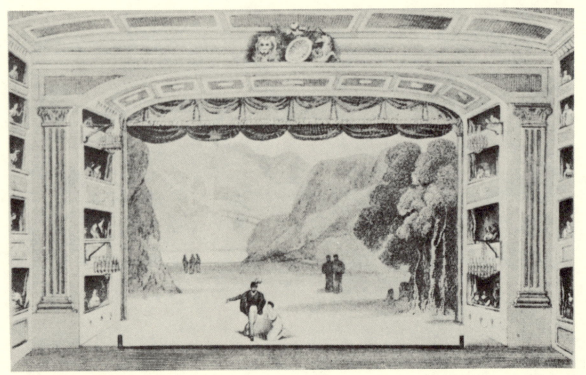

Pantheon Theatre, London, 1815

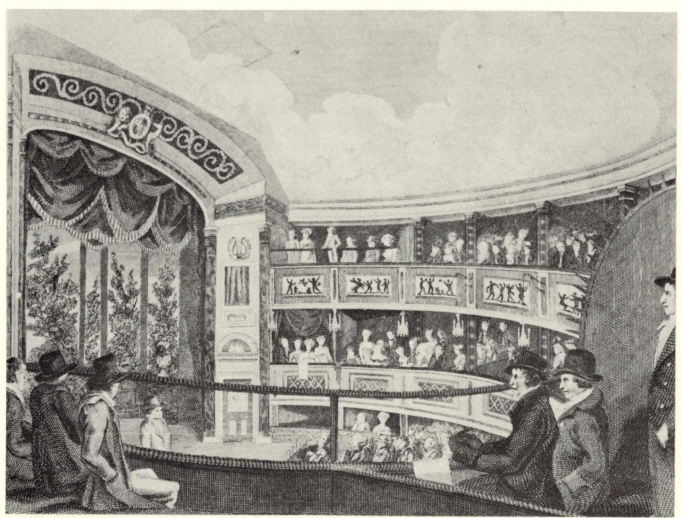

Olympic Theatre, London

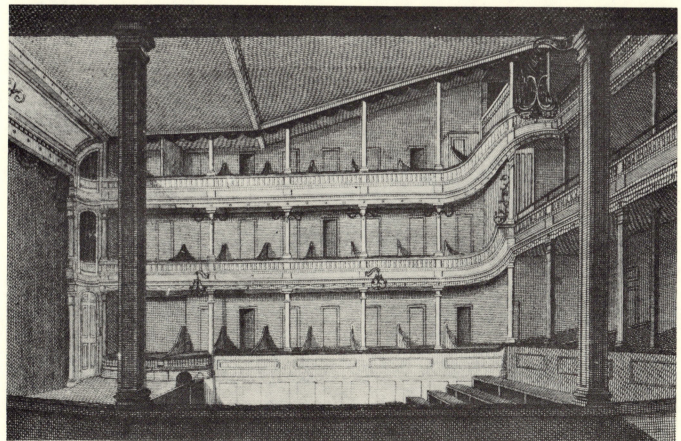

Haymarket Theatre, London, 1807

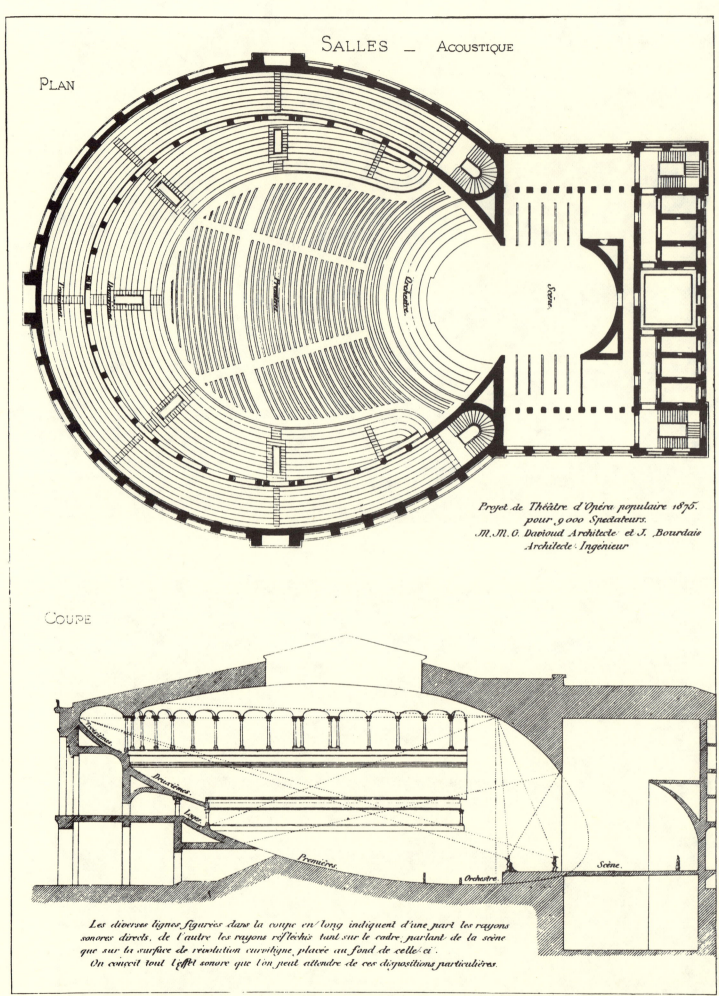

SALLES — ACOUSTIQUE

PLAN

COUPE

Projet de Théâtre d'Opéra populaire 1875.
pour 9000 Spectateurs.
M.M.G. Davioud Architecte et J. Bourdais
Architecte-Ingénieur

Les diverses lignes figurées dans la coupe en long indiquent d'une part les rayons
sonores directs, de l'autre les rayons réfléchis tant sur le cadre parlant de la scène
que sur la surface de révolution curviligne placée au fond de celle-ci.
On conçoit tout l'effet sonore que l'on peut attendre de ces dispositions particulières.

Project for an Arena Theatre
Paris, 1875, with 9000 seats

Courtesy, Metropolitan Museum of Art

104

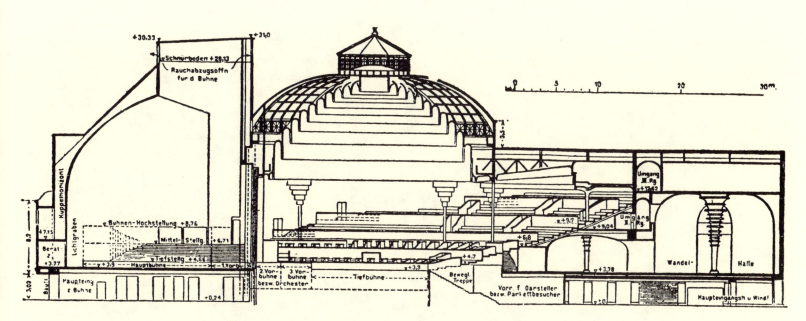

M 1 : 500

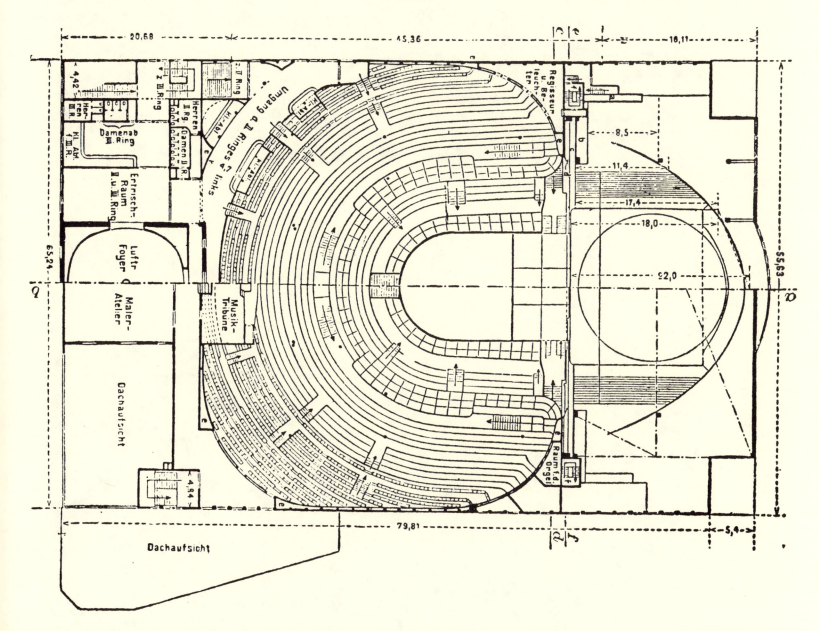

Reinhardt's Arena Theatre, Hans Poelzig, Architect
ca. 5000 seats, Berlin, 1910

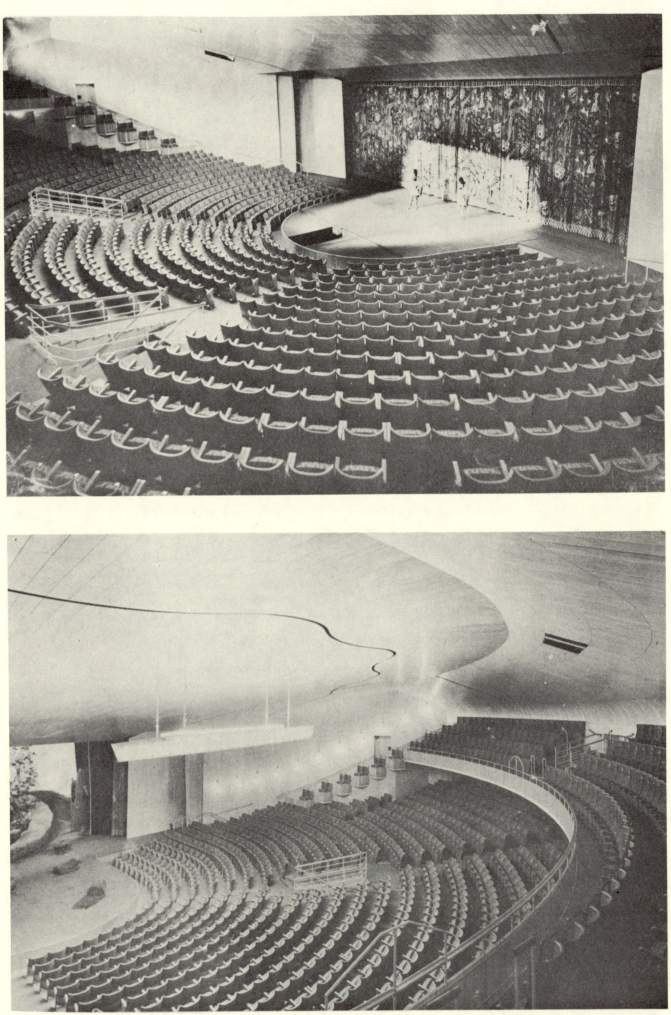

Municipal Theatre at Malmö, Sweden, 1944

Courtesy, American-Swedish News Exchange

106

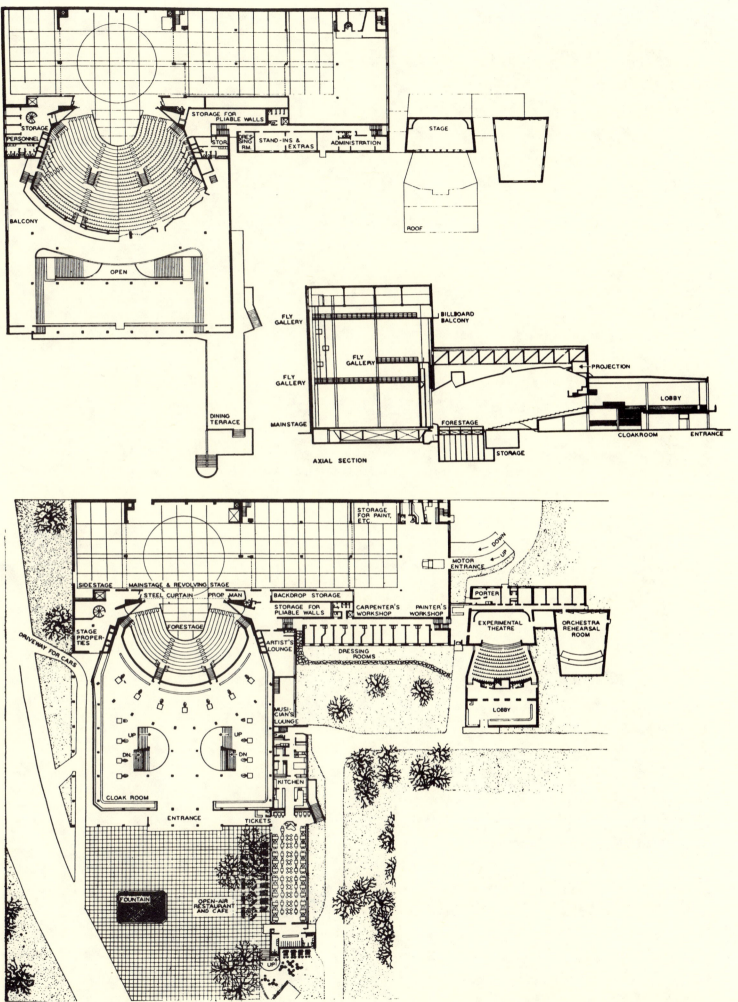

Plan and Cross Section, Malmö Theatre

Courtesy, The Architectural Forum

107

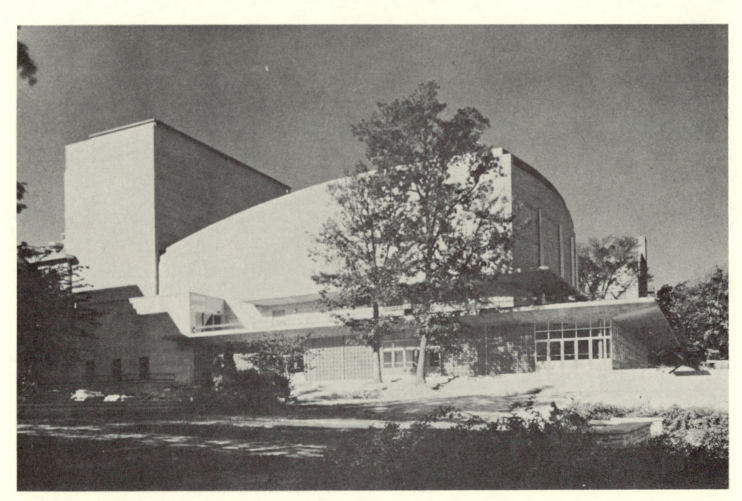

University of Wisconsin Theatre, 1939

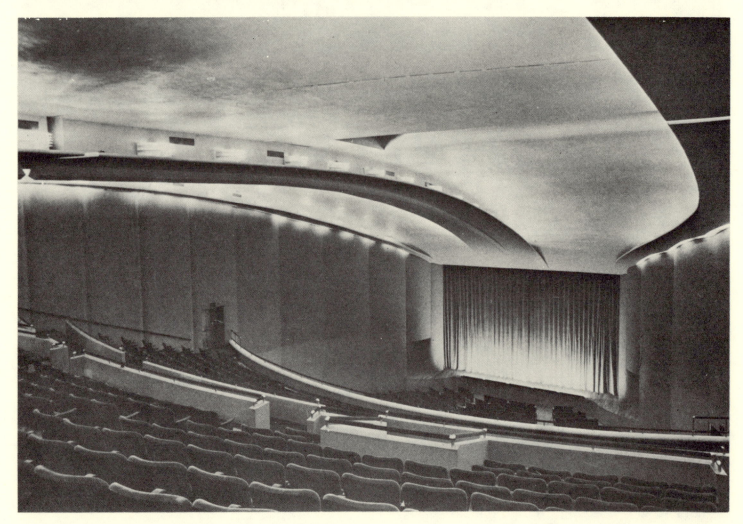

Interior Main Auditorium

Promenade

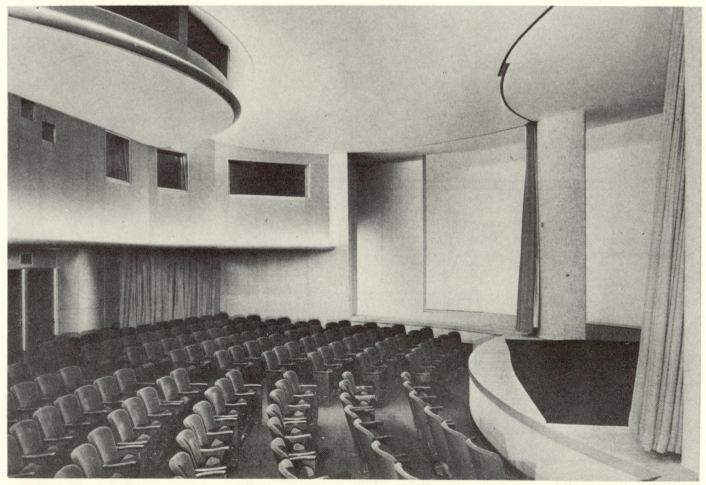

Laboratory Theatre
 Michael M. Hare, Corbett and McMurray, Architects
 Lee Simonson, Theatre Consultant

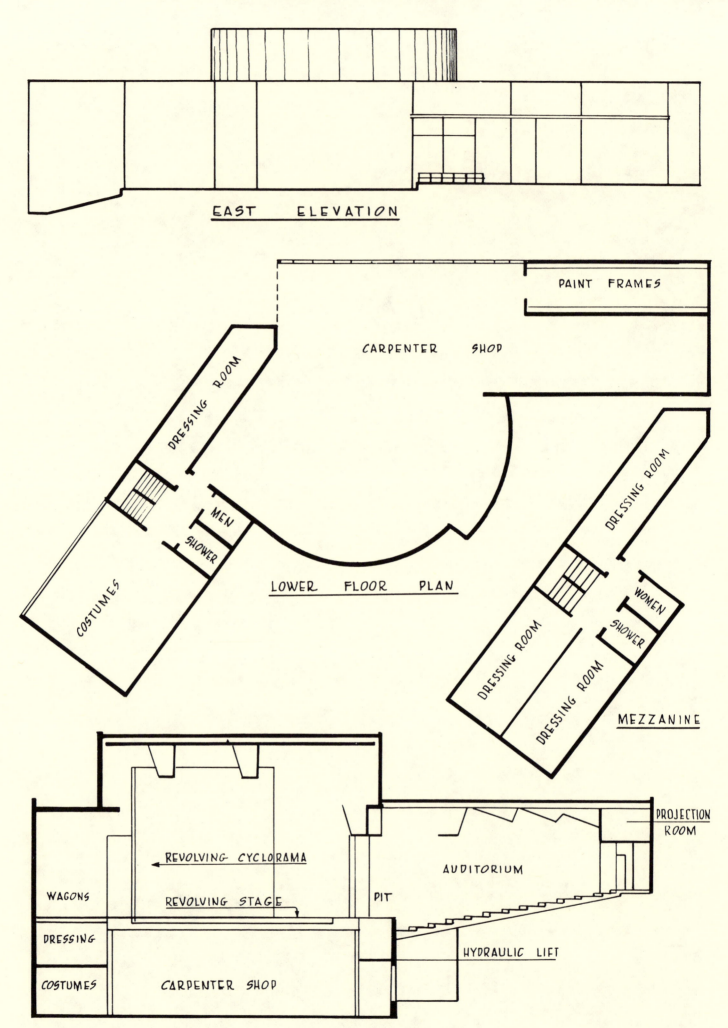

EAST ELEVATION

PAINT FRAMES

CARPENTER SHOP

DRESSING ROOM

DRESSING ROOM

MEN

SHOWER

COSTUMES

LOWER FLOOR PLAN

DRESSING ROOM

DRESSING ROOM

WOMEN

SHOWER

MEZZANINE

REVOLVING CYCLORAMA

REVOLVING STAGE

WAGONS

DRESSING

COSTUMES

CARPENTER SHOP

PIT

AUDITORIUM

PROJECTION ROOM

HYDRAULIC LIFT

Plans for Theatre at the University of Washington, Seattle, 1949

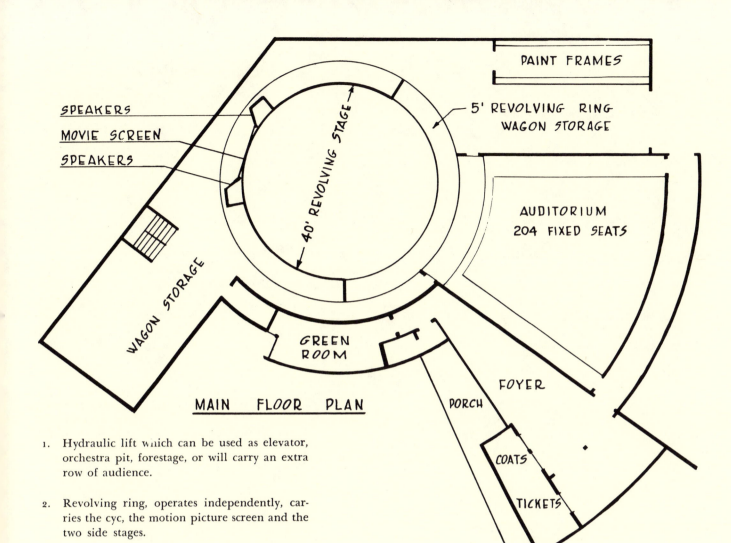

SPEAKERS
MOVIE SCREEN
SPEAKERS

PAINT FRAMES

40' REVOLVING STAGE

5' REVOLVING RING
WAGON STORAGE

WAGON STORAGE

AUDITORIUM
204 FIXED SEATS

GREEN
ROOM

FOYER

PORCH

COATS

TICKETS

MAIN FLOOR PLAN

1. Hydraulic lift which can be used as elevator, orchestra pit, forestage, or will carry an extra row of audience.

2. Revolving ring, operates independently, carries the cyc, the motion picture screen and the two side stages.

3. Side stage
3a. Side stage { When used in conjunction with the forestage, will allow a set of 11 feet depth. The two proscenium doors and balconies are available if needed.

4. First lighting bridge

5. Second lighting bridge.

5a. Connecting bridge for cyc lighting.

6. Bridge for light and sound control . . . same elevation as first light bridge.

7. Stair and platform connecting control panel with 2nd light bridge.

8. Light beam, entered thru wall from wagon storage #12.

9. Plaster cyclorama.

11. Revolving stage 40 feet diameter.

12. Wagon storage.

13. Wagon storage.

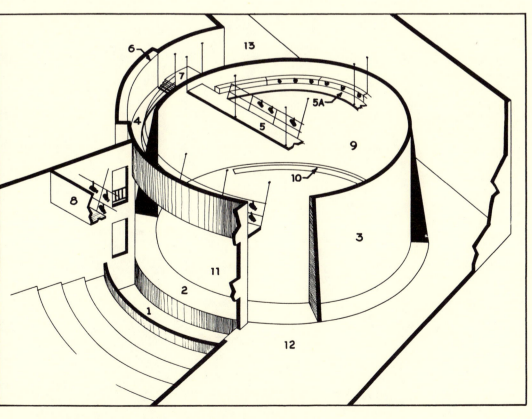

Chiarelli and Kirk, Architects, John Conroy, Theatre Consultant

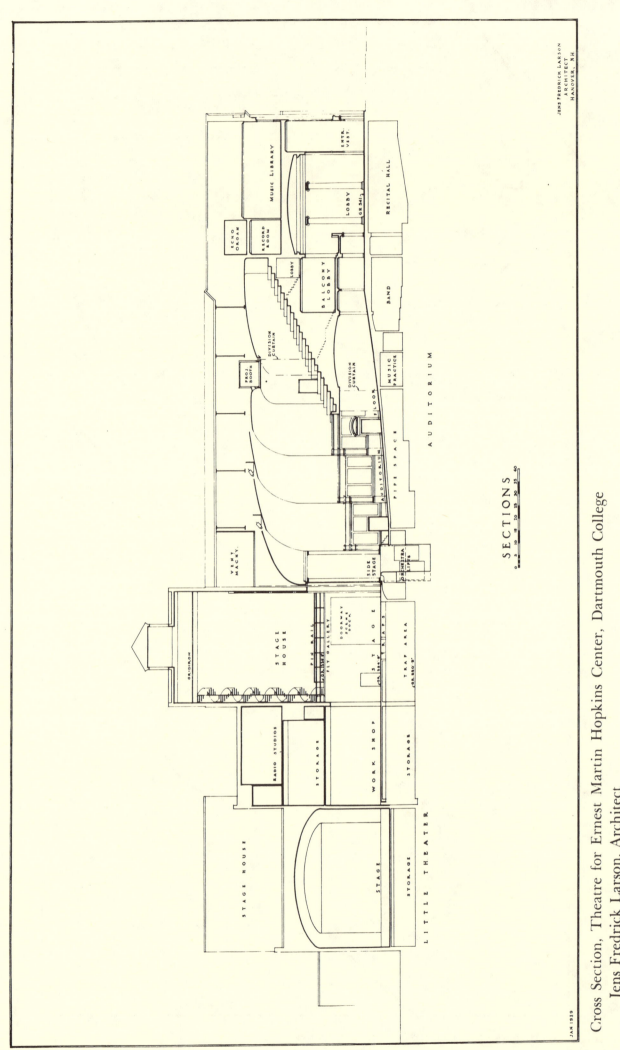

Cross Section, Theatre for Ernest Martin Hopkins Center, Dartmouth College

Jens Fredrick Larson, Architect

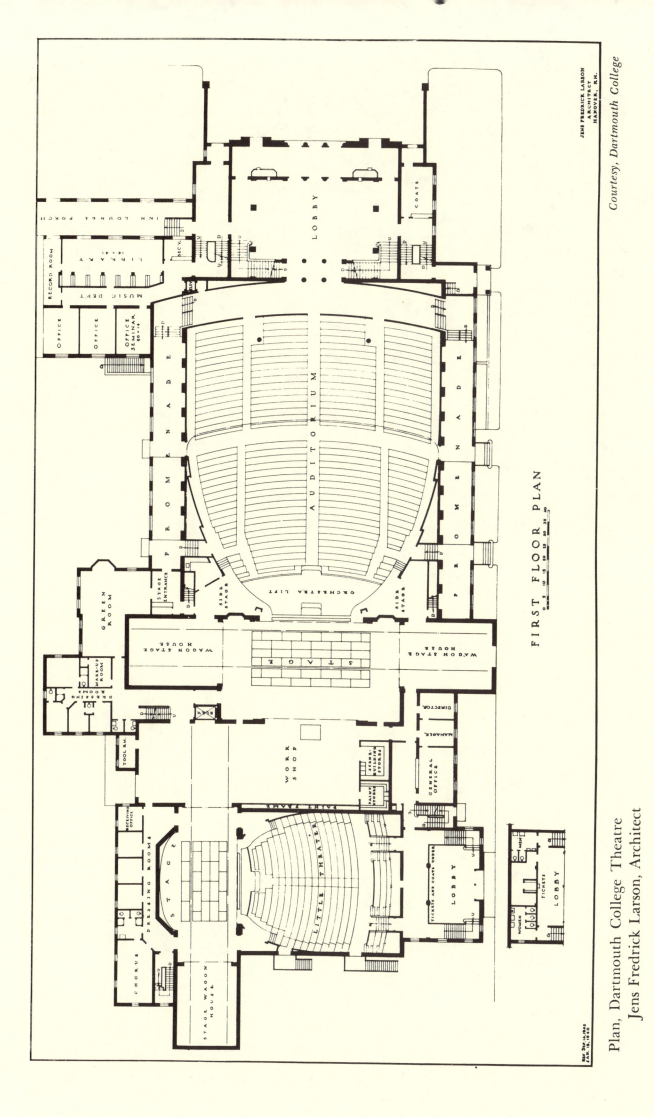

FIRST FLOOR PLAN

Plan, Dartmouth College Theatre
Jens Fredrick Larson, Architect

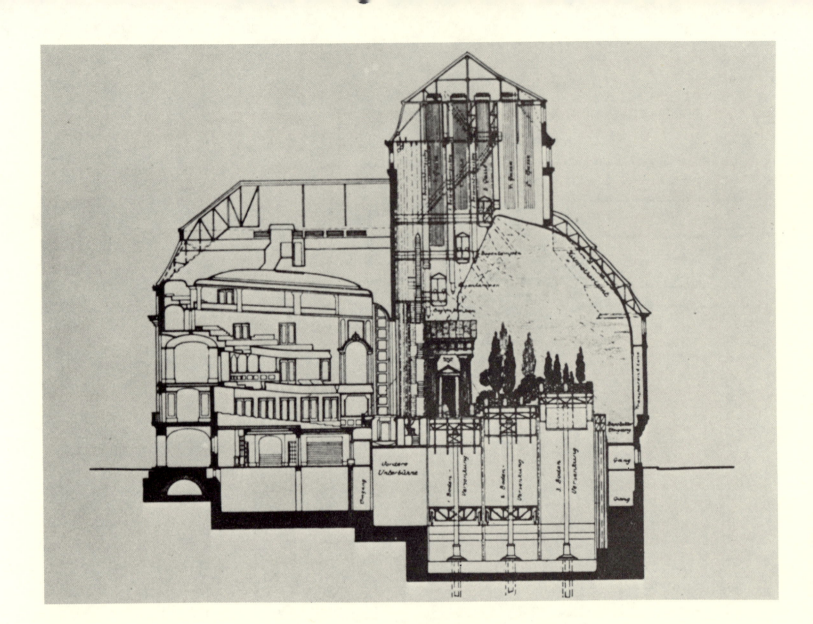

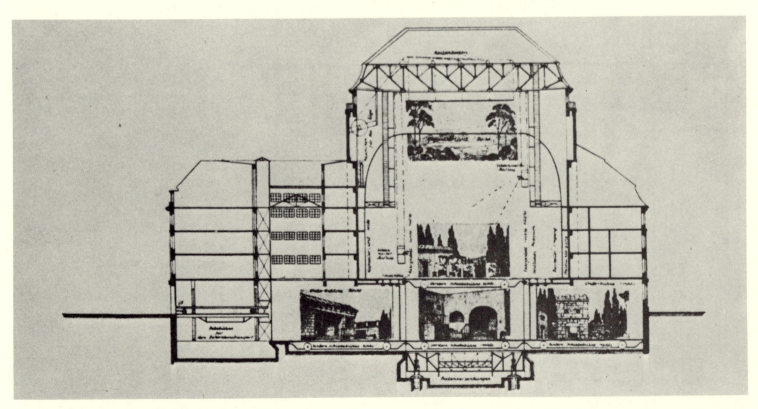

Elevator Wagon Stages
Dresden, State Theatre, 1918

114

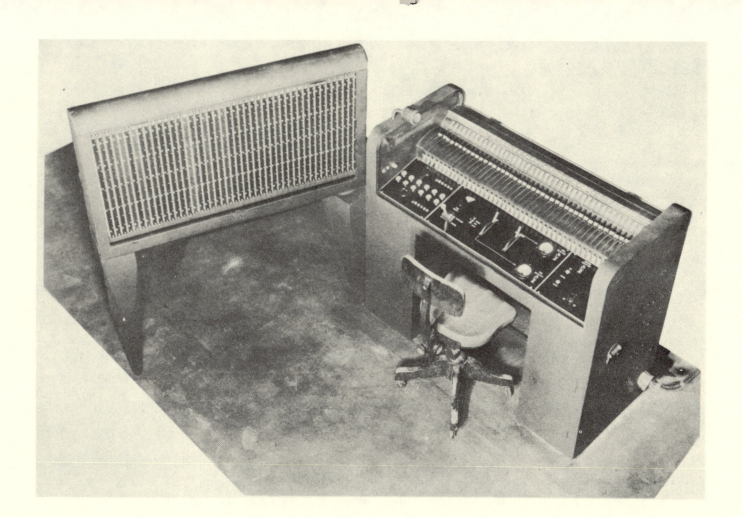

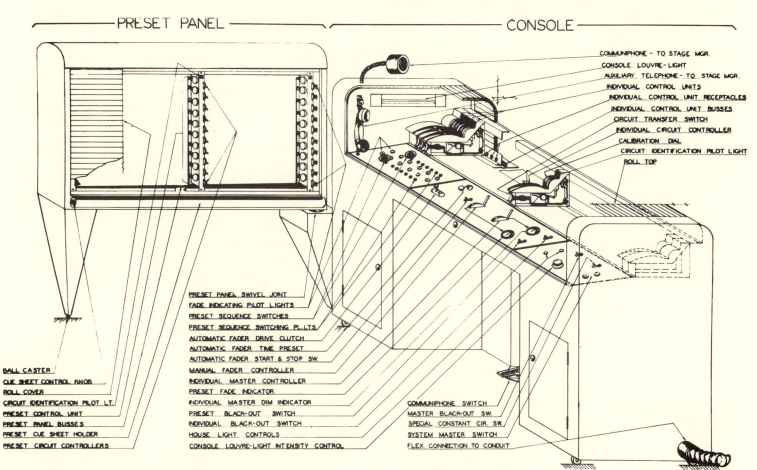

COMMUNIPHONE - TO STAGE MGR.
CONSOLE LOUVRE - LIGHT
AUXILIARY TELEPHONE - TO STAGE MGR.
INDIVIDUAL CONTROL UNITS
INDIVIDUAL CONTROL UNIT RECEPTACLES
INDIVIDUAL CONTROL UNIT BUSSES
CIRCUIT TRANSFER SWITCH
INDIVIDUAL CIRCUIT CONTROLLER
CALIBRATION DIAL
CIRCUIT IDENTIFICATION PILOT LIGHT
ROLL TOP

PRESET PANEL SWIVEL JOINT
FADE INDICATING PILOT LIGHTS
PRESET SEQUENCE SWITCHES
PRESET SEQUENCE SWITCHING PL.LTS.
AUTOMATIC FADER DRIVE CLUTCH
AUTOMATIC FADER TIME PRESET
AUTOMATIC FADER START & STOP SW.
MANUAL FADER CONTROLLER
INDIVIDUAL MASTER CONTROLLER
PRESET FADE INDICATOR
INDIVIDUAL MASTER DIM INDICATOR
PRESET BLACK-OUT SWITCH
INDIVIDUAL BLACK-OUT SWITCH
HOUSE LIGHT CONTROLS
CONSOLE LOUVRE-LIGHT INTENSITY CONTROL

BALL CASTER
CUE SHEET CONTROL KNOB
ROLL COVER
CIRCUIT IDENTIFICATION PILOT LT.
PRESET CONTROL UNIT
PRESET PANEL BUSSES
PRESET CUE SHEET HOLDER
PRESET CIRCUIT CONTROLLERS

COMMUNIPHONE SWITCH
MASTER BLACK-OUT SW.
SPECIAL CONSTANT CIR. SW.
SYSTEM MASTER SWITCH
FLEX. CONNECTION TO CONDUIT

Electronic Dimmer Control Board
 George C. Izenour, Designer and Engineer

TWENTY PRODUCTIONS
DESIGNED BY THE AUTHOR
1919-1948

I HAVE already discussed *Liliom* and the poetic implications that can be conveyed by essentially realistic settings. Most of the other productions illustrated in this section are based on some method of simplification, or stylization, or use of one form or another of a unit setting. But in each I utilized all the resources of dramatic lighting. Although the general effect of a setting may have been formal or decorative, the lighting was never flat.

In *The Faithful*, the change of scene from indoors to outdoors was made simply by setting six-fold screens across the opening of the palace interior. The decorative conventions of Japanese landscape painting fitted appropriately into the scheme.

The simplest scheme, suggested by the director, Feodor Kamisarjevsky, was the one used in *The Tidings Brought to Mary*, consisting simply of two inner prosceniums in the shape of gothic arches and a single-terraced platform. A single block form served in turn as a table, a roadside bench, and a bier. The gray tone of the platform had been lightly spattered with silver; under steel-blue light, in the roadside scene, it seemed lightly powdered with snow. The total design of the production depended largely on the successive movements and groupings of the actors. I made their costumes of felts and flannels by way of giving them a sculpturesque quality and made many of them brilliant in tone to suggest the richness in color of stained glass.

The tree of the Garden of Eden in *Back to Methuselah* was projected from the rear—the first time, I believe, that projected scenery was used in this country on a fairly large scale.

In *Peer Gynt*, two sets of stylized rocks were used in reversed positions. Backed by the jagged opening of a cut-out drop they became the cave of the Troll King. The trees of the wedding scene were suggested by cast leaf shadows. The Egyptian scenes in the desert were projected by a lantern.

For *As You Like It*, I used revolving prisms, periaktoi, at each side. A curtain painted like a large tapestry backed the palace scene. When raised, it revealed the dais of the Duke, and his court assembled for the wrestling match. The Forest of Arden was made of trees that were almost silhouettes, but modeled in low relief and touched with gold, in order to catch glints of side lighting. A translucent curtain at the rear, painted in silhouette, suggested the green light and shade of a forest.

The settings for *Juarez* and *Maximilian*, although realistic in detail, were, in structure, enlarged screens for the interior scenes. No ceilings were used. Because I was unable to get back from Paris (where I had designed the show) in time for the opening, I filled my working drawings with more details and printed instructions than is usual. But the placing of furniture and the details of draperies are also an essential part of a design. I would have given many of these instructions verbally to the constructing carpenter or the property maker, had I been on the spot. The only way a designer can be sure that his sets on the stage

will correspond to his conception is to give this amount of care and supervision to every detail. Super-intendence is a large and essential part of every designer's job.

The problem facing the Theatre Guild when it planned *Marco Millions, Faust,* and *Volpone* was how it could afford to do three such elaborate productions in succession. I helped to solve this by using the same unit frame throughout. Changing the inserts in its three openings made all the scene changes for *Marco.* Festooned with Baroque draperies and with another set of inserts, the unit successfully suggested Volpone's Venice. A sliding Gothic arch in the center panel made the city gate of *Faust,* the nave of a cathedral and, when lowered, the dungeon of the prison scene.

In *Man and the Masses,* the design of the production consisted almost wholly of the patterns made by groups of actors and the way they were lighted. The steps used were eighteen inches high. In the scene where the crowd cried for revolution, this height, as the actors took a single step up and at the same time raised their arms, gave the scene its climactic élan. In a later scene, when the revolution failed, the same basic structure, as the actors slid down into it and huddled below its rim, conveyed the mood of despair and defeat. In the dream scene, the clamoring hands were those of actors; but the lighting was arranged so that their bodies were blotted out and only their hands were visible.

In *Roar China,* for the scenes among the coolies on the dock, the sails of the sampans floating in the shallow tank formed an inner curtain almost concealing the warship. Then on cue, at a call of "Sampan," they parted, revealing the ship. This was seen first as a menacing, towering silhouette, then with its turret guns highlighted, and finally in its entirety. Here, as in all these productions, the light plot was an integral part of the design of the play.

I have discussed the use of translucent backdrops in connection with the Ring Cycle. The construction of the trees for the forest scene of *Siegfried* was changed after I had made the blueprints, although the plan of the setting remained the same. These trees were made of rough burlap, soaked in glue size, then twisted tightly lengthwise and allowed to dry. Once dry, these wrinkles became set enough to hold their shape and to suggest the crenelations of bark. A chain was then sewed into a flap at the base of each tree, and its top tacked to a semicircular strip of wood. When hung, the weight of the chains at the bottom held the trees taut. They were stacked, still tied, backstage, then attached to battens, and raised into place. In this way I was able to get the scale and height of massive trees in a primeval forest—each tree was thirty feet high—and at the same time keep them light enough to set and strike easily.

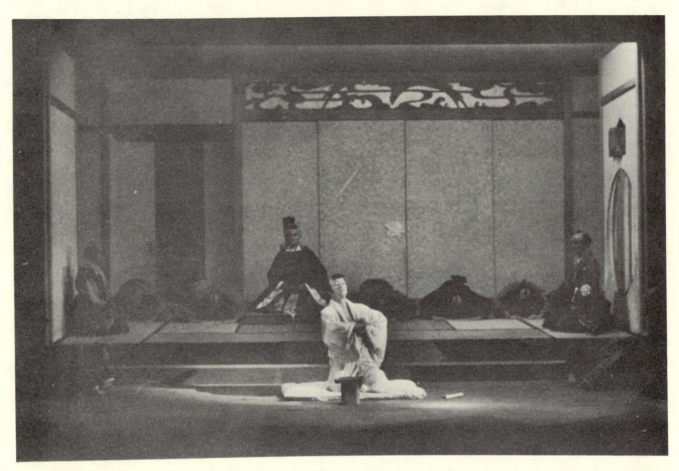

Death of the Hero

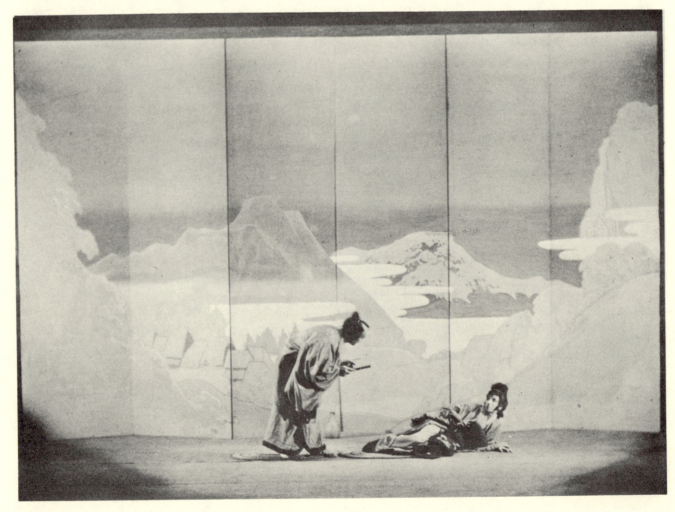

Hilltop

Four Settings for *The Faithful* by John Masefield, 1919

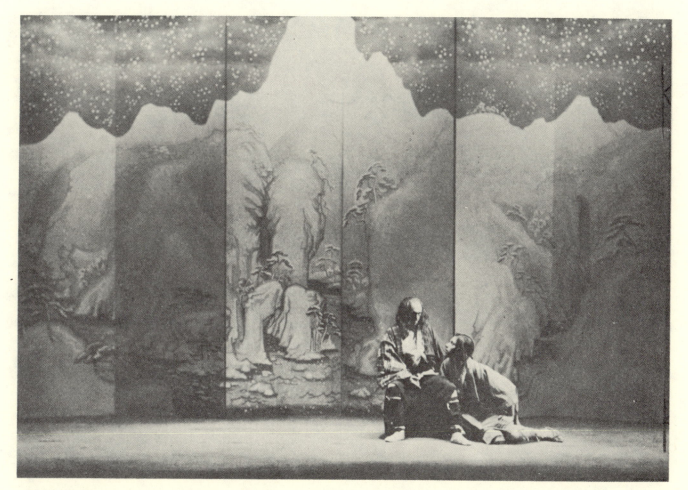

Snow Gorge

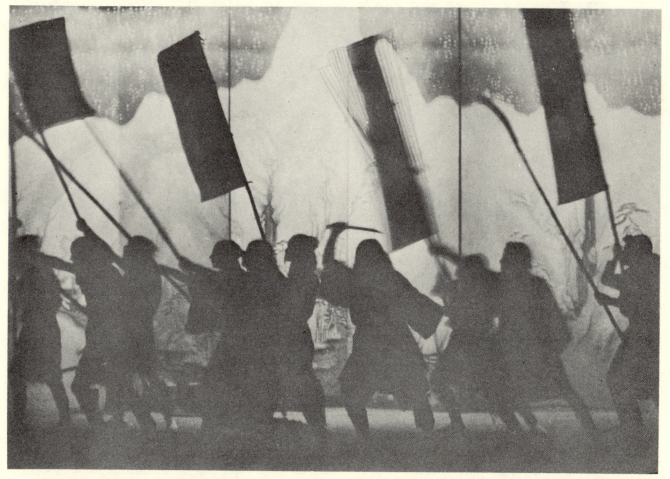

March of the Ronin

Photos Bruguière-Vandamm

Designed by Lee Simonson

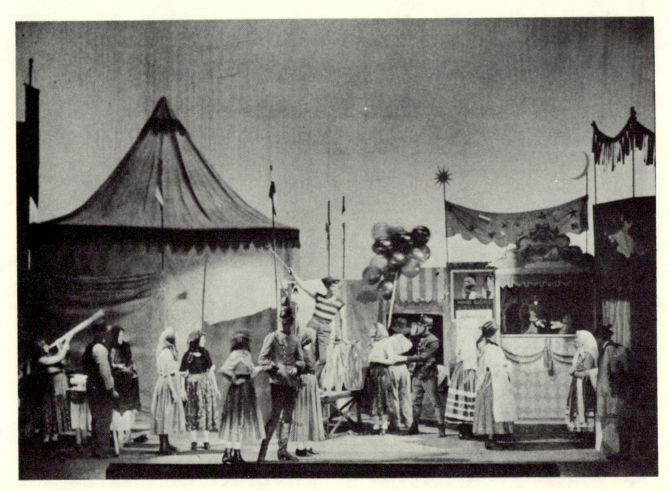

Amusement Park

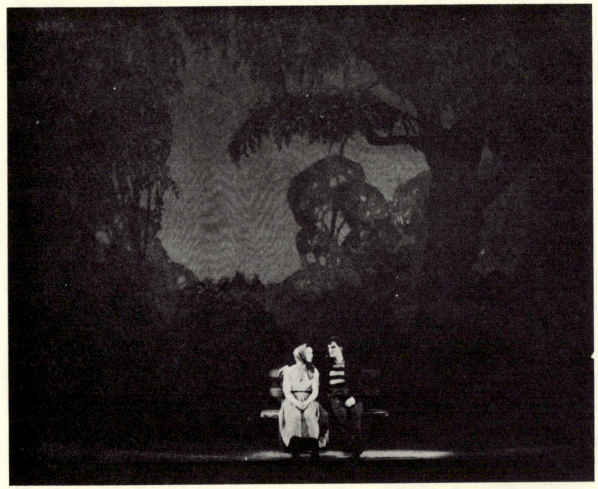

Park

Four Settings for *Liliom* by Molnar, 1921

Railroad Viaduct

Death

Photos Bruguière-Vandamm

Lee Simonson, Designer

121

Heaven

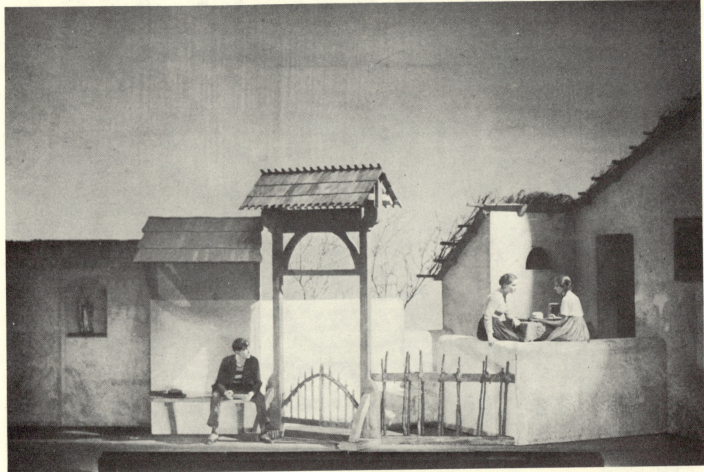

Photos Bruguière-Vandamm

Return

122 Settings for *Liliom* by Molnar, 1921
 Lee Simonson, Designer

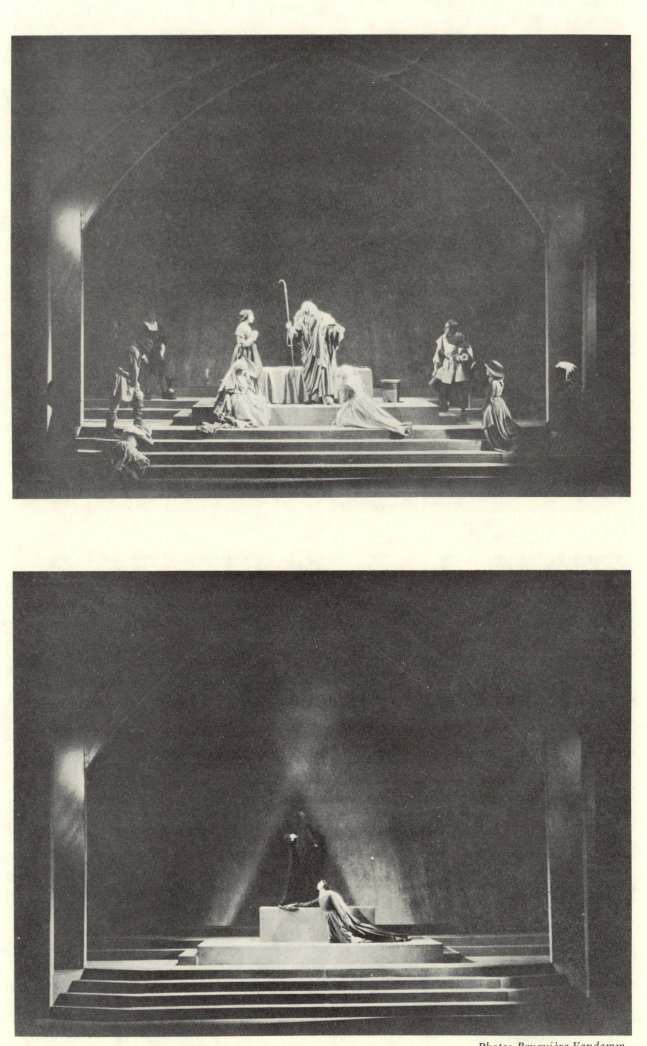

Settings for *The Tidings Brought to Mary* by Paul Claudel, 1922
Lee Simonson, Designer

Photos Bruguière-Vandamm

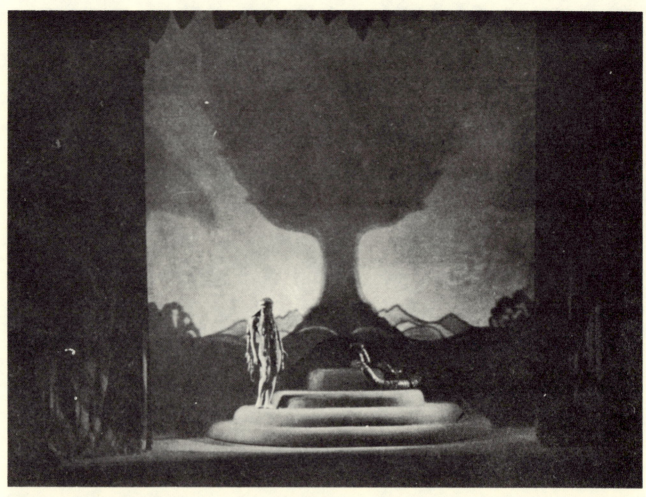

The Garden of Eden

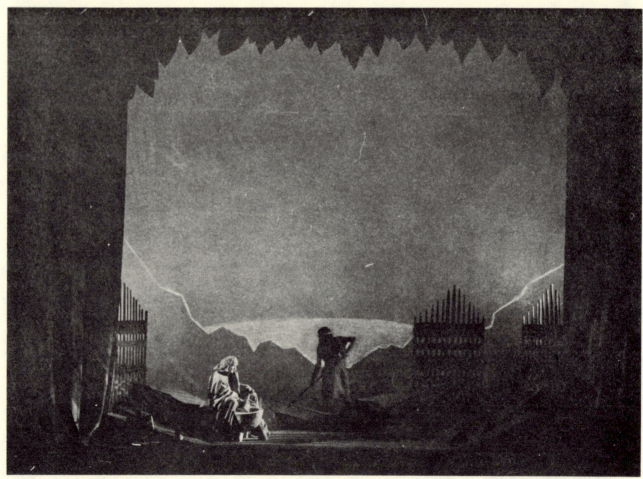

Oasis in Mesopotamia

Photos Bruguière-Vandamm

Four Settings for *Back to Methuselah*, by Bernard Shaw, 1922

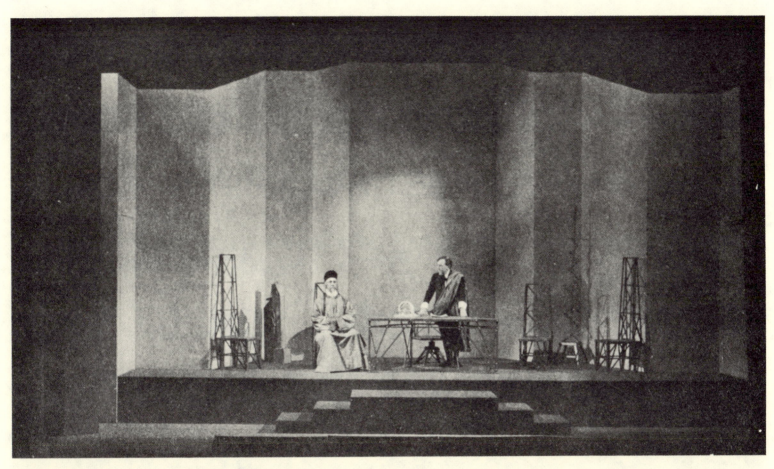

Office, President of the British Isles, 2170 A.D.

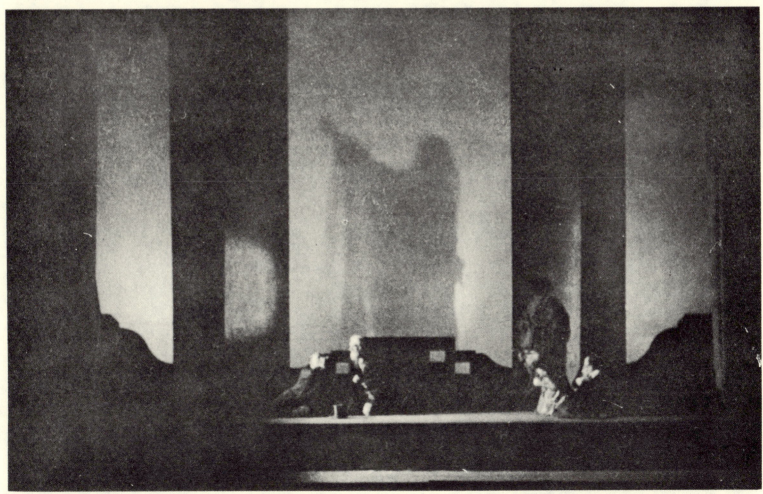

Inside a Temple

Lee Simonson, Designer

Photos Bruguière-Vandamm

Photos Bruguière-Vandamm

Three Settings and Working Drawings for *Peer Gynt* by Henrik Ibsen

126

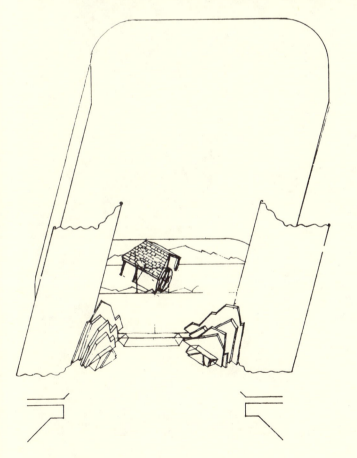
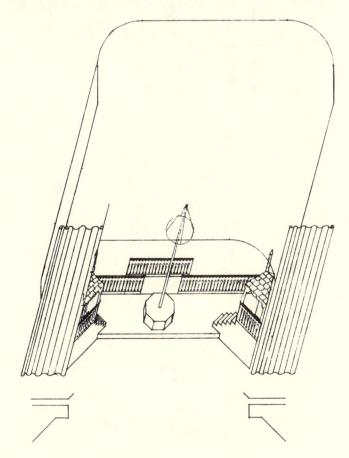

Lee Simonson, Designer

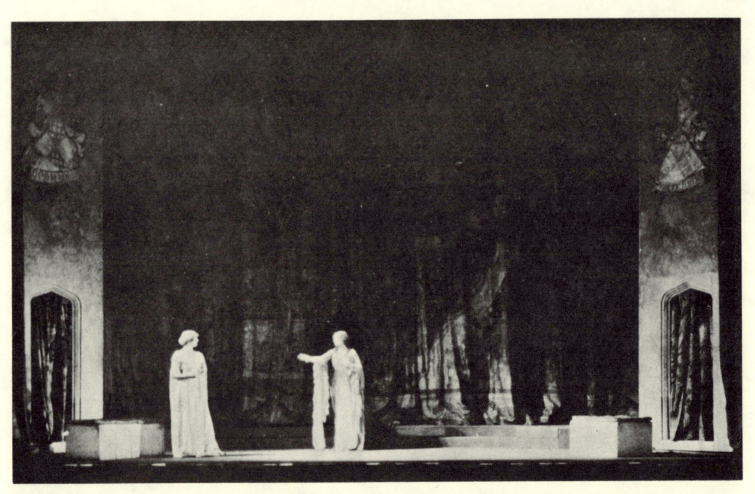

Palace

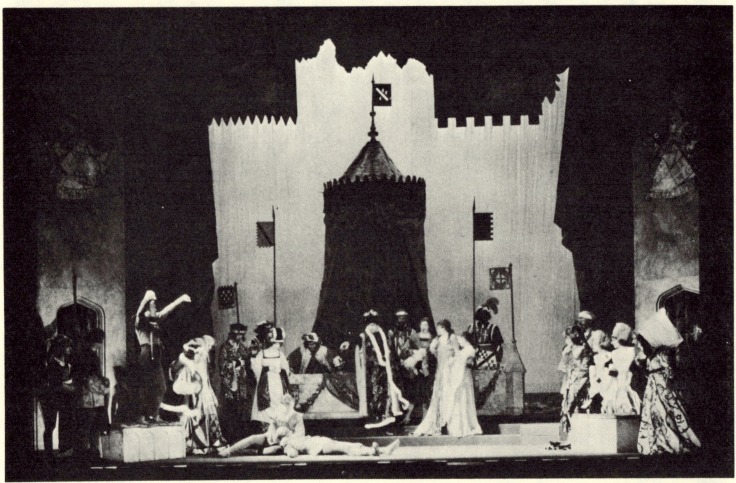

Wrestling Match

Bruguière-Vandamm

Three Settings for *As You Like It*, 1923

128

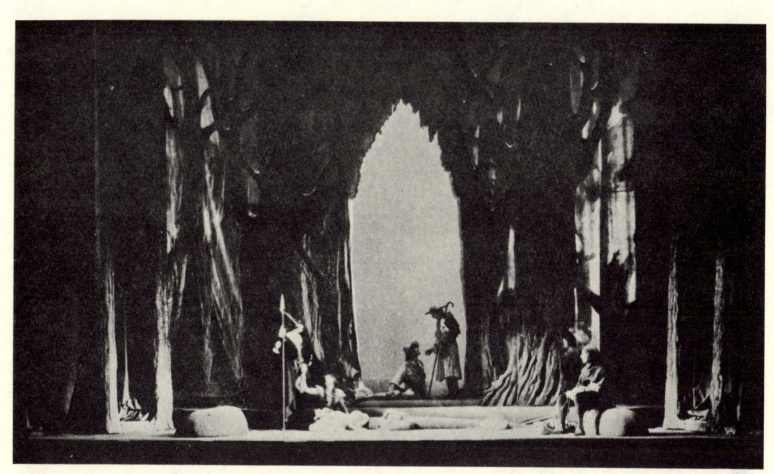

The Forest of Arden

Photos Bruguière-Vandamm

Diagram of Scene Shift, with Periaktoi
Lee Simonson, Designer

"Strike"

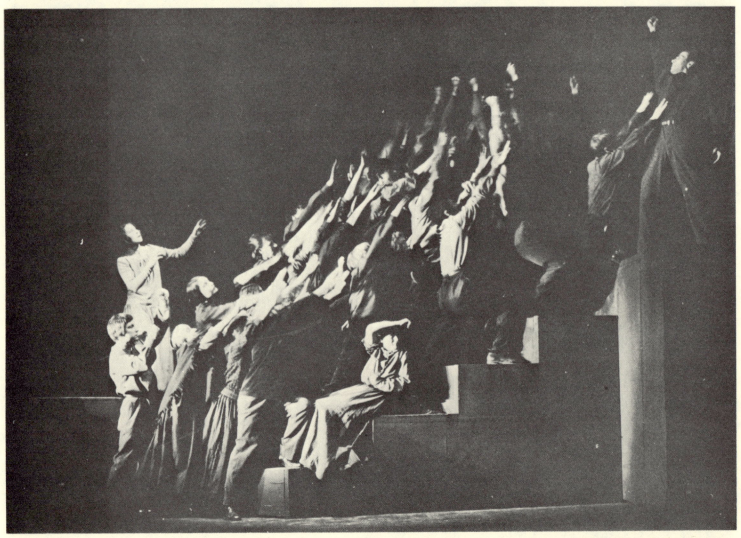

"Revolution"

Photos Bruguière-Vandamm

Settings for *Man and The Masses*, by Ernst Toller, 1924

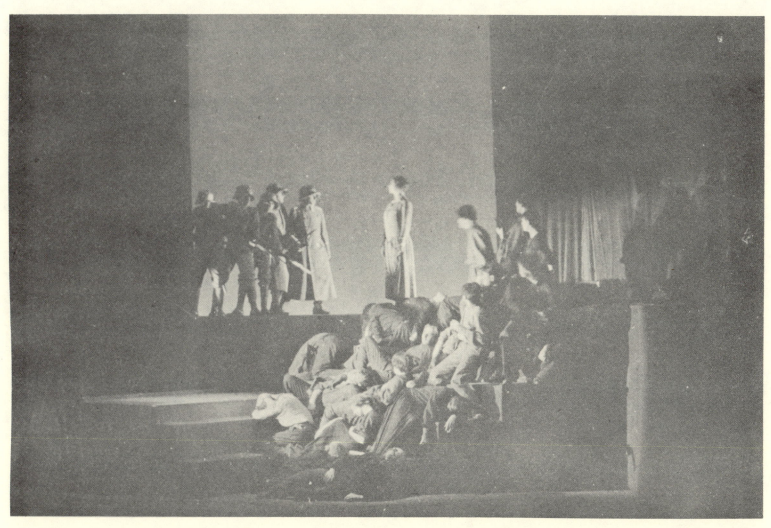

Defeat

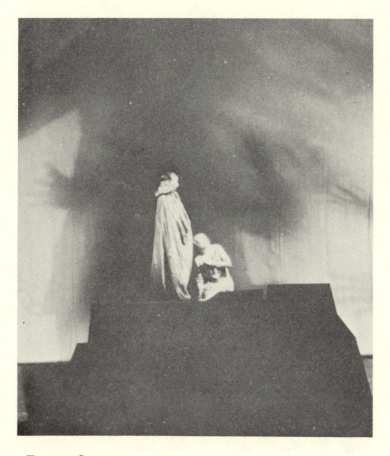

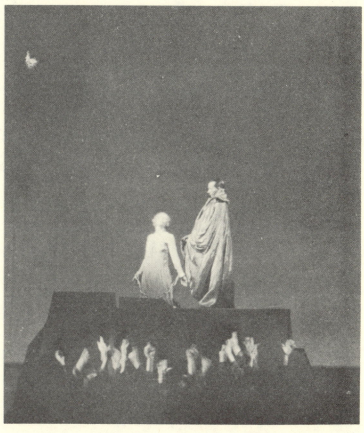

Photos Bruguière-Vandamm

Dream Scenes

Designed and directed by Lee Simonson

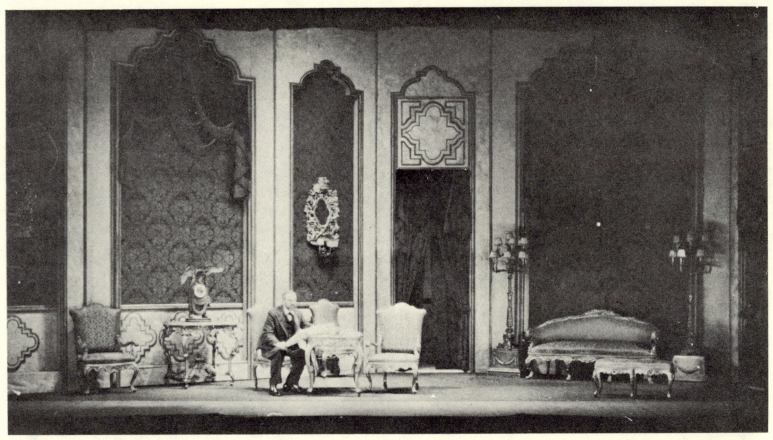

Maximilian's Palace

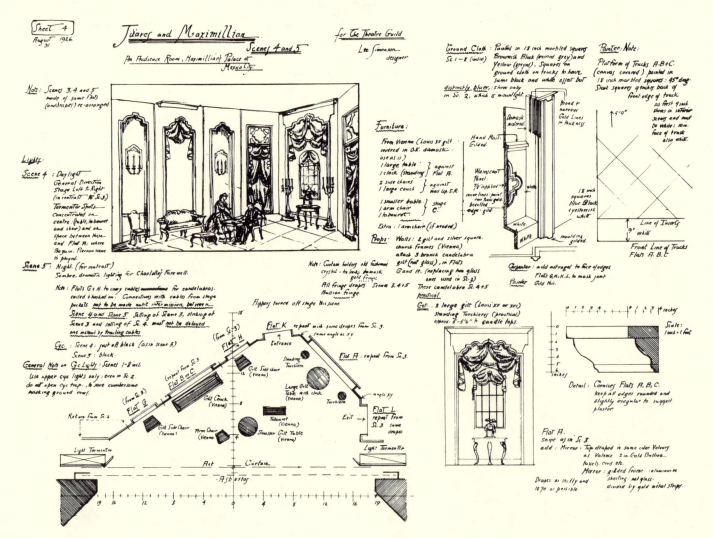

Working Drawing for the Set

Settings for *Juarez and Maximilian* by Franz Werfel, 1926

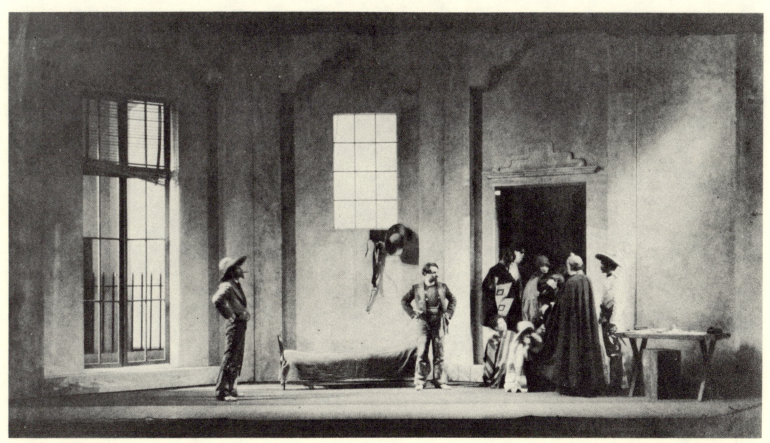

Juarez' Headquarters

Photo Bruguière-Vandamm

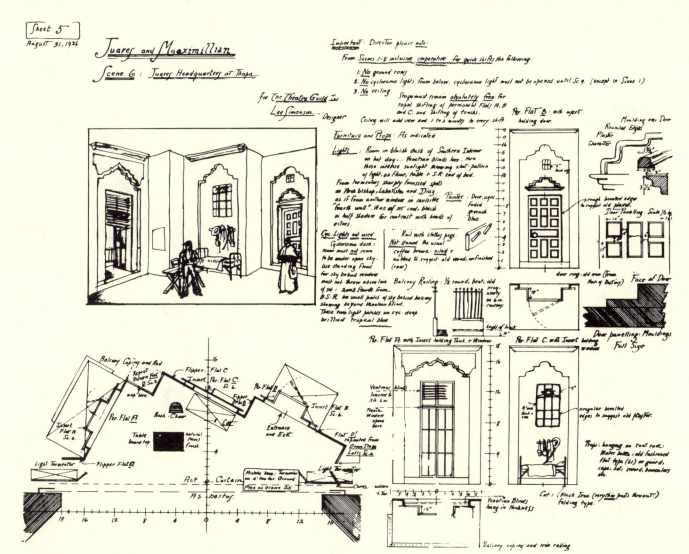

Working Drawing for the Set

Lee Simonson, Designer

133

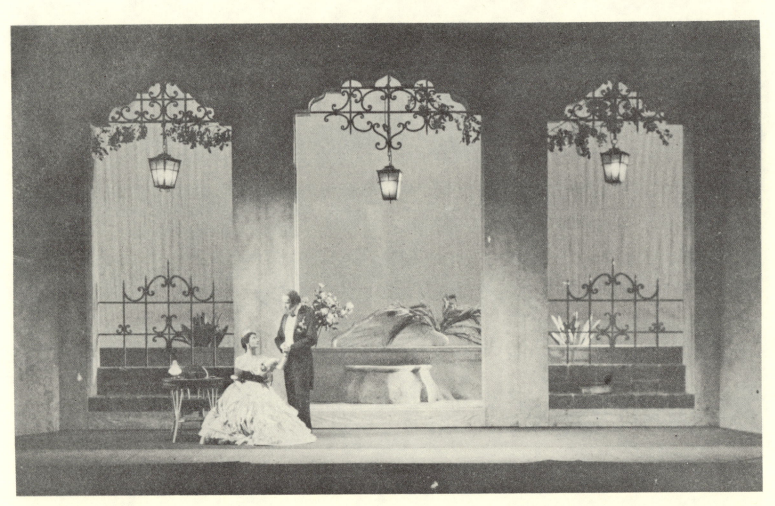

Palace Terrace

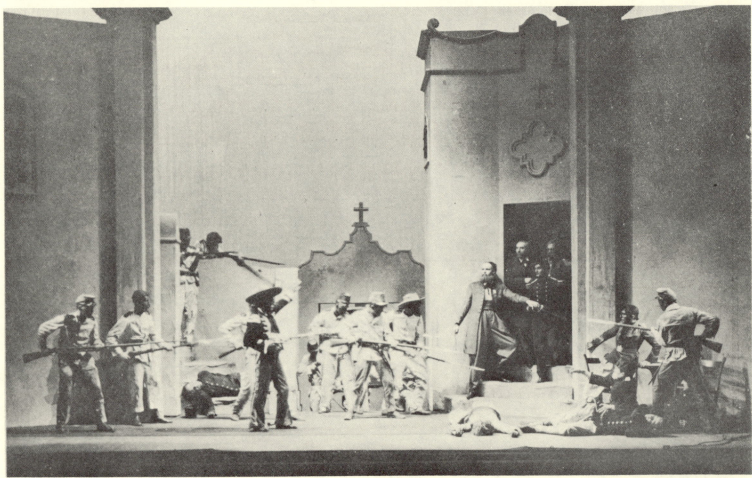

Cloister, Vera Cruz
 Settings for *Juarez and Maximilian* by Franz Werfel, 1926

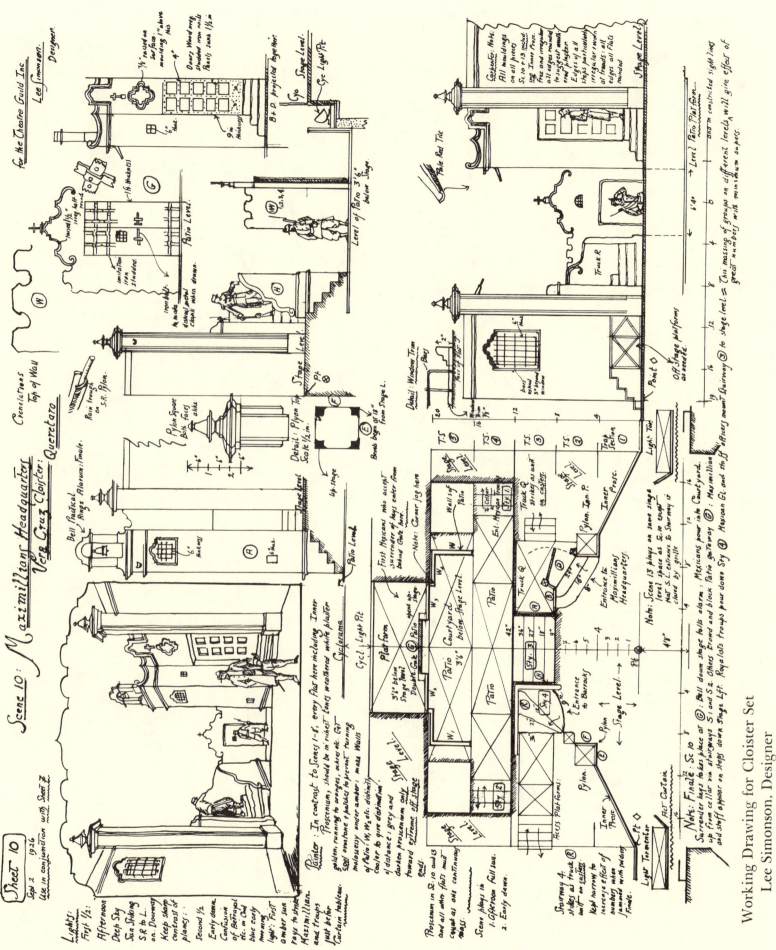

Working Drawing for Cloister Set
Lee Simonson, Designer

135

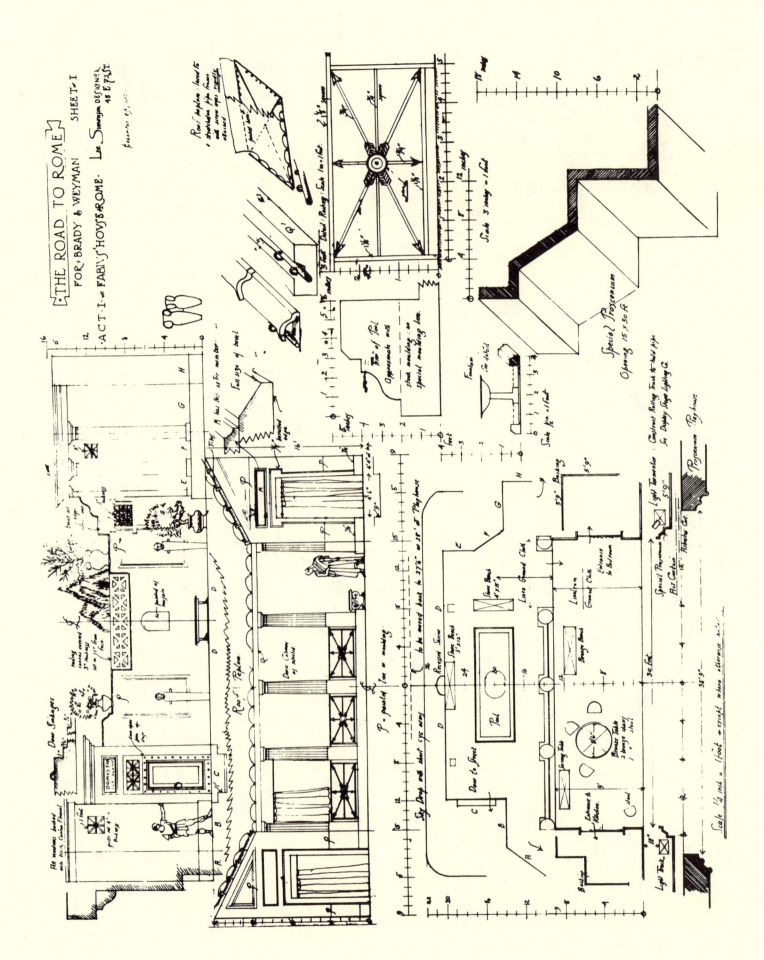

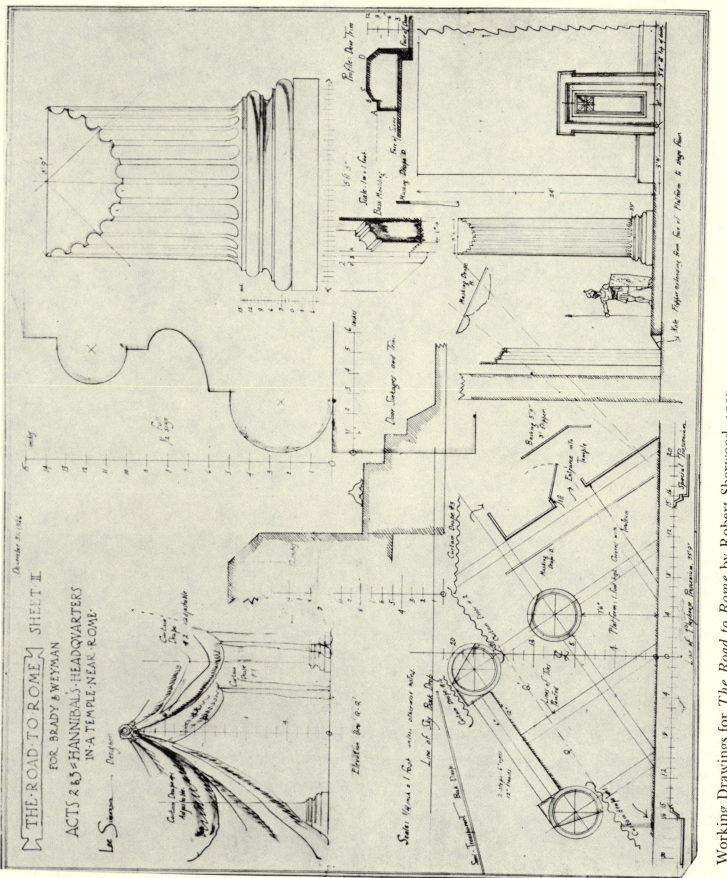

Working Drawings for *The Road to Rome* by Robert Sherwood, 1927
Lee Simonson, Designer

137

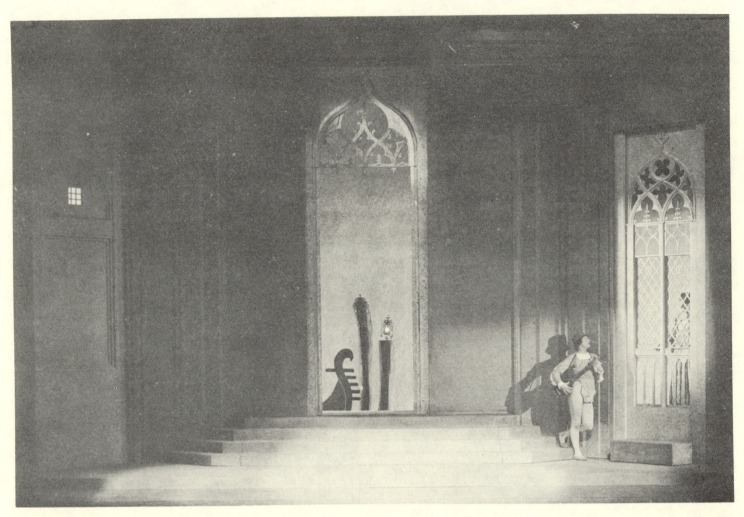

Venice

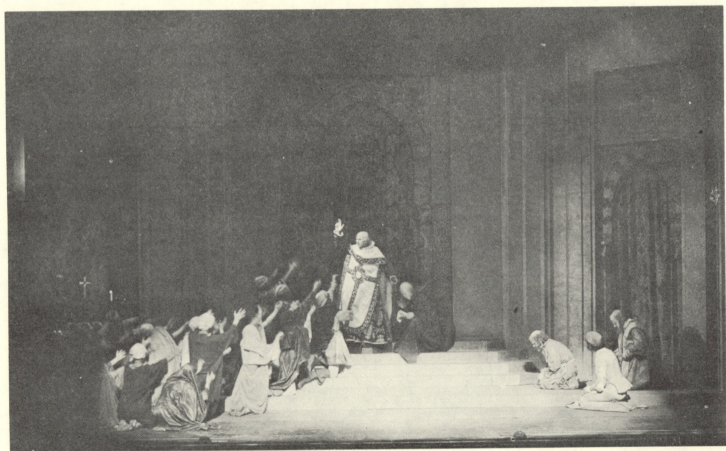

Photos Vandamm

Acre

Four Settings for *Marco Millions* by Eugene O'Neill, 1928

138

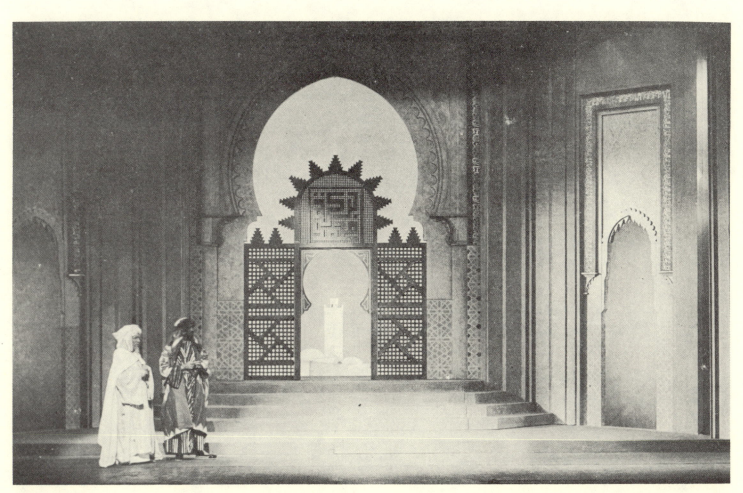

Morocco

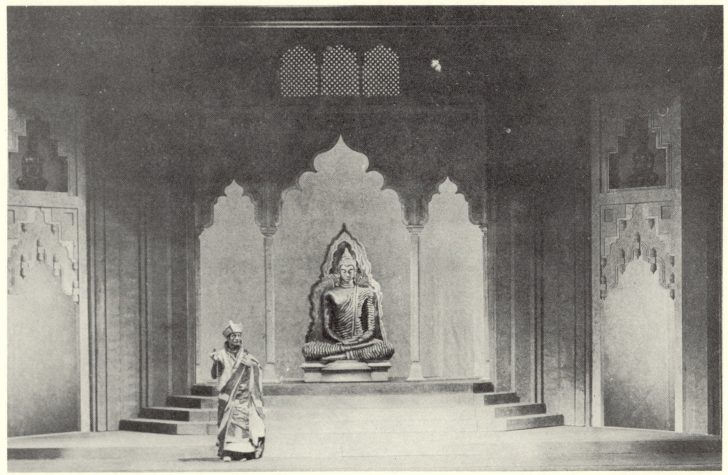

India

Lee Simonson, Designer

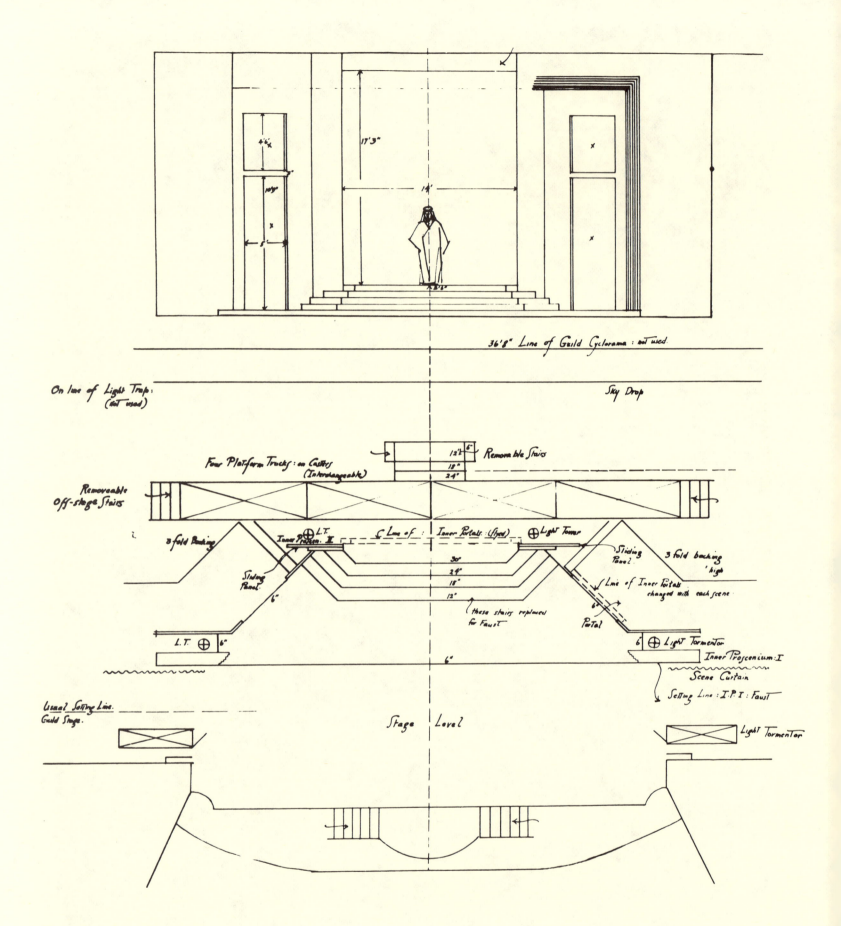

Working Drawings for Unit Setting for *Faust, Marco Millions* and *Volpone*

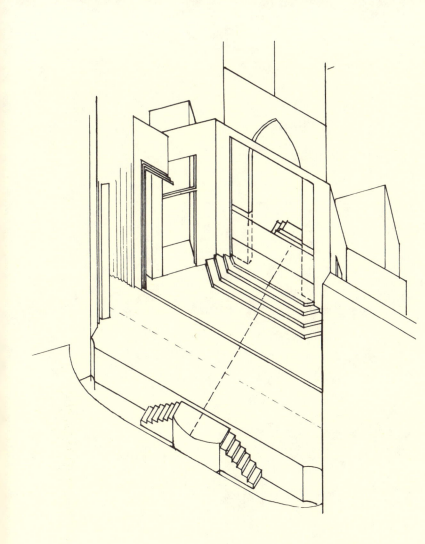

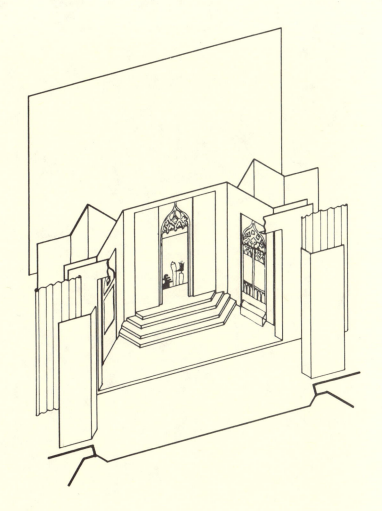

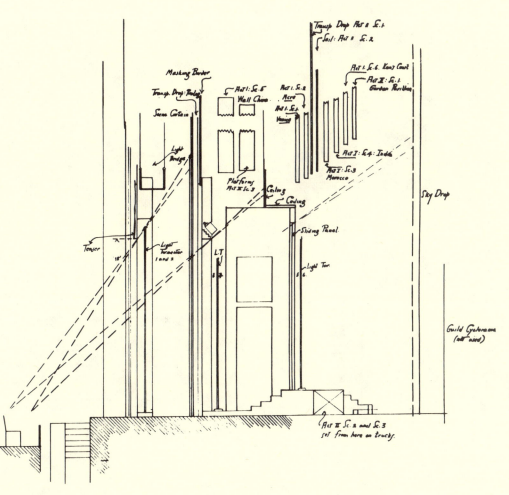

Lee Simonson, Designer

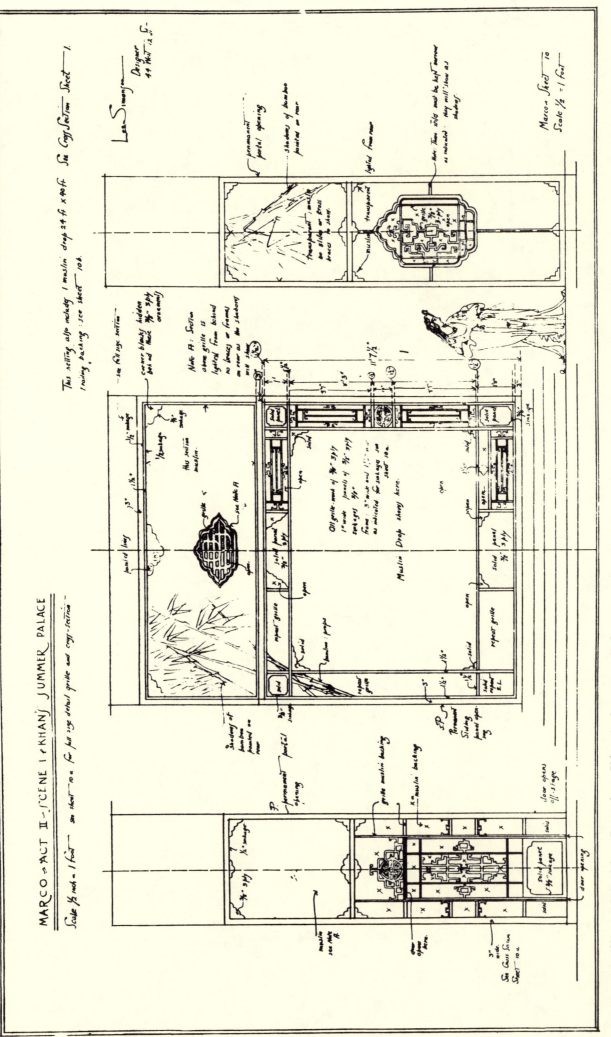

Marco Millions, Working Drawing, Khan's Summer Palace

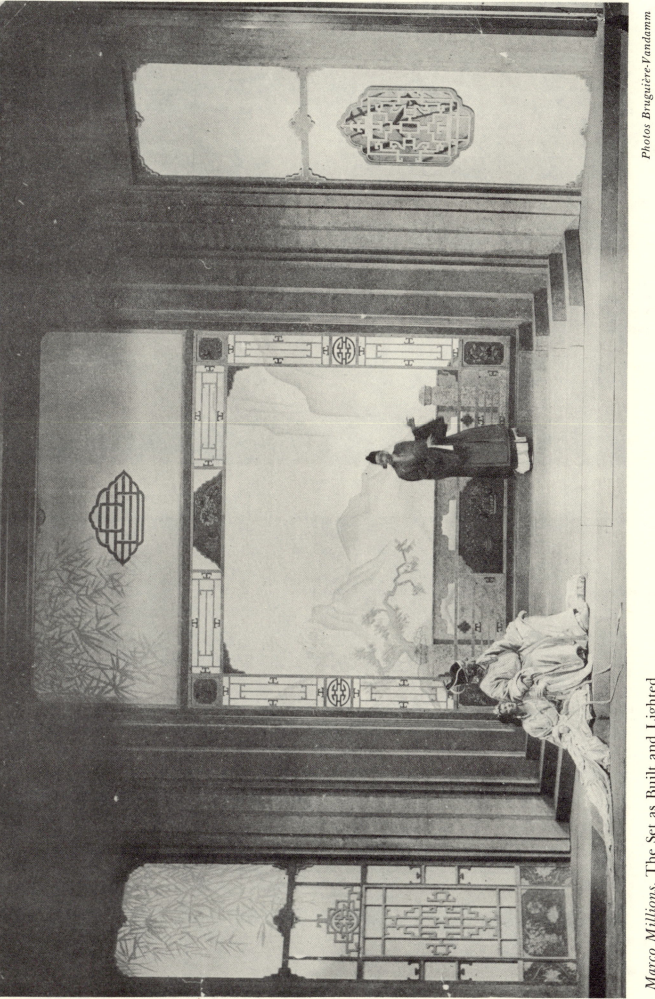

Marco Millions, The Set as Built and Lighted
Lee Simonson, Designer

143

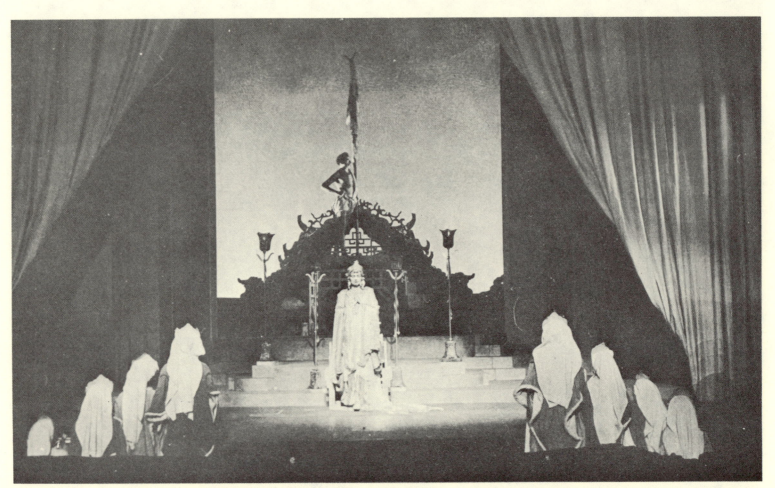

The Princess's Ship

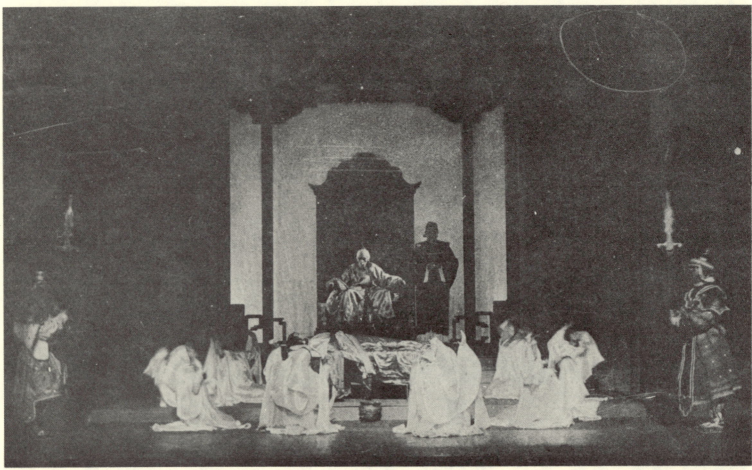

Funeral of the Princess
 Settings for *Marco Millions* by Eugene O'Neill, 1928
 Lee Simonson, Designer

144

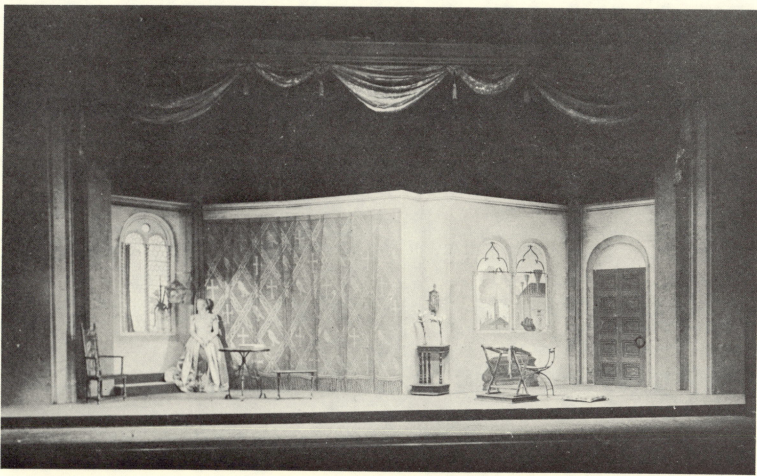

Colomba's Room

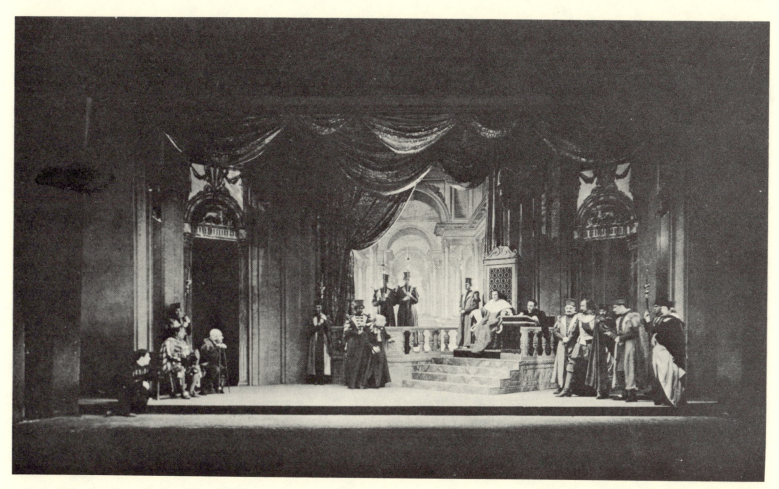

The Trial

Settings for *Volpone*, by Ben Jonson, 1928
Lee Simonson, Designer

Photos Vandamm

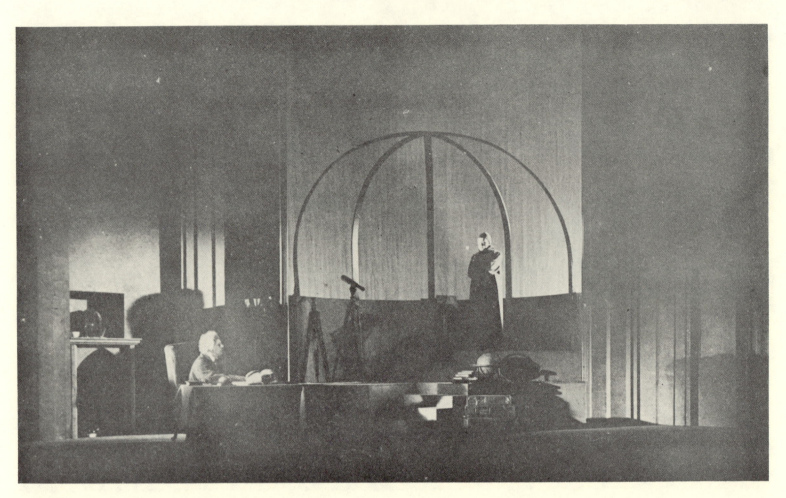

Study

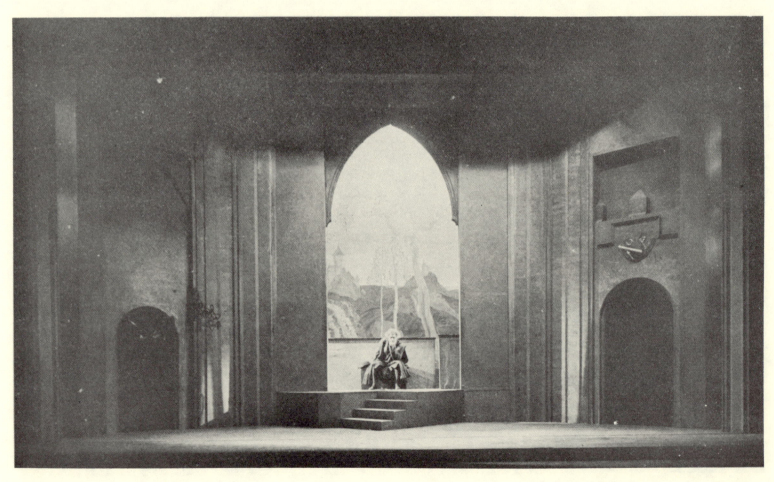

City Gate

Settings for *Faust*, by Goethe, 1928

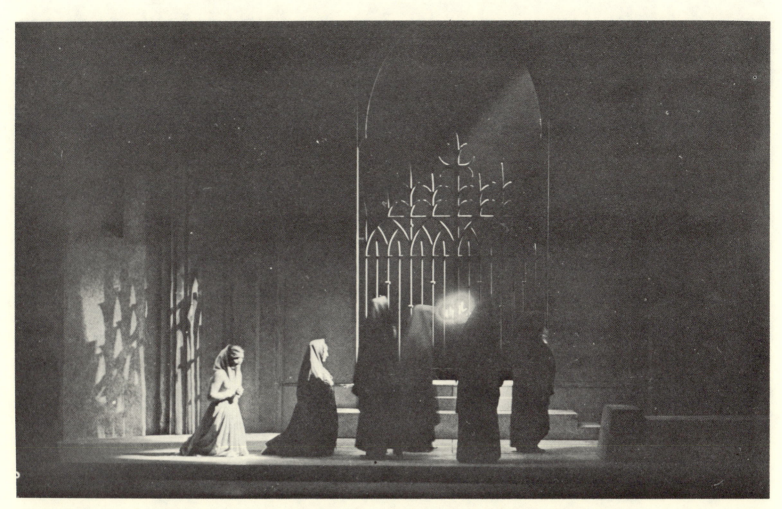

Cathedral

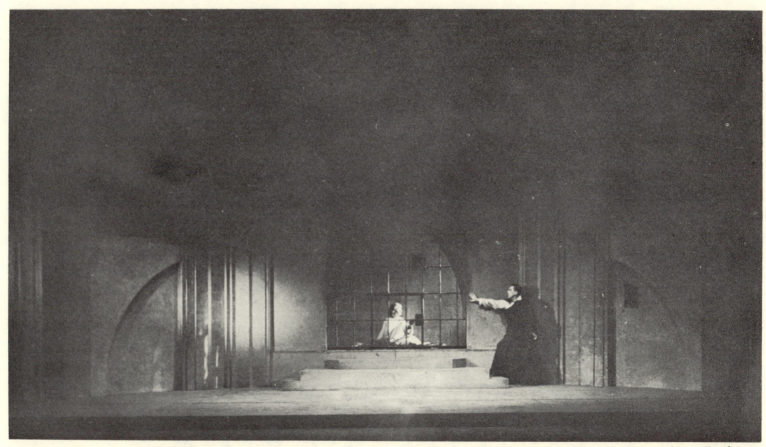

Prison

Lee Simonson, Designer

147

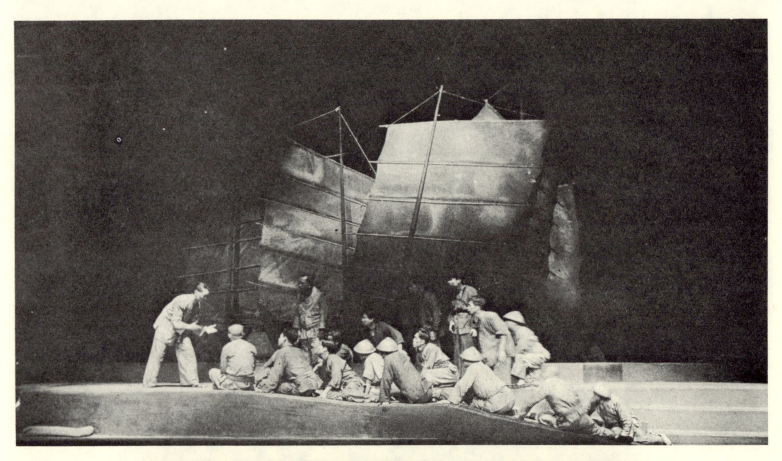

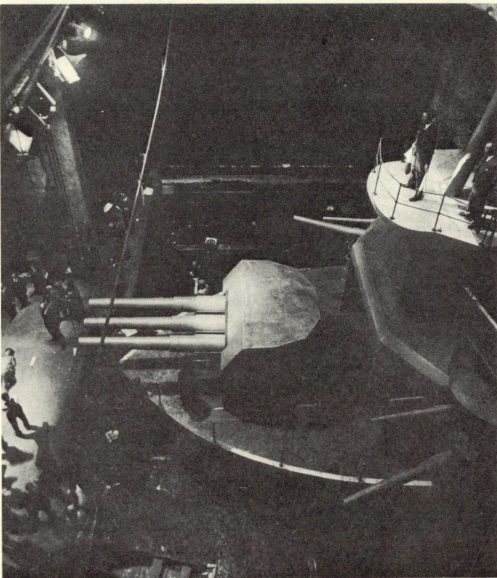

Settings for *Roar China* by Tretyakov, 1930

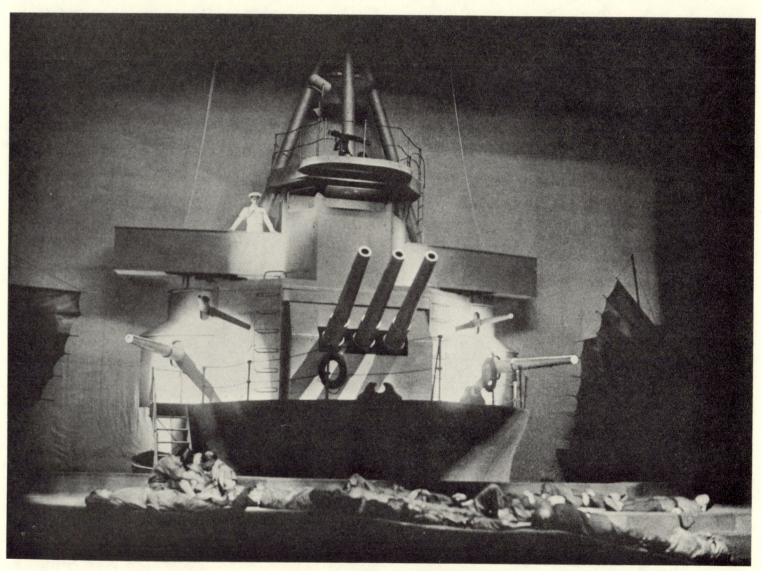

Lee Simonson, Designer

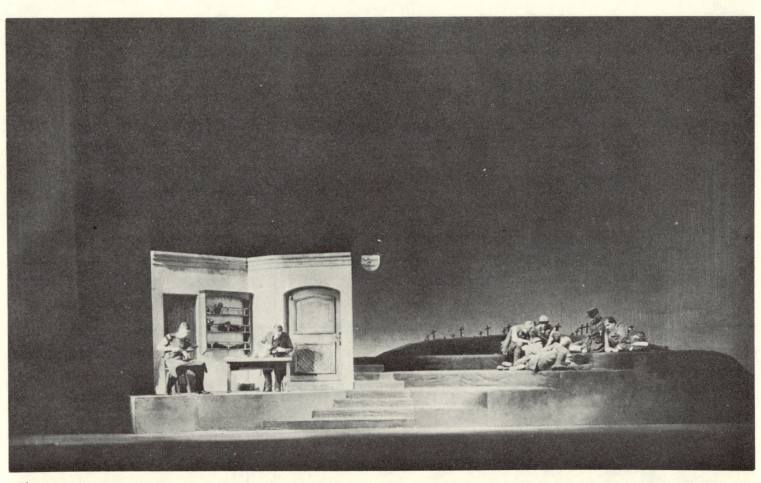

Shop

Peace Conference

Settings for *Miracle at Verdun* by H. Chlumberg, 1931

Cemetery

The Dead Rise
Lee Simonson, Designer

Photos Vandamm

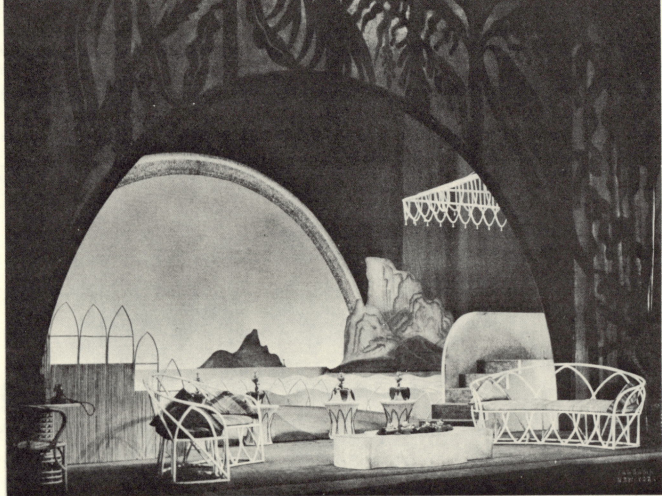

Settings for *The Simpleton of the Unexpected Isles* by Bernard Shaw, 1935
Lee Simonson, Designer

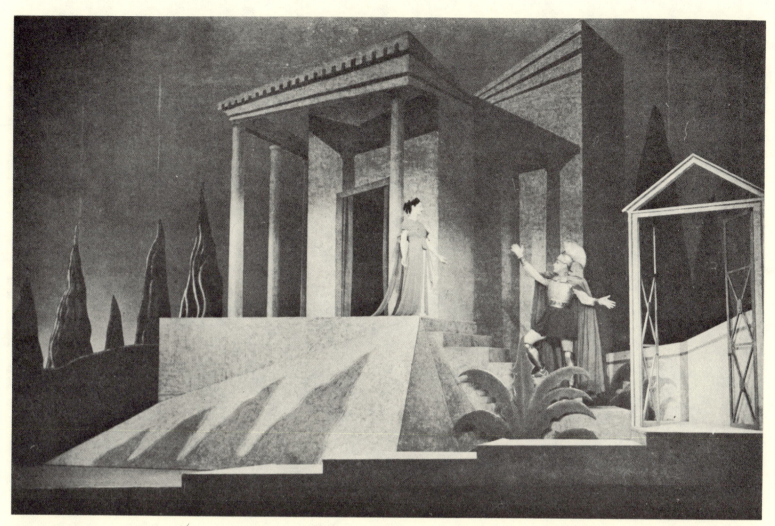

Act I

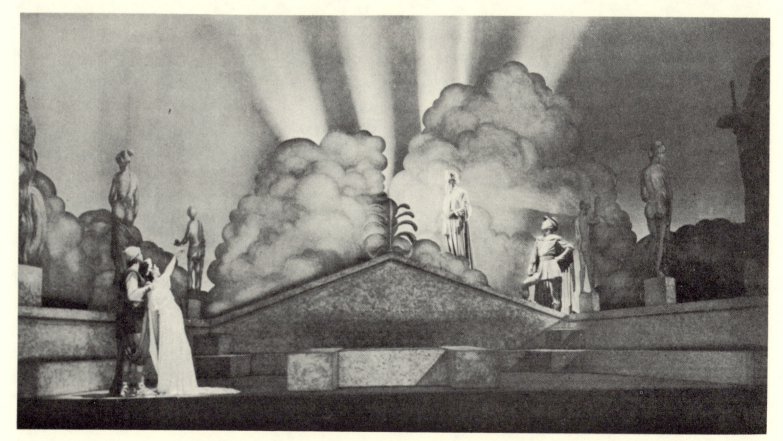

Act III

Settings for *Amphitryon 38* by Giraudoux, 1937
Lee Simonson, Designer

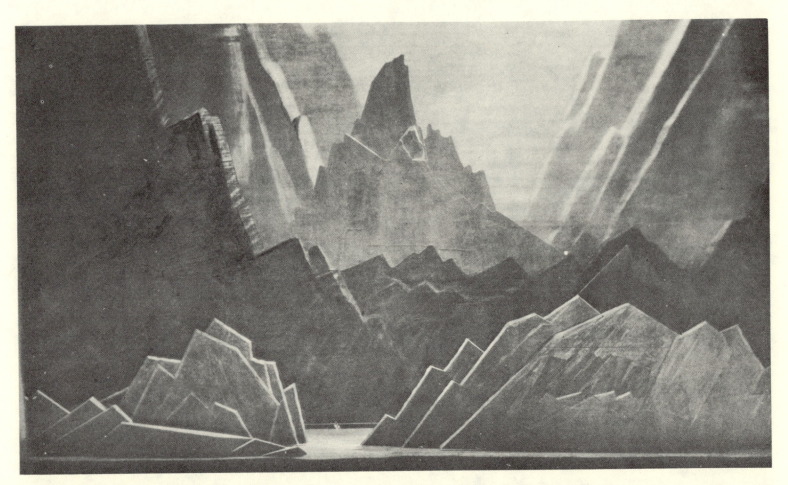

Das Rheingold Scene 1

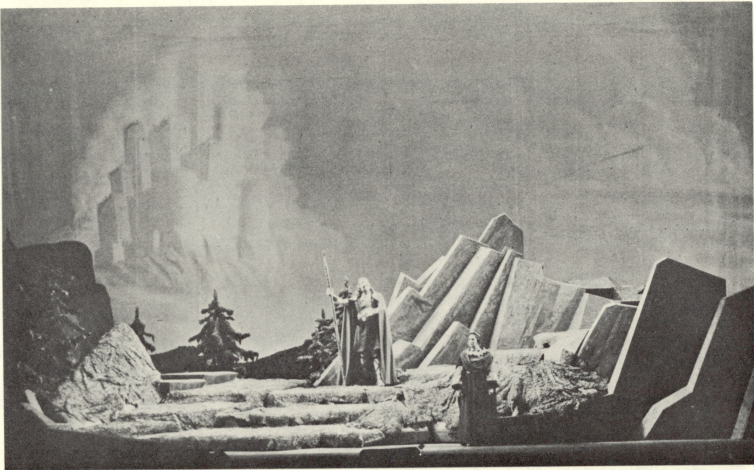

Photos Louis Melançon

Das Rheingold Scene 2

Settings for *The Ring of the Nibelung* by Richard Wagner
Metropolitan Opera Assn. N. Y. 1948

154

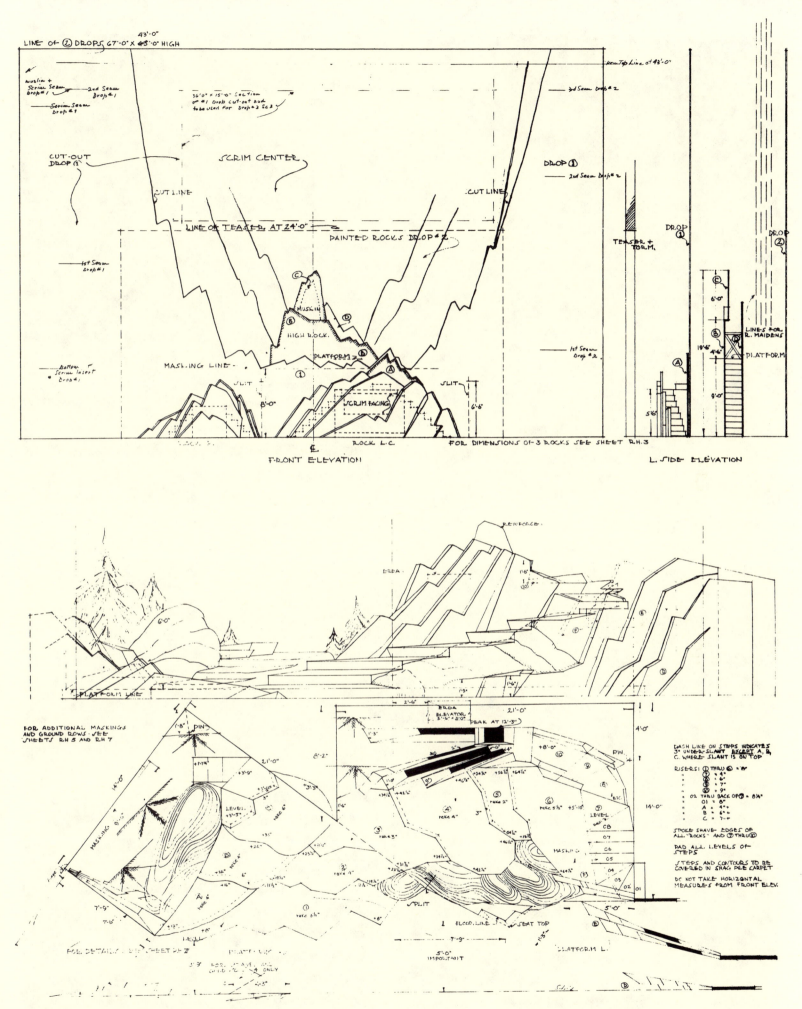

Working Drawings for the Sets

Lee Simonson, Designer

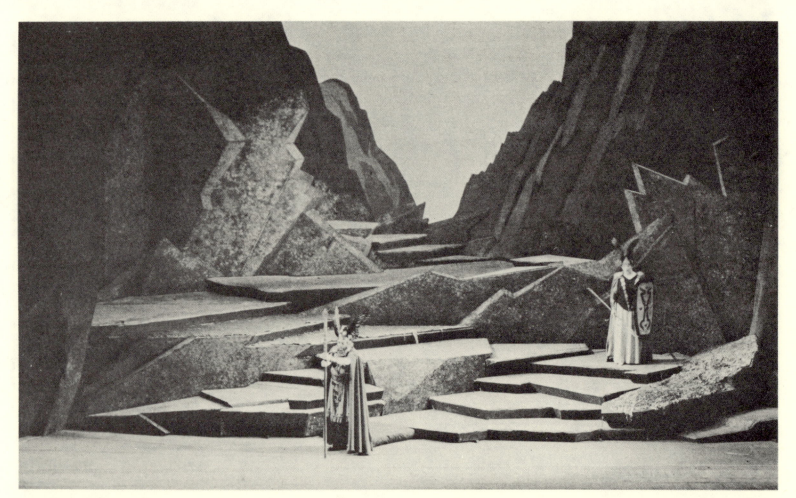

Die Walküre Act II

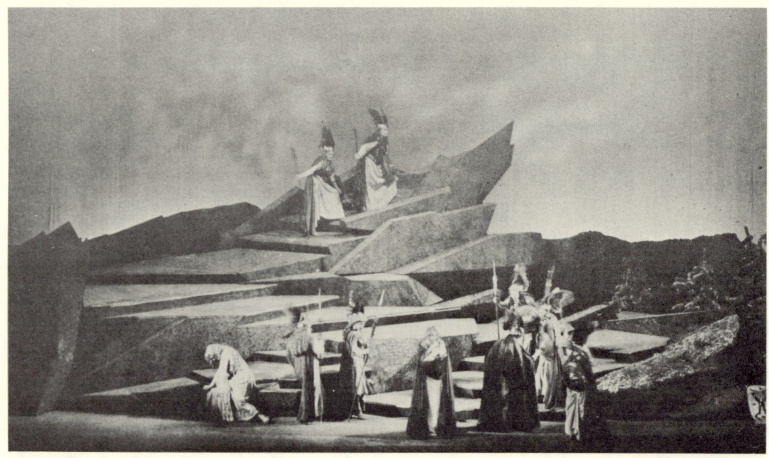

Photos Louis Melançon

Die Walküre Act III

Settings for *Die Walküre* by Richard Wagner, 1948
Lee Simonson, Designer

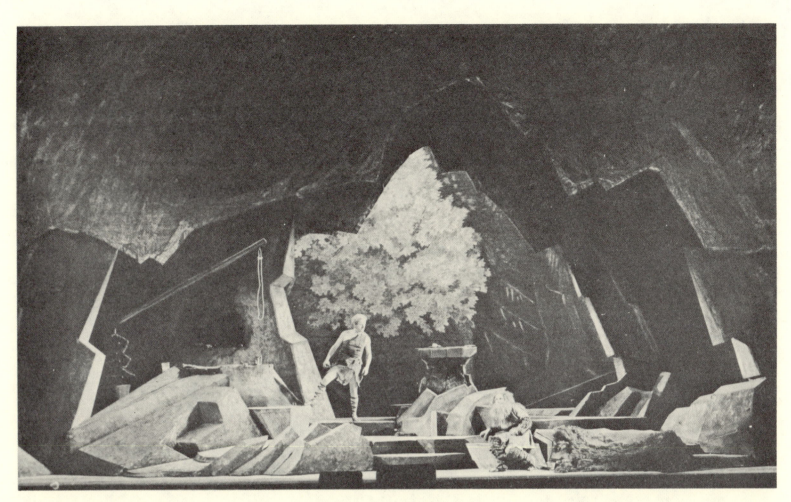

Siegfried Act I

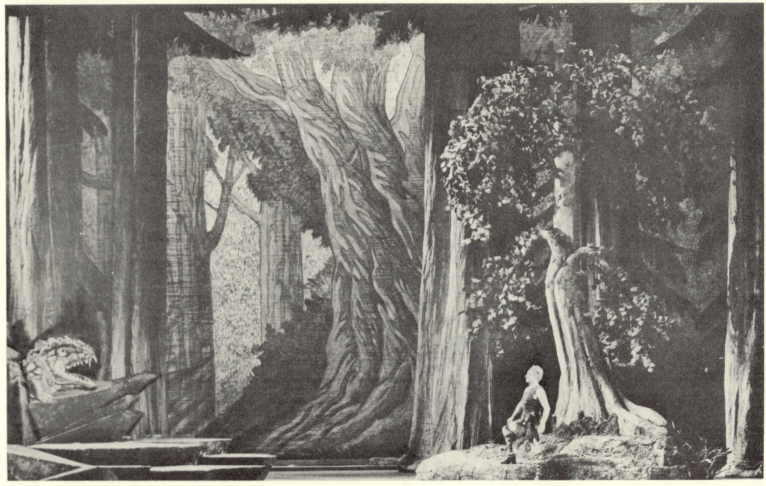

Siegfried Act II

Settings for *Siegfried* by Richard Wagner, 1948
Lee Simonson, Designer

157

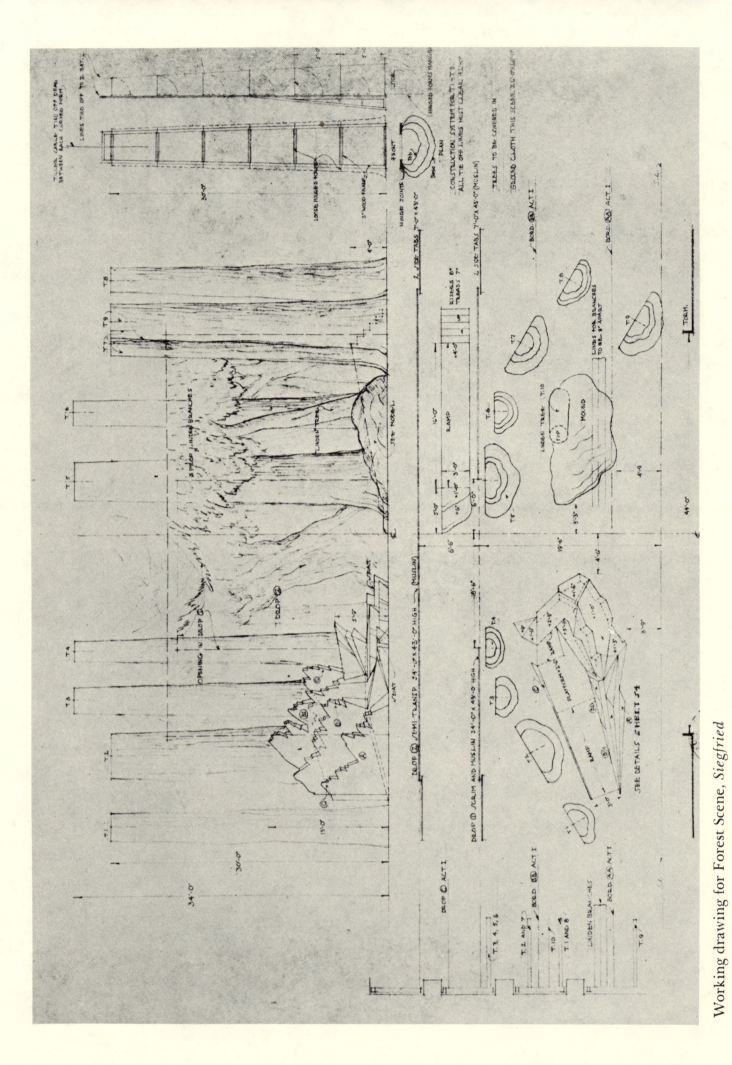

Working drawing for Forest Scene, *Siegfried*

158

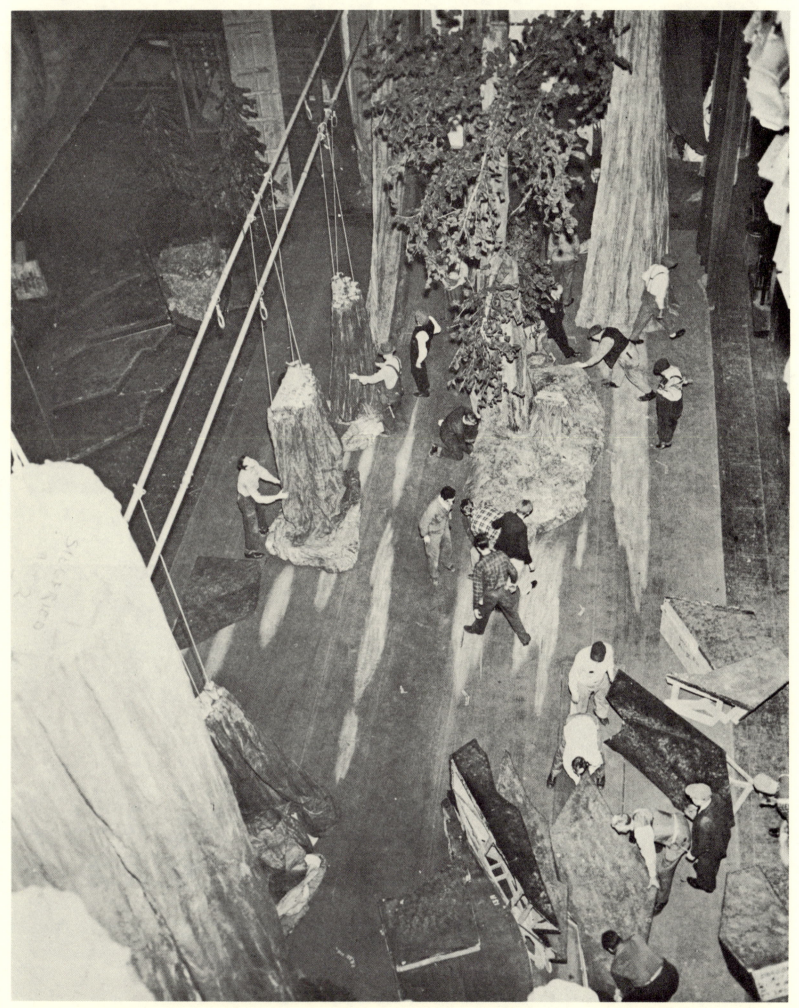

Forest Scene being Set

Photo Louis Melançon

159

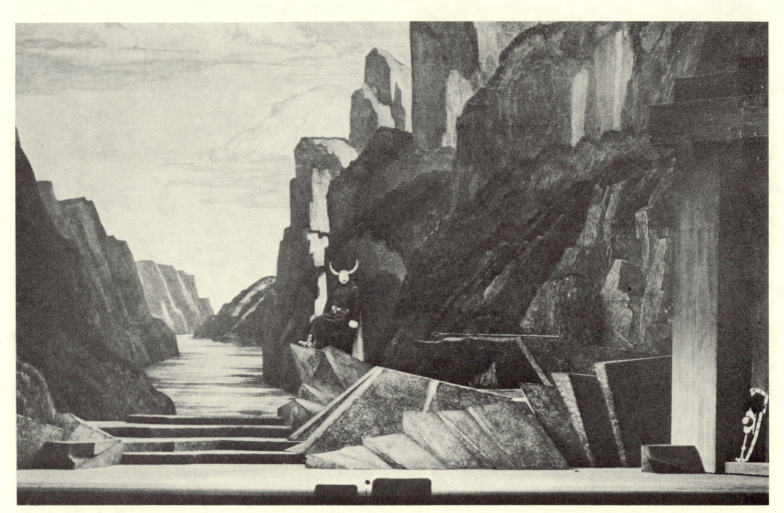

Götterdämmerung Act II

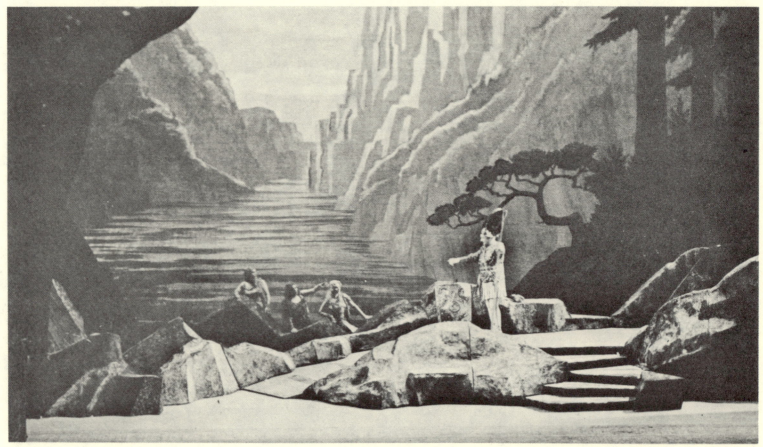

Götterdämmerung Act III. Sc. i

Photos Louis Melançon

Settings for *Götterdämmerung* by Richard Wagner, 1948

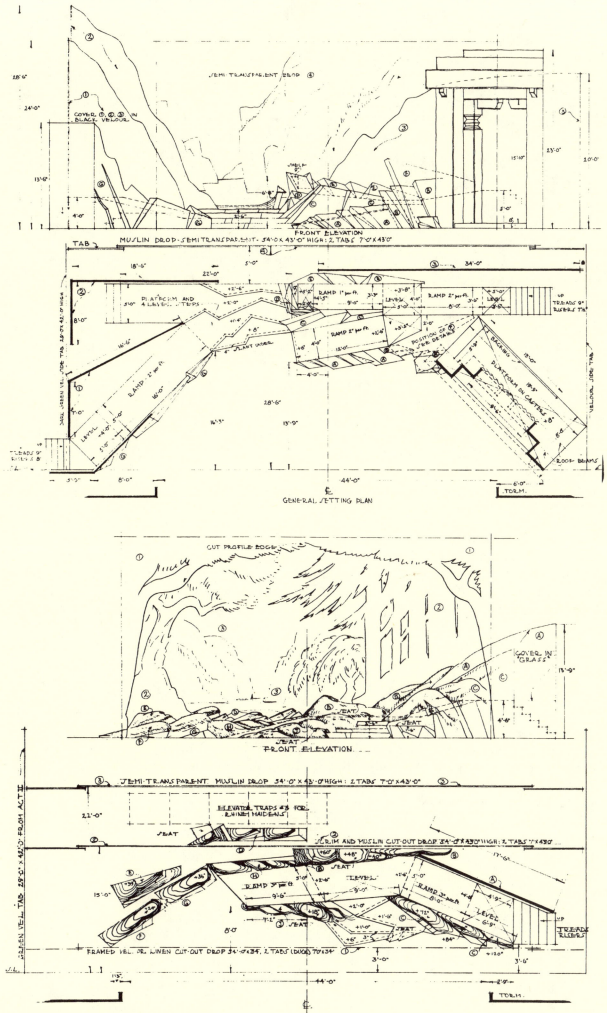

Working drawings for the Sets

Lee Simonson, Designer

MORE WAYS THAN ONE
SIX INTERPRETATIONS OF HAMLET

THESE six productions of *Hamlet*, projected or executed, indicate how varied the imaginative emphasis of a stage setting can be at the same time that it sustains the interpretation of a script in its structure and design.

Hofman's scheme shows an interesting use of screens that concentrate the action of each scene. In Jones' production, a single unit setting framed the entire action of the play. The Ghost appeared at the rear, under the central archway. The changing mood and pattern of the lighting and the pattern of the actors' movements suggested all the necessary changes of locale. In Norman Bel Geddes' production, the same result was achieved on the varied levels of a single, monolithic structure with virtually no suggestion of scenic background.

Stewart Chaney has supplied the following notes for his setting: "The stage is broken up into four levels, the forestage and the central area being used for the larger interior scenes. The two side, upper platforms were used for the King's chamber and the Queen's bedroom. Directly behind this ran a passageway, pierced with windows, through which actors could be seen making their way to the exit. In this way there was a constant flow of movement. In the exterior scenes, the central bay slipped up to reveal a sky against which the outdoor scenes, such as the parapet and the grave-digging scenes were played.

"I felt that the motivating impulse throughout the play was the death of Hamlet's father. For this reason a stone effigy of the dead King acted as a keystone to the scenic production. In the center of the face of the platform, a low arch held the stone effigy of the dead King. In the majority of the scenes, this low arch was closed with masonry. In the crypt scene, this masonry was removed revealing the effigy of the dead King. When the ghost leads Hamlet from the parapet to the crypt, he is seen standing over his own grave as he addresses Hamlet. Thus the audience has the visualization of the importance of the dead King to the integral architecture of the play."

Hamlet is usually thought of as a black figure in a gloomy world, or his gloom is projected onto his surroundings. The basic idea of my project is that he is a black and brooding figure in a bright world and the scheme of production is designed to emphasize his isolation in a sensuous, guzzling, luxurious court. Therefore, the center of the castle structure is a dull red. Every time the court assembles it brightens this glow of red with its brilliant robes studded with jewels and ornamented with bronze and gold. Hamlet moves against this brightness in solitary protest, uniquely black.

When the ghost appears for the second time, the rim of the wall below is touched with a smoldering light—as though it were standing on the rim of hell. A vermilion carpet leads like a bloody trail to the guilty bedroom. At the close of the play, the followers of Fortinbras fill the parapet above Hamlet's body in a great semicircle and lower their banners in salute.

In his volume *Scenery Then and Now*, Oenslager describes the scenes I have reproduced, as follows. For the Player's Scene: "The whitish wall at the back has three high, dark doors. Two high-backed

thrones are placed atop a pyramid of steps. They face a black platform with a bare, white, three-fold screen as background for the play. The King and Queen are in bright scarlet, the courtiers in robes of white with dark linings, the white relieved by blots of watery red." Hamlet is placed between the players and the King. When the King rushes out "and is lost in the confusion of the courtiers' exit, all the lights dim down. Only Hamlet and Horatio remain behind, casting spectral shadows over the walls of Elsinore."

For the Queen's Closet: "It is a lofty white room, irised with sultry red. There are three doors, one in each wall. The center is hung with heavy crepe, behind which Polonius hides. When Hamlet draws aside the arras to discover the slain body of Polonius, only darkness reveals darkness. In the cavernous death of this opening the ghost of Hamlet's father will later appear."

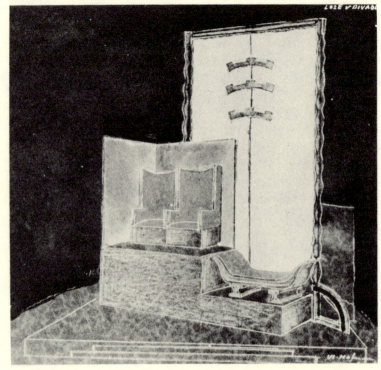

Hamlet, Prague, 1926
Designed by Vlatislav Hofman

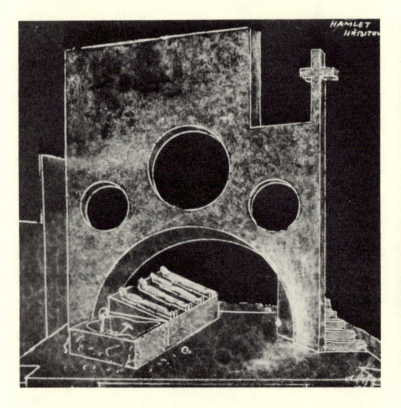

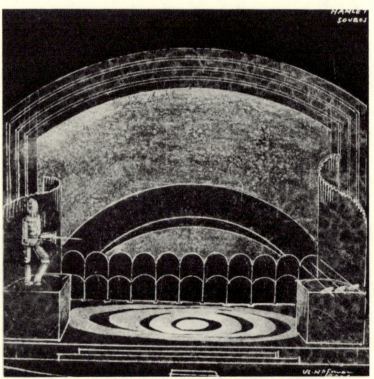

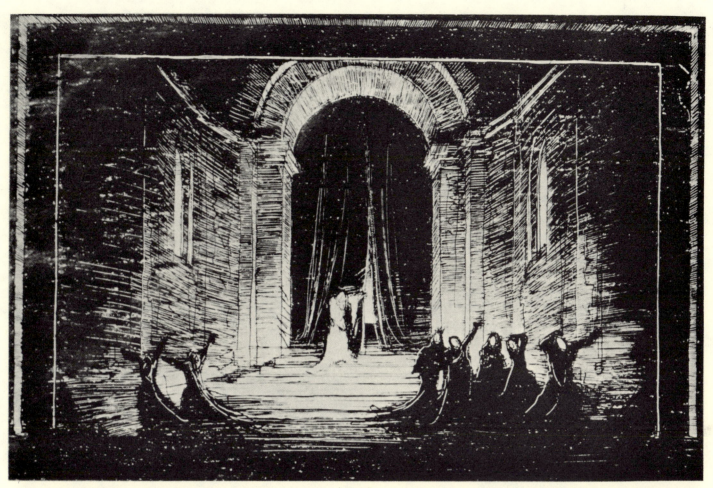

Ophelia's Mad Scene

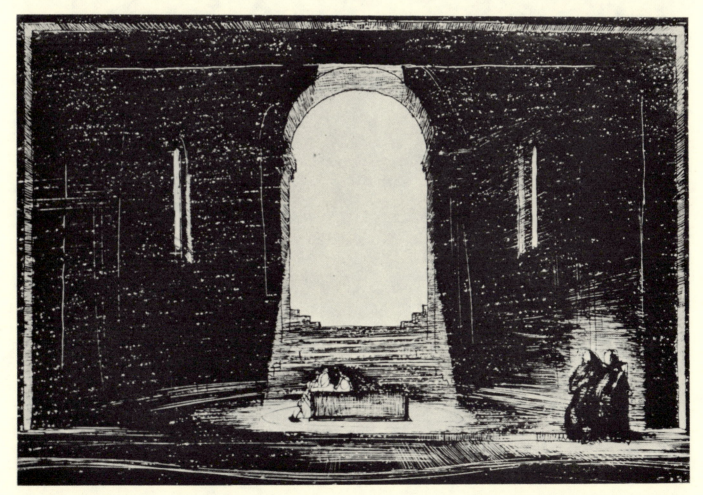

Burial of Ophelia

Hamlet, 1923
Designed by Robert Edmond Jones

165

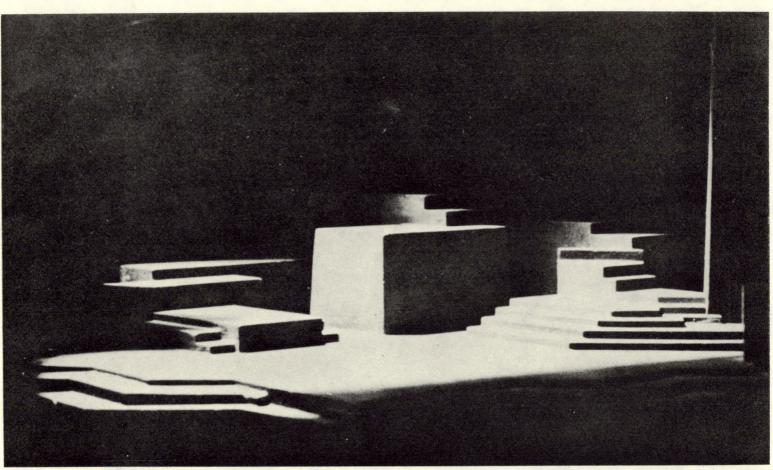

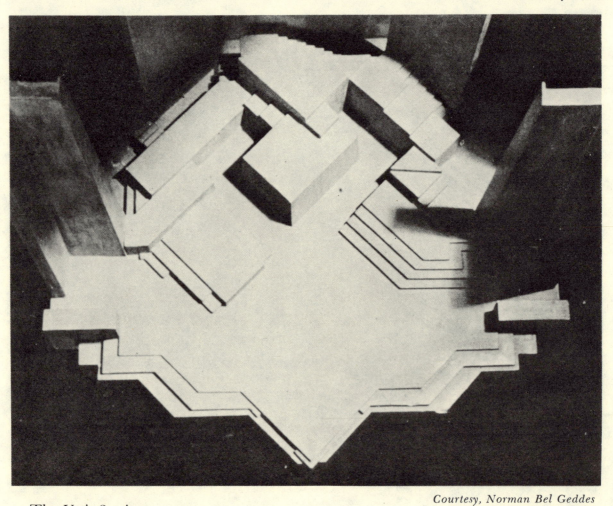

The Unit Setting

Hamlet. Designed and Directed by Norman Bel Geddes, 1931

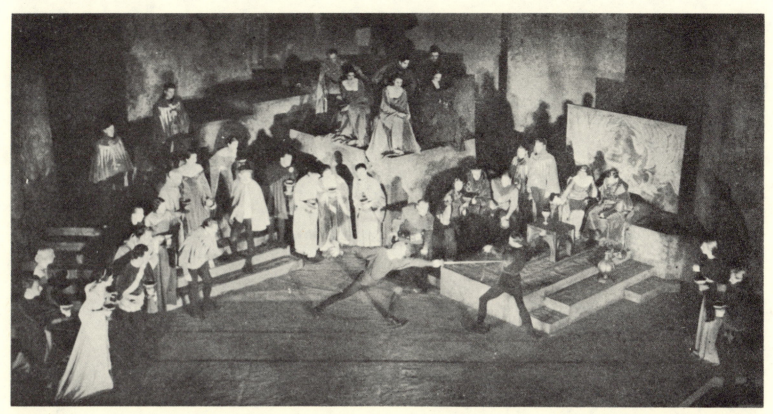

Duel Scene

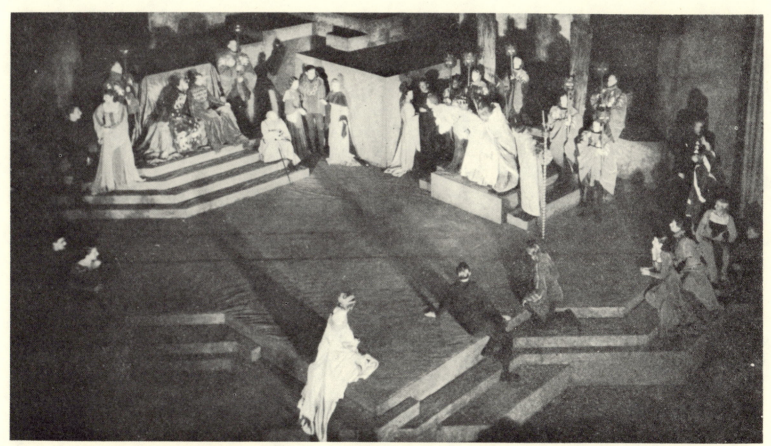

Players Scene

Hamlet. Designed and Directed by Norman Bel Geddes,

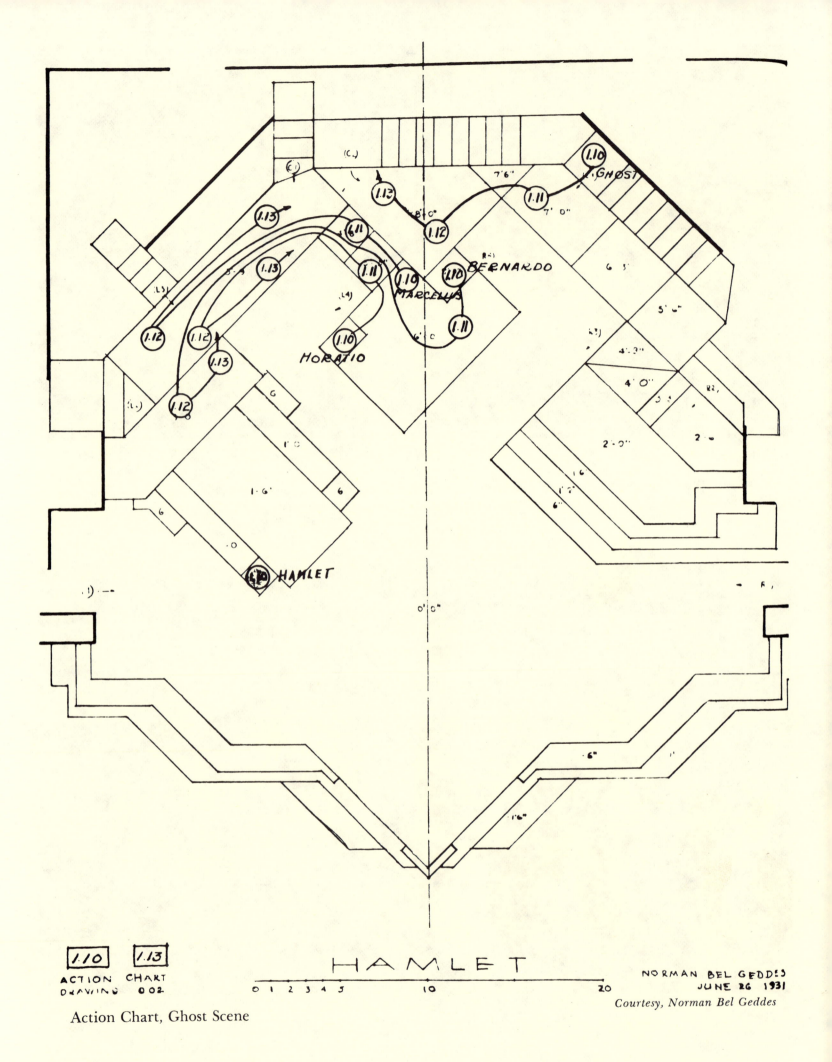

Action Chart, Ghost Scene

BERNARDO I have seen *nothing*.

MARCELLUS Horatio says 'tis but our fantasy, this dreaded sight, twice seen of us: therefore I have entreated him along with us to watch the minutes of this night, that if again this apparition come, he may approve our eyes.

HORATIO Tush, tush, 'twill not appear.

BERNARDO Sit down a while; and let us once again assail your ears, that are so fortified against our story.
What we have *two* nights seen.

HORATIO Well, sit we down.

And let us hear
Bernardo speak of this.

[1.10] BERNARDO Last night of all, when yon same star that's westward from the pole had made his course to illume that part of heaven where now it burns, Marcellus and myself,

[1.11] the bell then beating one,—

MARCELLUS Peace, break thee off;

Look: where it comes again!

[1.12] BERNARDO In the same figure, like the king that's dead.

MARCELLUS Thou art a *scholar*; speak to it, Horatio.

BERNARDO Looks it not like the king? mark it, Horatio.

HORATIO Most like: it harrows me with fear and wonder.

BERNARDO It would be spoke to.

MARCELLUS *Question* it, Horatio.

HORATIO What art thou, that usurp'st this time of night, together with that fair and warlike form in which the majesty of buried Denmark did sometimes march?

By heaven I charge thee, speak!

[1.13] MARCELLUS It is offended.

BERNARDO See, it stalks away!

HORATIO Stay! speak, speak!

Text for the Action Chart
Hamlet, Norman Bel Geddes, 1931

ENTER: C3—Ghost (unseen by audience or players) from temporary platforms behind R tab.

Lightly—casually.
Blows on his cold hands.

Bernardo sits. On 8′ level.

Ghost starts up
Horatio sits. L up stage end of 6 ft. On 6′ level

Marcellus stands. One foot on each step.

Music: Theme 12, Horns 4,
 Monitors, Volume 6

Bernardo pointing to the star—toward C3.

Horatio staring into space—toward C3.

Marcellus watching Horatio.

Horatio sees Ghost over Bernardo's shoulder —terror creeps over his face. On 7

Marcellus seeing expression on Horatio's face, turns head slowly toward C3.

Horatio terrorized and unable to speak, rises slowly to his feet.

Bernardo seeing expression on Horatio's face stops short.

Pause:

Marcellus sees Ghost—hushed voice. Is on 3′9 level.

LIGHT: Start up—on Ghost.

Bernardo turns in same direction. Goes to 3′9 level, below Marcellus.

Horatio follows to 3′9 level.

All three bodies become rigid. Rush to 3′9 on "Peace" and "break thee off".

Hardly audible. On 7^6

Pause: of terror.

Ghost moves imperceptibly (smoothly, without motion of walking) toward Horatio.

Ghost on 8
Marcellus clutches Horatio. Bern R

The group draws slowly away (L3) moving together.

Horatio touches Marcellus to assure himself of reality.

In a whisper.

His voice trembles.

LIGHT: Full up—on Ghost. Walking L on 8

Marcellus clings to Horatio.

Bernardo, Marcellus, Horatio stand huddled together—still.

Ghost moves imperceptibly toward them.

Pause:

Voice wavering. In a little to Ghost. Starts up steps to 6′ level.

LIGHT: Start down—on Ghost.

Pause:

Voice trembling. R end of 3^9
Ghost, without turning, withdraws toward C2—slowly, smoothly, as though floating instead of walking.

Terrified. Follows to steps leading to 6′ level.

Quickly.

Crescendo. On 6 ft.

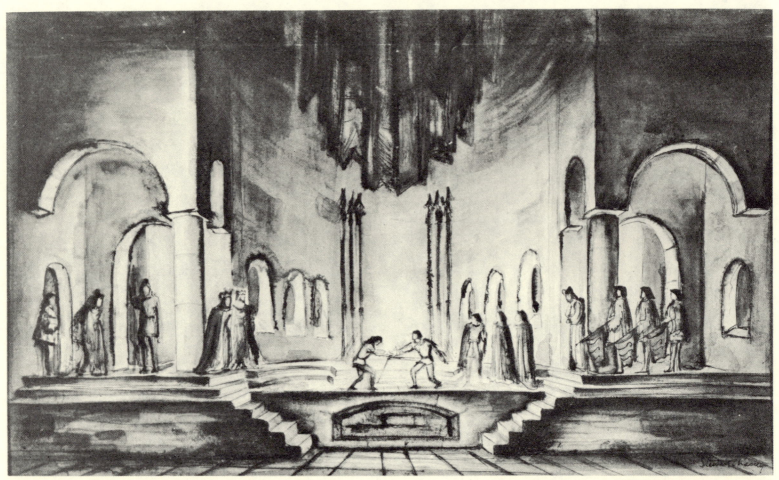

Drawing for the Unit Set

Photo Peter A. Juley & Son

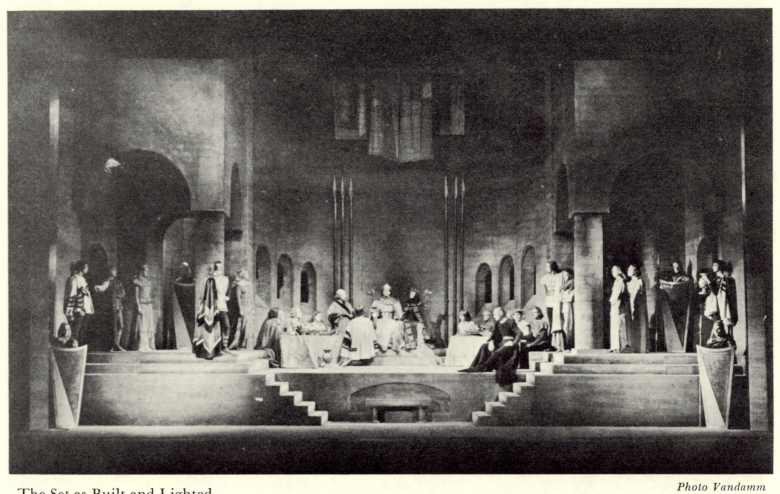

The Set as Built and Lighted

Photo Vandamm

Settings for *Hamlet*

170

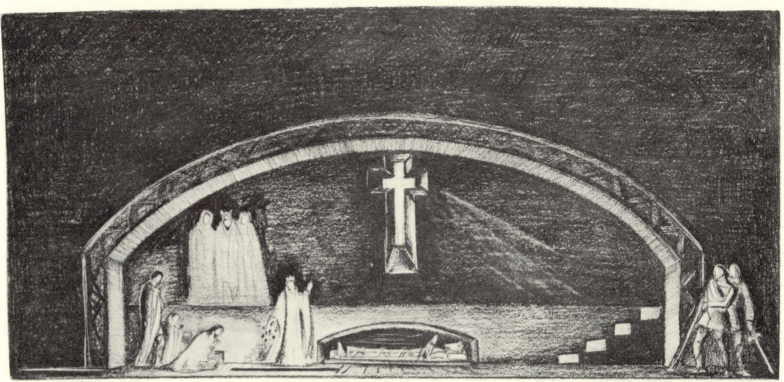

Drawing for Graveyard Scene

Photo Peter A. Juley & Son

Photo Vandamm

Ghost Scene
Designed by Stewart Chaney, 1936

171

Prologue

Ghost Scene
 Collection of Century Lighting, Inc.

Project for *Hamlet*, 1933

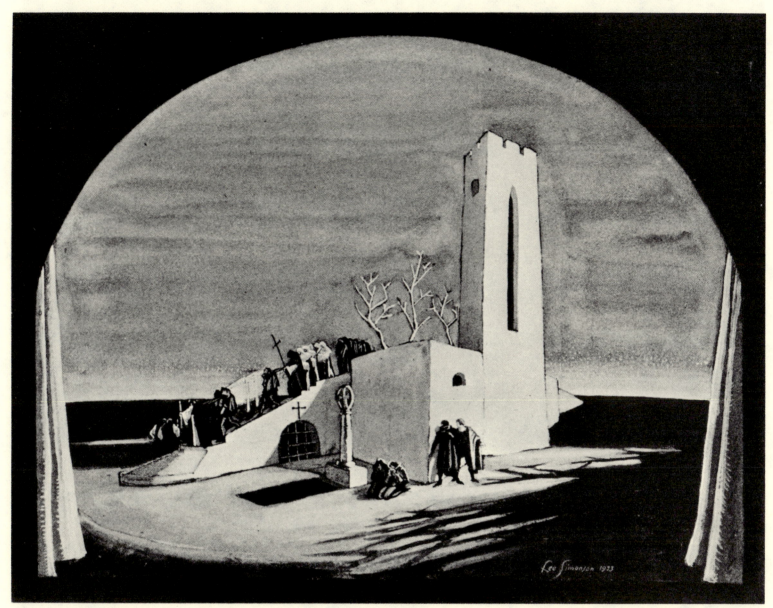

Burial of Ophelia

The Prologue is in pantomime with the court carousing and Hamlet brooding at one side. When the King, Queen and their retinue exit the first scene of the play on the parapet begins. The castle structure revolves on a turn-table. Smaller screen units for the more intimate scenes are brought on from the central arches while the lights are momentarily dimmed.

Lee Simonson, Designer

Closet Scene

Courtesy of the Artist

Players Scene
 Designs for *Hamlet*, by Donald Oenslager, 1936

174